ALL

about techniques in

OIL

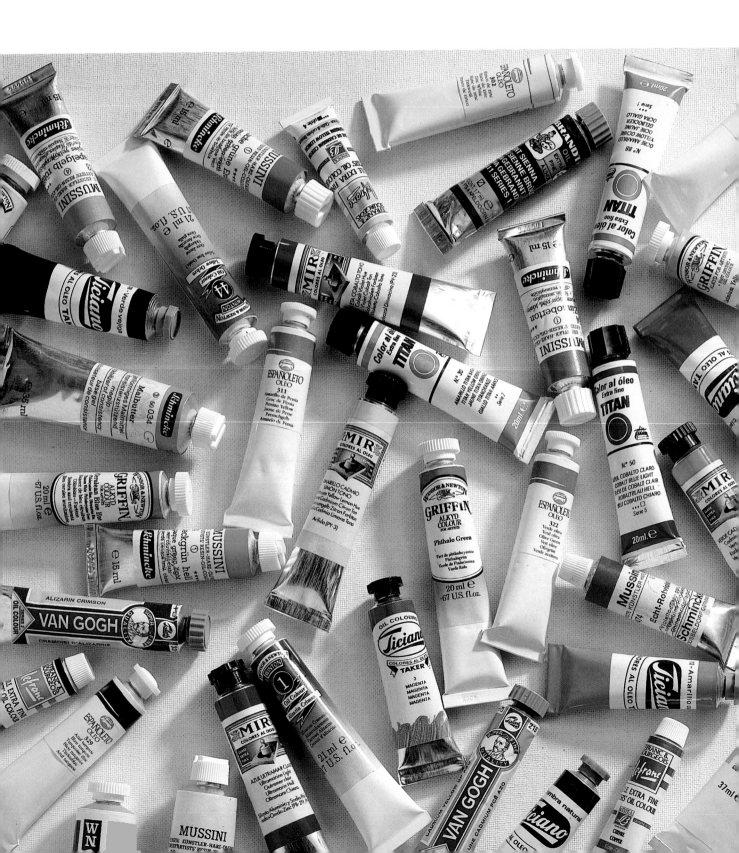

ALL

about techniques in

OIL

BARRON'S

Contents

Preface 5

MATERIALS AND TOOLS **6**
Paint 6
Supports 10
Brushes 16
Additives for Oil Paint 22
Paintboxes and Cases 28
Palettes, Palette Knives, and Cups 30
Easels and Seats 32
Other Materials and Accessories 34

OIL TECHNIQUES **36**
Stretching Canvas on Stretcher Bars 36
Priming 38
Using a Brush 42
Using a Palette Knife 46
How to Make Oil Paints and Use the Palette 48
One Color 50
Two Colors 54
Three Colors 56
Background Color 64
Oil Painting Procedure: "Fat Over Lean" 66
Painting Over Wet Paint: Painting *alla prima* 68
Painting Over Dry Paint: Painting in Stages 70
Painting with Diluted Paint: Painting with Glazes 72
Painting with a Palette Knife 74
Painting with Impasto 76
Painting with Small Strokes of Color 78
Painting Over a Base of Oil: Creating Atmosphere 80
Tricks of the Trade 82

SUBJECTS FOR OILS **102**
Skies 102
Water 108
Vegetation 114
Flesh Tones 124
Animal Textures 130
Glass 138
Metal 140

Topic Finder 142

Throughout the history of painting, it would be difficult to find a more important medium than oil. Painting in oil is a technique that has earned unrivalled respect thanks to its tradition and the wide range of effects it offers, the richness of hues, its infinite range of color, and for many other reasons. Oil painting is always the declared or undeclared aspiration of all artists.

Although all artists eventually acquire their own style, technique, and personal palette, there is a basis of fundamental knowledge concerning this medium—the materials, accessories, and the tricks of the trade—that it is essential to know and to take into account when painting in oil. A technique such as this comprises an infinite number of aspects that an artist must be familiar with to obtain the best results.

This book aims to cover virtually all the knowledge currently available regarding the technique of oil painting. To gather together in a single volume such a vast amount of in-depth information was quite a challenge and had its risks. Yet the need to produce a work as useful as this one, was more an obligation than a temptation as we were conscious that we would be helping a large number of people who practice oil painting.

This book has been divided into topics that are clearly identified and explained. Each explanation and the accompanying illustrations form an inseparable whole so that the reader is never left with unanswered questions.

The subject matter of this work and the way in which it is presented make it suitable for many types of readers. For teachers of fine arts, it will serve as a reference and as a guide for explanations in class. For students, beginners, and amateurs, it will provide help and practical advice as they progress and broaden their knowledge of oil painting techniques. And for professionals who find what they already know clearly set out, this book offers technical information of which they may be unaware.

Each chapter has been written by a team of professionals dedicated to studying, investigating, and teaching this painting medium. It is the result of many work sessions and the exchange of ideas and opinions, based on their knowledge and experience. Everything stated here has been thoroughly verified. The tricks of the trade, hints, advice, solutions, all have been confirmed by practice. All of this effort has focused on helping the reader acquire the knowledge and gradual mastery of this fascinating technique called oil painting.

Paint

O il paint, which has a creamy consistency, contains oil and pigments that dissolve in turpentine. Oil paint does not dry, but oxidizes and allows the artist to superimpose layers of opaque and transparent paint.

Painting with oils is complex and time consuming, not only due to the preparation of the materials but also to the many possibilities this technique offers. Because it is slow drying and can be constantly retouched, oil is one of the most versatile of the existing pictorial techniques. The main advantage of oil is the plasticity of the medium itself and the possibility of correcting the work at any stage in its development.

Oil paint is a dense, viscous medium that does not shrink when dry. Colors can be mixed on the palette if you want a clean, studied tone. Or they can be mixed directly on the canvas to create different chromatic effects. Oil can be used as impasto—in thick layers, or as glazes—in thin layers of highly diluted paint. The surface you paint on absorbs the medium and determines the degree of brilliance, permanence, and durability of the final result.

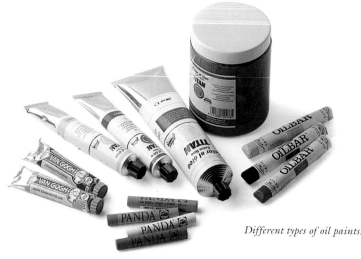

Different types of oil paints.

CHARACTERISTICS

Oil paint is an opaque, slow-drying medium with elastic properties that maintains color and durability after drying, providing the paint is of good quality, has been used correctly, and has been applied to a suitable surface.

Oil paint can be applied with a palette knife or a brush. Its consistency can be altered by adding turpentine or additional oil.

The outstanding characteristics of oil paint are its viscosity and body, which allow the artist to maintain the same texture on the canvas while softly gradating tones and colors. Oil paint can be used on virtually any surface that has been properly prepared.

COMPONENTS

Oil paint consists of pigment, oil, and turpentine.

The pigment that lends color to oil paint is ground with oil, the properties of which vary depending on its origin. The most commonly used oils have a certain degree of transparency and drying capacity: these are linseed, walnut, poppy seed, safflower, and soy.

The quality of oil paint depends on how fine it is; the density and the color will vary according to how much

Oil and pigment: the main ingredients of oil paints.

pigment has been ground with the oil.

Each pigment has its own characteristic drying time and stability when exposed to light. To minimize problems, other products are introduced, such as siccatives (drying agents) or other additives, depending on the chemical makeup of the pigment.

In the final stage of making oil paint the pigment is mixed with the oil and then ground into a thick paste.

PIGMENTS

Pigment is color in powder form that is present in all kinds of paint.

The color, quality, and luminosity of the paint depends on the pigment, how concentrated and pure it is, and what it is made of.

Pigments may be mineral or organic, natural or synthetic, although most of those used today are synthetic—either synthetic mineral pigments obtained from coal or synthetic organic pigments from petroleum products.

White pigments have their own characteristics, which should be taken into account in oil painting. Titanium white has great covering capability and is a powerful lightener of other colors; lead white is less opaque than titanium and is stable and elastic; zinc white is useful for creating transparencies, but tends to dry too quickly if used in thick layers.

The pigments used for lacquers produce transparent oil; most red pigments, however, produce opaque colors.

TOXICITY OF OIL PAINT

Until recently, there were a series of pigments that were highly toxic: those obtained from lead, silver, and arsenic, among others. These pigments have now been banned and replaced by harmless ones. Even so, it is best to avoid breathing the vapors from turpentine and to make sure no pigment is ingested, as most are potentially harmful.

BINDERS

A binder is a substance that holds the pigment together making it adhere.

The binder for pigments is oil, which is combined with the pigment and other ingredients to enable them to stick to the canvas. The main qualities of this kind of oil are as follows: it should allow the colors to be applied and spread, holding the pigment particles together and allowing other layers to be superimposed. When it dries, it should be adhesive, causing the pigment to bond to the surface. The binder should also bring out the intensity and the tone of the pigment, lending it a different quality from dry pigment.

Oil and turpentine are the main binders used for pigments.

Oil does not dry by evaporation like water. It is a medium that dries by oxidation, that is, by absorbing oxygen, after passing through a stage when it is slightly sticky to the touch. Different oils are obtained from plants, the most common ones being linseed, poppy seed, soy, walnut, sunflower, and hemp.

Linseed oil dries well, but tends to yellow, so it is best used for tones and colors that will not be unduly altered by this change, such as earth or black colors. Poppy seed oil is transparent and does not yellow but, like soy oil, is very slow drying. The drying speed of the oil must be taken into account when mixing it with the pigment. Slow drying, transparent oils are used for binding blue pigment. This helps to counteract the fast drying quality of these pigments, and because the oil does not yellow, the blues will not take on a green tone.

PROBLEMS OF OIL PAINT

Oil paint, if not properly used, can develop a series of faults after drying that reveal how the paint was incorrectly applied.

The following defects can largely be avoided if you abide by the main rule in oil painting: always apply fat over lean. (See *Painting Processes*, pages 66, 67.)

CRACKS

There are many kinds of cracks. These can arise when a layer of paint is less flexible than an underlying layer; it is desirable that the underlying layers contain less oil than those painted over them. Cracks can also develop when colors containing little oil are applied over highly absorbent layers of paint.

Extreme changes in temperature can also produce cracks as the canvas and the layer of paint contract or expand.

Cracks can be caused by a number of different conditions: painting lean over fat, extreme temperature changes, applying colors containing little oil over highly absorbent layers, the excessive use of drying agents, and so on.

DRY SPOTS

Dry spots occur when the painting surface has not been properly primed.

The areas of the canvas that have not been correctly primed will absorb oil from the paint, making it matte and brittle.

An unprimed surface can absorb too much oil from the paint.

SWELLING

Swelling, in the form of bubbles, occurs for two basic reasons: moisture penetrating from the reverse side of the canvas, or because part of the surface was greasy or damp when it was painted.

Wrinkles may form because of mistakes in the formulation or mixing of the oil.

PRESENTATION IN THE STORES

Oil paint is generally sold in tubes, wide necked jars, or cans. It can also be found in the form of oil sticks or oil pastels.

TUBES

The most common type of container is tubes. Sizes for the needs of

When the oil and pigment have not been correctly ground together, small lumps of dry pigment may form that can dry out the oil, causing part of the layer of paint to peel off.

Where oil paint has been applied thickly, lumps of paint may form that never really dry and that burst when the slightest pressure is applied.

both the amateur and most professional artists can be found in tubes. Although specific brands may vary slightly, these tubes usually contain 37 ml, 150 ml, or 200 ml.

Oil tubes can be bought singly or in sets. There is a wide variety of sets on the market, of different quality and price.

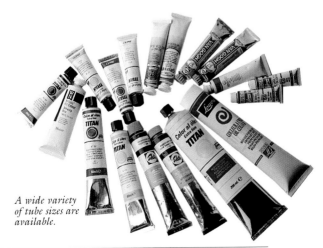

A wide variety of tube sizes are available.

JARS

For professional artists or for amateurs whose work requires a large quantity of oil paint, it is available in pint and quart sizes, with a tightly fitting cover or a screw-on-cap to prevent it from drying out.

These large containers are only recommended for painters who use very large amounts of paint, either for many paintings or for working on large formats. It is too much for those who use small or medium formats as it can easily dry and harden in contact with the air before it is used up.

These large sizes of oil paint are not available in every brand, but the companies that offer them usually provide good quality in all the sizes they sell.

QUICK DRYING PAINT

At the same time that traditional paints have been developed, so has another series of products that combine different properties. These are alkyd colors, which use alkyd resin as a binder rather than linseed oil. As they are resinous products, produced from rectified turpentine and different plant resins, they are similar to oils, but they are faster drying and their colors tend to be brighter and cleaner. Alkyd colors can be intermixed with all oil paints and oil mediums.

Another product with similar characteristics was one that Edvard Munch attempted to develop by mixing resins and oils to make a water soluble medium. This was not possible until recently, and the brand that carries this artist's name produces a paint that gives results similar to those of latex paint, although it maintains the body and volume of oil paint.

Chemical drying agents derived from cobalt, manganese, or lead oxide can, if used in large amounts, alter the natural oxidizing process of oil paint.

OILBARS

Another application of oil media is to mix them with other ingredients such as pastel or wax. The resulting product is called an oilbar. It combines the characteristics of the two media and can be blended to create thick layers of paint or thinned with turpentine.

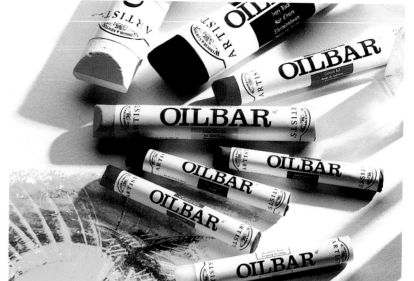

Oilbars can be dissolved in turpentine and mixed with tubed paint.

QUALITY

The quality of different oil paints depends on several factors that determine the luminosity, brilliance, and covering power of the paint.

The quality of oil paint depends on how fine the particles are. Extra-fine colors contain a larger amount of pigment than others.

The paint should be creamy and it should spread easily; it is of high quality if it has good covering ability. Coloring power is the capacity of one color to alter another; the better the quality of a color, the less you need to use to alter another tone or color.

Certain well-known brands market paints of different qualities intended for students or amateurs, offering much cheaper products under a different name. It is not advisable to confine yourself to a single brand as many oil paints are now being produced that are of acceptable quality, both with regard to the oils used and the pigments.

Many experienced artists buy certain colors of one brand and others of different brands, obtaining ranges and hues that would not be possible without this combination of different brands.

ADVANTAGES AND DISADVANTAGES

The most commonly used oil paint comes in tubes, which allow you to use just the amount you need, cleanly and quickly. Always remember to clean the threaded neck of the tube so that the cap does not stick. When working with paint in jars, you need to use a palette knife to extract the paint. There is a risk the top surface will dry on contact with the air. This form does have the advantage, though, that any paint not used can be returned to the jar with the palette knife.

If the paint dries around the neck of the tube, it can be softened by warming it a little with a lighter.

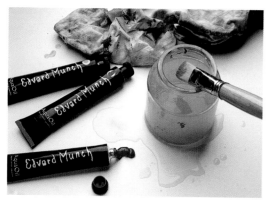

Edvard Munch oils are quick drying and are soluble in water due to their resin content.

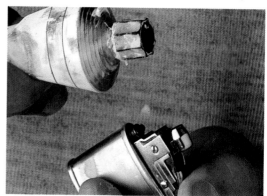

COLOR CHART

A color chart is a photographic representation of all the colors of a commercial brand.

Each brand has its own color chart that allows you to identify colors by sight, rather than name, which may vary depending on the manufacturer. By comparing different charts you can see how many different colors the manufacturer produces, according to the variety of pigments used and how they are combined.

A chart is a perfect guide as it displays the basic colors and enables the artist to select the one he or she needs. It also shows certain tones and colors available to the artist without having to mix them on the palette.

Thanks also to the color chart, the artist can decide on a particular chromatic range, choosing those colors that best suit a particular style of painting. A palette will not, naturally, contain all the colors of the chart—just the ones that are really necessary. Take into account that by mixing colors on the palette, an artist can create a wide variety of tones and colors and an infinite number of variations by mixing primary and secondary colors.

The chart is one of the most important accessories as it enables the artist to mix values to obtain specific variations of color.

When consulting a color chart, do not confine yourself to a single brand. On the contrary, a palette becomes much more personal when it includes colors from different manufacturers, selected after studying the different chromatic qualities of several brands. This study should consider the quality of the paint, its density, and covering capacity. The main characteristics of each color are shown in the chart by symbols that provide all the information necessary concerning the colors. For example, the chart on this page shows 35 colors with their covering capacity. The numbers at the side of each color indicate their classification in the catalogue; maximum resistance to light is indicated by ★★★, good resistance to light by ★★; the transparent capacity of the color is indicated by a box.

Some manufacturers use a blank box symbol to indicate that the color is transparent.

To stop the cap from sticking, clean the thread with a cloth.

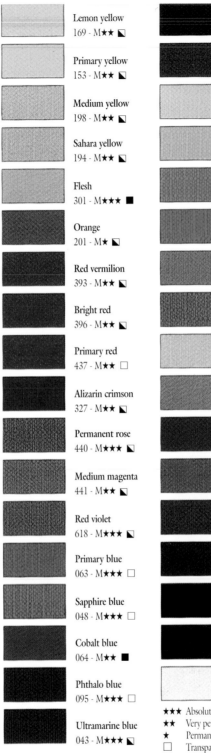

Lemon yellow 169 - M★★ ◨	Marine blue 042 - M★★ □
Primary yellow 153 - M★★ ◨	Blue violet 604 - M★★★ □
Medium yellow 198 - M★★ ◨	Yellow green 590 - M★★ ◨
Sahara yellow 194 - M★★ ◨	Light green 556 - M★★ ◨
Flesh 301 - M★★★ ■	Medium green 561 - M★★ ■
Orange 201 - M★ ◨	Dark green 531 - M★★ ◨
Red vermilion 393 - M★★ ◨	Chrome oxide green 542 - M★★★ ◨
Bright red 396 - M★★ ◨	Green ochre 311 - M★★★ ■
Primary red 437 - M★★ □	Pale ochre 310 - M★★★ ■
Alizarin crimson 327 - M★★ ◨	Yellow ochre 302-M★★★ ■
Permanent rose 440 - M★★★ ◨	Red ochre 306 - M★★★ ■
Medium magenta 441 - M★★ ◨	Raw sienna 482 - M★★★ ■
Red violet 618 - M★★★ ◨	Burnt sienna 481 - M★★★ ■
Primary blue 063 - M★★★ □	Burnt umber 477 - M★★★ ◨
Sapphire blue 048 - M★★★ □	Ivory black 269 - M★★★ ■
Cobalt blue 064 - M★★ ■	Mars black 271 - M★★★ ■
Phthalo blue 095 - M★★★ □	Permalba (Zinc) titanium white 013 - M★★★ ■
Ultramarine blue 043 - M★★★ ◨	

Oil color chart indicating their characteristics.

★★★ Absolutely permanent colors, even when lightened
★★ Very permanent colors
★ Permanent colors used in a pure state
□ Transparent colors
■ Opaque colors
◨ Semi-opaque colors, semi-transparent, also called neutral
M Colors that remain permanent when mixed

Supports

In oil painting, a support is any surface that can be painted on, provided it is non-fatty, for example, canvas, wood, paper, and plastic. The only requirement in oil painting is that the surface does not have a higher fat content than the paint itself.

When choosing supports for oil painting, you must take into account any possible changes the surface may undergo; although oil paint is highly stable and has a certain elasticity when dry, any contraction or warping of the support could spoil the layer of paint. Because the rigidity and stability of the support are fundamental to the conservation of the painting, ideal supports are those least prone to changes or alterations. Seasoned wood, masonite, canvas board, or illustration board are all perfectly rigid surfaces. The most commonly used surface, however, is canvas. It needs to be correctly mounted on a stretcher, which ensures that the entire surface is equally taut. Canvas allows the paint to breathe, is light, and more stable in adverse conditions that may cause warping of rigid, wood surfaces.

Although any surface can function as the support for a fatty medium such as oil, all surfaces made of natural fiber, such as canvas and wood, need to be protected from direct contact with the paint to prevent the oil from spoiling them. The primer applied to the surface has a dual function: it prevents the natural fiber from rotting and prevents the porous surface from absorbing too much oil or additives.

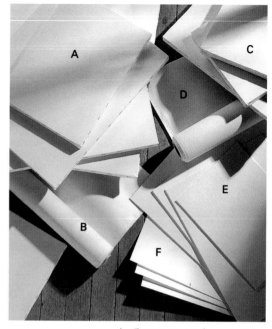

A. *Canvas mounted on a stretcher.*
B. *A roll of primed canvas.*
C. *Prestretched canvas.*
D. *A roll of unprimed canvas.*
E. *Canvas boards.*
F. *Winston paper for oil sketches.*

Different types of primed and unprimed canvas.

CANVAS

Canvas has been the main surface used for painting since the fifteenth century when it began to replace wood, due to the advantages it offered, such as its lightness and elasticity. A wide range of canvases has been developed to suit the different stylistic and economic requirements of the artist.

Canvas can vary in its elasticity, resistance, and capacity for recovering its original state. The most highly prized types of canvas are highly resistant, finely textured, and elastic. The quality of canvas depends on its composition, weave, weight, and density. Composition refers to the fiber content, both quality and quantity; weave defines the weft of the threads; the weight of canvas is measured in ounces per square yard (g/m²), before priming; density is the number of threads of weft and warp per square inch (cm²).

Detail of the dense weft of unstretched cotton.

The texture of unprimed fabric.

UNPRIMED CANVAS

Unprimed canvas is canvas that is identical on both sides of the fabric, showing the same characteristics of the texture of the woven surface.

Canvas can be purchased either unprimed or primed, depending on the preference of the artist. Unprimed canvas can always be prepared according to the requirements of the artist's work, regarding absorption, sealing, and even color. It is sold by the yard (meter) and, depending on the manufacturer, may vary in width. The composition of the canvas determines its quality. It may be made of vegetable fiber or a combination of natural and synthetic fibers.

Unprimed canvas is easier to stretch than primed canvas, particularly in the case of large paintings, and it is preferable for artists who want full control over the preparation of their material.

CANVAS

Canvas does not refer to any fabric in particular; it is a generic name for describing any fabric support used for artistic painting. When we refer to canvas, we usually mean cloth that has been prepared or primed, or the finished painting itself.

LINEN, COTTON, SACKCLOTH, AND SYNTHETIC FIBERS

Among the unprimed types of canvas, those woven of natural fibers stand out for their high quality. Of these, linen deserves a special mention for its great resistance to tension and climactic variations. It is highly stable once it is primed and stretched. There are many different types of finish for linen, depending on the cloth's thread and the weft. Unprimed linen has a characteristic burnt Sienna color and an even, regular surface.

Cotton is highly elastic. Although it needs careful stretching to prevent sagging, this makes it suitable for painting. Cotton canvas is easy to mount on stretchers and can be treated with sizing or with a primer. Occasionally there may be nubs in the surface, but these can be sanded when the primer is applied. Cotton canvas is a creamy white color and although it is inferior in quality to linen, its much lower price is compensation.

Sackcloth or burlap, ochre in color, has a rough and fibrous surface, which is a very interesting texture to paint on. Painting on this open weave also obliges the artist to use a great deal of paint, which tends to penetrate the fabric unless it is completely filled with a primer. However, because sackcloth is not very durable, it should not be used for works intended to last a long time.

There is also a wide variety of blended fabrics that combine cotton and linen. Fabric woven from two types of fiber with different elasticity and resistance to expansion are usually of lower quality than those that use just one, as each type of fiber absorbs moisture to a different degree, causing changes in tension over the entire surface of the canvas when it is stretched.

Synthetic fibers, such as nylon, polyester, or viscose are ideal surfaces for oil paints because they assimilate the medium very well and are non-organic. Mixed synthetic and natural fibers usually provide a good surface since the capacity of synthetic fibers to recover their form combines perfectly with the weave of natural fibers.

PRIMED CANVAS

A primed canvas is one with a solid layer that protects the fiber from contact with the medium.

Any unprimed organic surface to be painted with oils needs priming to prevent the fibers coming into contact with the oil. Different primers adapt the canvas to the different types of finish the artist requires, so the same canvas with different primers can be found on the market. Fabric with highly textured surfaces of an alkyd origin are also available as smooth surfaces primed with acrylic that covers the weave entirely.

Canvas can be primed using one of three basic methods: a simple, thin glue that does not affect the color of the canvas; a compound containing rabbitskin glue and Spanish white or chalk; or resinous sealers such as acrylic gesso. Each type of primer has its own properties of absorption and porosity, causing oils painted on them to produce different finishes, depending on the texture and porosity of the canvas.

COARSE, MEDIUM, AND FINE WEAVES

The weave is the variation in texture of the canvas produced by the thickness and weft of the fibers. Some canvas is double fill canvas, woven with two threads in both directions while some is single fill, woven with two threads in one direction and one thread in the other. A fine grade of canvas, such as linen, is often woven with long yarns and with equal warp and weft for added stability when stretched. Priming emphasizes the texture and weave of the canvas.

The same priming will respond differently to different types of canvas, depending on the degree of absorption of each fabric and weave.

A tightly woven, fine weave will result in a dense, smooth surface, free of irregularities and blemishes. If this canvas is primed with careful attention to the amount and choice of primer, the result will be a smooth, resistant and flexible painting surface.

A fine weave canvas, such as a good quality of linen, which is well primed, is an ideal surface for portrait painting, for fine detailed painting, or for subjects that require a delicate finish, such as glazes.

The thicker the thread used in the weft, the thicker the weave of the cloth. It is substantial in feel and body, with great stability once it has been stretched. Medium weave canvas is the type most commonly used by artists. It has a surface texture which adapts perfectly to most painting requirements such as landscapes, stilllife, or abstract paintings as well as some types of portraiture.

Coarse weave canvas is formed by thick warp fabric, producing a full-bodied weft, though not necessarily dense. There is often great dimensional stability in a coarse weave canvas, which will satisfy most professional artists. The pronounced surface adds an interesting element to a painting.

Unprimed sackcloth.

Sackcloth is fragile despite its thickness and will deteriorate rapidly if alkyd priming is used.

Sackcloth with an alkyd primer.

100% linen, 181 threads per square inch (28 cm²)

On this page and the following, we show different types of canvas and the kind of brushstrokes they produce. On the right, the same cloth with alkyd and acrylic priming.

Cotton and linen cloth; this is a very close weave.

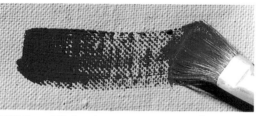

100% linen, 155 threads per square inch (24 cm²)

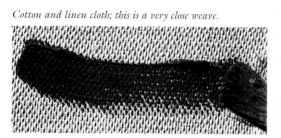

100% linen, 155 threads per square inch (24 cm²)

TYPES OF PRIMED CANVAS

A major distinction should be drawn between canvases primed using oil gesso and those that use acrylic gesso. The former are thinned with turpentine or mineral spirits and are especially suitable for oil paint. There are very good quality canvases primed according to the traditional method, that is, with oil gesso, although this obviously increases the price.

Acrylic gesso primer, used for both acrylics and oil paints, is thinned with water, which saves the trouble of stretching the canvas, and makes it more elastic. This is an advantage with top quality cotton and linen as the tautness is produced by the fibers themselves. When low quality canvas

is primed using acrylic gesso, however, the different degrees of tension between the canvas and the primer causes the fabric to swell and curl, damaging the painting. (See *Priming*, pages 38, 39.)

THICKNESSES OF COTTON

Cotton is vegetable fiber extracted from the plant of the same name. Spinning creates the weave of the cloth that varies in thickness depending on the thread and the type of weft.

Cotton comes in several qualities, three of which are the most common. In any case, the quality of the fabric depends on how fine the thread is, the weave, and the priming. Very fine cotton cloth has an even surface and is produced

100% linen, 135 threads per square inch (21 cm²)

100% linen, 148 threads per square inch (23 cm²)

100% linen, 168 threads per square inch (26 cm²)

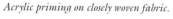

Acrylic priming on closely woven fabric.

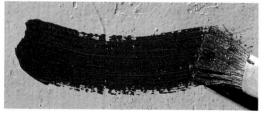

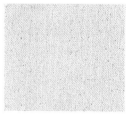

100% linen, 155 threads per square inch (24 cm²)

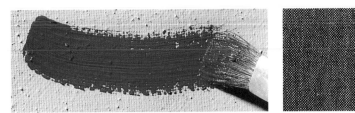

38% linen, 62% cotton, 155 threads per square inch (24 cm²)

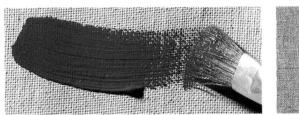

65% linen, 23% polyester, 12% vicose, 155 threads per square inch (24 cm²)

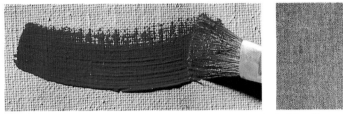

78% linen, 14% polyester, 8% viscose, 168 threads per square inch (26 cm²)

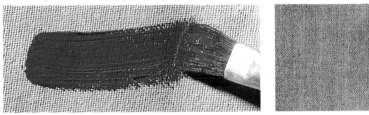

60% cotton, 26% polyester, 14% viscose, 155 threads per square inch (24 cm²)

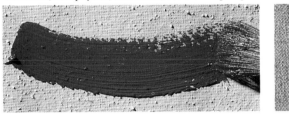

73% cotton, 17% polyester, 10% viscose, 148 threads per square inch (23 cm²)

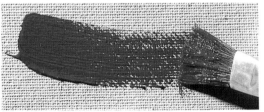

65% cotton, 28% polyester, 7% viscose, 148 threads per square inch (23 cm²)

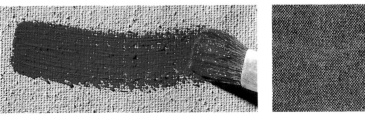

67% cotton, 27% polyester, 6% viscose, 155 threads per square inch (24 cm²)

using very thin thread. Depending on how closely woven it is, primed cotton will be more resistant and elastic. Despite its light weight, it has substantial body. It can be bought in a very fine weave which, together with careful priming, will result in an almost flat surface. This quality of fine weave cotton canvas, like fine linen, provides a smooth surface which is excellent for portraiture or other fine work.

Medium cotton cloth is the most commonly used as it is the right thickness and texture for all kinds of work; in addition, the elasticity of the cotton is compensated for by increasing the thickness. This adds to the stability of this fabric when it is stretched. Heavy cotton canvas may be cotton duck or sailcloth and it uses thread woven into cord. It is extremely strong and durable, thus suitable for paintings that require firm brushwork or use of the palette knife.

Cotton cloth may contain linen, polyester, or viscose to make it more elastic.

THICKNESS OF LINEN

Linen is one of the most stable fibers, because it resists expansion or contraction caused by changes in temperature or humidity. It can therefore be used to obtain excellent results, whether the canvas is thin or thick, although the final choice will depend on the type of work you are going to paint.

GRADES OF CANVAS

The grade or quality of canvas is determined by a set of properties including its elasticity, resistance to temperature and humidity changes, priming and durability. The better these properties, the higher the grade of the canvas.

Commercial canvas is sometimes divided between canvas for amateurs and superior quality canvas for professionals. The former is inexpensive, although there is also some economical cotton canvas of quite acceptable quality. You can even find fine quality cotton canvas with a thick acrylic priming. Cheap canvas for amateurs does not usually produce good results; it is preferable to pay a little more and buy professional quality canvas.

The prices for canvas vary widely, depending on the composition of the fabric, the weave, the weight, and whether it is primed or unprimed. A fine grade of unprimed linen is usually expensive, as is a fine grade of cotton canvas, as well. If they have already been carefully primed, they will cost even more. These superior qualities of canvas are used by professional artists and by amateurs who want good results.

FORMATS: ROLLS OR PRESTRETCHED

Canvas is usually available in one of two forms: in rolls sold by the yard (meter) or prestretched and primed.

Canvas by the roll can be bought primed or unprimed, depending on

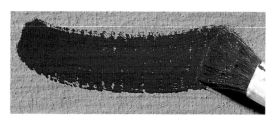

Fine weave cloth is suitable for delicate, detailed work, although it is not always necessary if the paint is thickly applied.

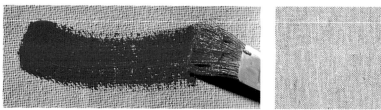

33% cotton, 55% polyester, 12% viscose, 181 threads per square inch (28 cm²)

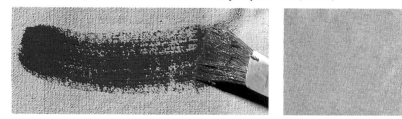

50% cotton, 50% polyester, 239 threads per square inch (37 cm²)

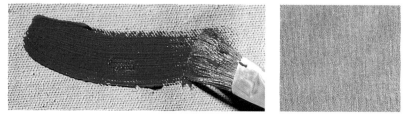

62% cotton, 25% polyester, 13% viscose, 219 threads per square inch (34 cm²)

the artist's requirements. The rolls are available in a variety of widths, allowing the artist to adapt the canvas to different stretchers.

If you don't want the bother of preparing your own canvases, you can buy them ready mounted on a stretcher. Many fine arts stores stock a variety of prestretched canvases. Should you need a special size that is not stocked, some stores will custom build stretchers to measure.

ADVANTAGES AND DISADVANTAGES OF DIFFERENT TYPES OF CANVAS

No type of canvas should cause any prob-lems if it is used correctly; its durability will depend on the type of fabric and the priming. The finest grade of canvas can be used for all kinds of pic-torial work, while a less expensive grade is more suited to studies since it can cause a finished work to deteriorate.

The quality and price of the canvas selected should be determined by what the artist intends to paint. It is advisable to choose medium and higher quality canvases. Medium grade canvas is recognizable by the close-ness of the weave and whether it is cotton, syn-thetic, or a combination of both.

Rabbitskin glue prim-ing often causes surface cracking, because it hard-ens and loses elasticity when dry. If we use this on elastic fabric such as cotton, the problem will be worse, so this type of priming should be used for resistant fabrics such as linen.

Buying canvas by the roll is handy for artists who are used to stretch-ing their own canvases; if not, they are apt to waste part of the roll, which then cannot be fitted onto any stretcher. When buy-ing prestretched canvas,

the artist saves time, al-though this option is ob-viously more expensive. (See *Mounting the Support on the Stretcher*, pages 36, 37.)

STRETCHERS

A stretcher is the frame on which canvas is tautly mounted so it can be painted on. Stretchers come in different quali-ties depending on the seasoning of the wood, the way the wooden strips are connected, and the bevel of the edges. A stretcher basically consists of four wooden strips connected in such a way that the surface of the canvas can be stretched taut and held in place with wedges inserted in the internal angle of the corners. Larger size

stretchers also incorpo-rate cross-strips of wood to reinforce them and en-sure that the surface of the canvas is stable.

The finish of the stretcher can also vary. The internal measure-ment shortens in com-parison to the outer edge to prevent the canvas from warping after it is stretched. Ever since can-vas mounted on a stretcher became popu-lar, this kind of frame has undergone various tech-nical developments.

Bridle joint; the wedge, ending in a butt, produces a right angle fit.

JOINING

Joining is the method by which the stretcher's wooden strips are con-nected. There are two basic methods: using bridle joints, or miter joints. Bridle joints are more solid and resistant than miter joints, and consist of the butt (1),

tenon (2), and wedge (3). These components enable the strips to be fitted at a right angle. Modern stretchers have wedges that are shifted slightly inward, which prevents the stretcher from coming apart once the canvas has been mounted. This type of joining produces a flat

surface parallel to the canvas, which may result in marks when the brush presses down near the profile of the stretcher. This is corrected using a miter joint which slopes inward, so that the canvas rests on a solid surface.

The miter joint allows the plane of the stretcher to slope down, but it is easier to dismount.

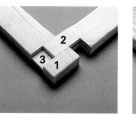

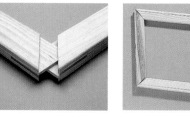

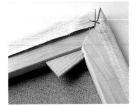

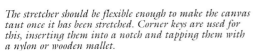

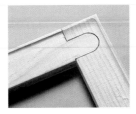

The stretcher should be flexible enough to make the canvas taut once it has been stretched. Corner keys are used for this, inserting them into a notch and tapping them with a nylon or wooden mallet.

A levantine joint, the most highly developed of stretcher joints.

WOOD, CARDBOARD, AND PAPER

Solid wood painting surfaces are cut out of tree trunks in the form of planks and then dried and seasoned; however, wood is seldom used today. Chipboard wood is a board made from gluing and compressing tiny fragments of wood. It comes in different thicknesses, from .020 inches (0.5 mm) to 2 inches (5 cm). It is sold either with or without a primed canvas surface.

Solid plywood is an ideal surface for painting and is resistant to warping and climatic changes.

Cardboard and paper are unsuitable surfaces for oils; however, properly primed, heavy cardboard can sometimes make a good support. There are also types of paper specially manufactured for oil painting.

INEXPENSIVE STRETCHERS

The simplest stretcher is also the cheapest. These models are made of simple strips of wood without a fine finish. Either bridle joints or miter joints can be used for assembling them.

Although they are sold in all sizes, it is advisable to use these simple stretchers only for smaller formats because the tension of large canvas can twist the stretcher and warp the painting.

amount of contact between canvas and wood.

French mitered stretchers have a sloping upper plane that prevents the canvas from coming into contact with the wood.

The Levantine stretcher is similar to the bridle type, but the tongue is rounded and not as wide as the side; it also has raised edges that separate the canvas from the wood.

A good quality stretcher over 24 inches × 36 inches (60 × 92 cm) is reinforced with crossbars when mounted.

They are miter joined and come in different widths: 1.8 inches (4.5 cm) and 2.4 inches (6 cm).

Large size European stretchers should be bought in the widest size as they lack crossbars and tend to be weak.

The edge of a European stretcher is raised in such a way that it separates the plane of the canvas from the plane of the stretcher, preventing it from warping the cloth as a result of the pressure of the brush in the corners.

An oak plank taken from an old piece of furniture. Varnish can be a good primer.

Plank primed with gesso. The pores are entirely filled.

Chipboard primed with glue.

Chipboard primed with gesso.

A piece of paper specially manufactured for oil painting; it needs no priming.

Priming on cardboard.

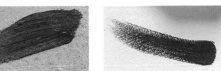

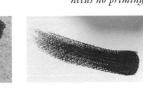

SPANISH, FRENCH, AND LEVANTINE STRETCHERS

Spanish bridle joint stretchers are attached at right angles, while French stretchers have mitered ends. Spanish stretchers may have the upper plane at right angles to the side and fully in contact with the canvas, or have a blunt inside edge, reducing the

EUROPEAN STRETCHERS

European stretchers come in a wide variety of sizes that can be used to create nonstandard sizes.

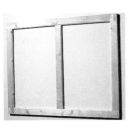

A stretcher with a crossbar.

STANDARD SIZES OF STRETCHERS

The stretchers sold in stores conform to standard measurements intended to cover most of the artist's requirements as regards format.

STRETCHER SIZES (in inches)					
STANDARD		MEDIUM DUTY		HEAVY DUTY	
8	26	8	28	18	62
9	27	9	30	20	64
10	28	10	32	24	66
11	29	11	34	30	68
12	30	12	36	32	70
13	31	14	38	36	72
14	32	16	40	40	74
15	33	18	42	42	76
16	34	20	44	48	78
17	35	22	46	50	80
18	36	24	48	52	82
19	38	26		54	84
20	40			56	86
21	42			58	88
22	44			60	90
23	46				
24	48				
25					

1 and 2, top quality French and Spanish stretchers; 3 European stretcher; 4, 5 and 6, inexpensive stretchers.

Brushes

A brush is the main tool used for applying paint to the surface of the support. Depending on the construction, the quality of the bristles, and the handle, the brush will produce different effects and brushstrokes. The materials used to make different brushes are selected according to the way the brush is meant to be used. Oils, which are a thick medium, can literally be scratched by the bristles; so, depending on how stiff or flexible they are, the mark left by each brushstroke will vary. A brush is a precision instrument that must be hand-made to obtain the best results.

The quality of a good brush depends on the materials chosen to manufacture it. For example, a good brush should not lose its bristles. This depends on the glue and the pressure applied by the ferrule. The bristles should be resilient and flexible so that they will recover their original shape after use. Despite the natural wear on the brush due to ordinary use, it will last much longer if it is properly cared for. In fact, artists prefer good brushes that they have used for some time.

Brushes can be used in many ways for oil painting. They can be used to apply thick layers of paint or, if the paint is highly diluted with turpentine, used in much the same way as in watercolor painting. The wide variety of techniques means you must choose the right brush for each occasion; a large number of different brushes are available with various types of fiber, in different shapes, and of varied quality, depending on how they are to be used.

Just a few brushes are sufficient to produce any type of painting; the choice is a personal one and depends on the characteristics of the brush and the artist's style.

HANDLES

The handle has an elongated shape that makes the brush easier to use.

The quality of the handle depends on the wood and the finish. Durable, light woods are generally used, although it is the varnish or lacquer finish that really guarantees the useful life of the brush. Good brushes survive a long time before the coating flakes off.

Long handles allow you to work at a distance. Handles are usually tapered at the end, even on very low-numbered brushes, although not as obviously. The spindle shape fits snugly into the hand, preventing it from slipping accidentally.

Large flat brush have flat handles, but still maintain the spindle shape.

Handles are also made from other materials such as acrylic resin or plastic.

DESIGN OF A BRUSH

A brush consists of three parts: the handle, the ferrule, and the fibers.

Making a brush is a delicate process that starts with the selection of the fibers. Ferrules can be chrome-plated to prevent them from corroding, and varnishes or lacquers are used to stop deterioration of the wooden handle.

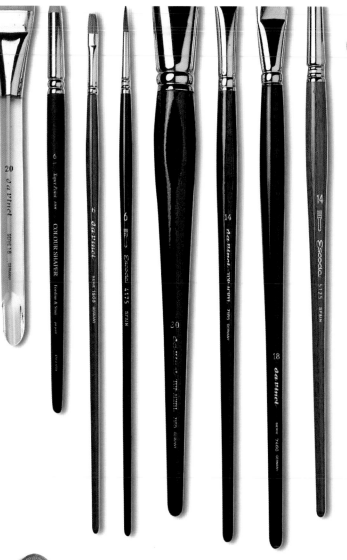

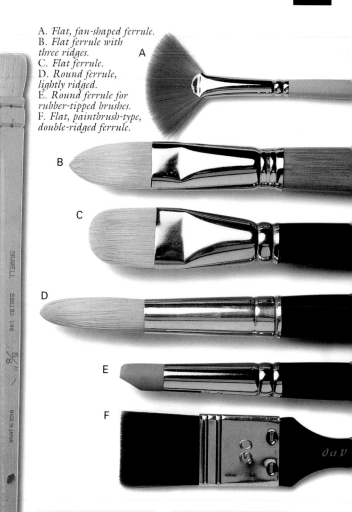

A. *Flat, fan-shaped ferrule.*
B. *Flat ferrule with three ridges.*
C. *Flat ferrule.*
D. *Round ferrule, lightly ridged.*
E. *Round ferrule for rubber-tipped brushes.*
F. *Flat, paintbrush-type, double-ridged ferrule.*

Assorted handles. The shorter ones are designed for more detailed work.

Paintbrush handles. The anatomical shape is characteristic.

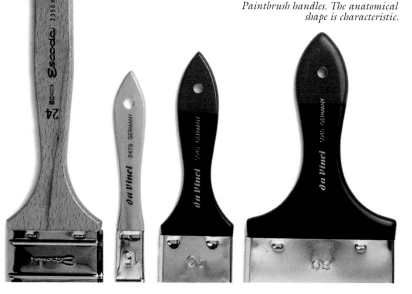

FERRULES

The ferrule is the metal part of the brush that grips the tuft of fibers and attaches them to the handle. It is usually made of aluminum or copper and is generally chrome-plated to keep it from rusting.

The way the ferrule grips the fibers largely determines the shape the brush will be. The ferrule is attached to the handle by stamped ridges that leave a characteristic ring shape around its base.

Good quality brushes have pronounced ridges that grip the ferrule tightly to the handle.

Ferrules can be round or flat; the flat type usually flares out a little.

FIBERS

This is the element that really determines the quality of a brush. Designed to hold paint and deposit it on the surface, the fibers must have special characteristics to increase their ability to carry the paint. Manufacturers obviously use good quality fibers in brushes with fine ferrules and well finished handles.

The better the fiber, the more paint it can hold without losing shape, enabling you to apply the paint easily to the surface. This is a sign of the best quality brushes, and there are now good quality products at reasonable prices.

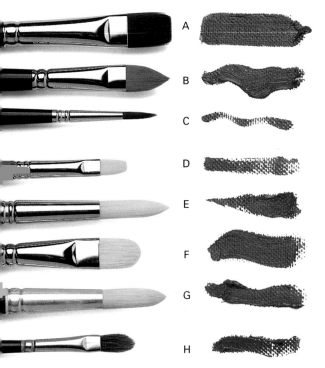

Assorted brushes and the mark they leave depending on their hair and shape:
A. Flat, synthetic. B. Filbert, synthetic. C. Round fine, synthetic. D. Flat, hog bristle. E. Round, hog bristle. F. Filbert hog bristle. G. Round thick, hog bristle. H. Small flat, ox hair.

TYPES OF FIBER

The fibers used for oil brushes can be animal or synthetic hair. Those of animal origin include hog bristle, which is very hard and flexible, or animal hair that is softer than hog's. Natural hair retains more liquid than synthetic bristles even though it is much softer.

Synthetic hair comes in different grades, some of which are just as good as natural hair brushes, and are less expensive.

HOG BRISTLE

Hog bristle brushes are the ones most oil painters use. Taken from the back and abdomen of boars, the bristles are usually bleached before the brushes are manufactured. The best bristles, however, do not need bleaching.

Fine bristle lacks a pointed tip; instead it branches out. This means it is very soft and, because it is also strong, produces a highly elastic tip. This kind of hair is naturally curved, a feature that good manufacturers take advantage of to shape the different tips.

The main exporter of hog bristle is China, which has come to replace Siberia and Manchuria as the primary exporters.

Hog bristle brushes come in different qualities. If possible, always choose the better quality which, although it is more expensive, will be a better value for the money in the long term.

Hog bristle brushes are available in all thicknesses.

Top quality Chinese hog bristle brushes, from the smallest size to the house paintbrush size; used for soft,

MONGOOSE

The mongoose is a protected species, so teijen, an artificial fiber with characteristics similar to mongoose hair, is used for brushes instead. Buying products

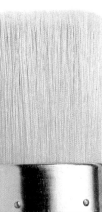

Sable hair brushes.

obtained from protected or disappearing species should always be avoided.

SABLE

Traditionally, this is the painter's favorite type of hair. It is very soft and pliant and is excellent for delicate, detailed brushwork. Its main advantage is the tip it forms and its capacity to recover its shape.

Red marten, kolinsky, or Siberian mink hair are the most elastic and long-lasting types that exist. They produce a perfectly sharp tip, swell out in the middle and taper away again toward the root. Sable hair is inserted into the ferrule up to the center, although this position is sometimes changed. The behavior of the brush depends on where it is gripped.

Not all sable hair is of the same quality. Martens (the animal from which it is obtained) bred in captivity in temperate climates grow hair that is much more delicate than wild martens bred in cold climates.

Sable hair can be used to paint long, soft, continuous brushstrokes thanks to the large amount of paint it can retain. It is ideal for works that require a very light touch and this hair is used to make all kinds of brushes: fine, round, or flat, and of all qualities.

Sable hair is the most expensive on the market, but it always produces precise, accurate results.

OX HAIR

This is obtained from the inner surface of ox ears. Less pliant and therefore less able to recover its shape than sable hair, it can be used as an economical alternative. However, the thickness of oil paints means that elasticity and the capacity of a brush to recover its shape are important; hence, because this type of hair does not form a good tip, nor is it as accurate as sable hair, we cannot recommend it.

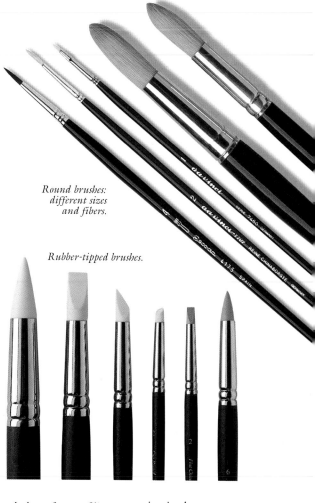

Round brushes: different sizes and fibers.

Rubber-tipped brushes.

SYNTHETIC HAIR

Synthetic hair is the best alternative to sable. Development and research into this type of fiber has succeeded in producing hair of extraordinary quality, similar in many cases to true sable with regard to strength and elasticity. Synthetic hair is, however, completely smooth and so it cannot retain quite as much paint as natural hair. This does not constitute much of a problem in oil painting as the density of the paint itself causes it to adhere to the hairs.

Brushes of synthetic fiber are available in different qualities and finishes. Higher quality brushes are at the same level as sable hair, with their perfect tip that never loses its shape. A new type of fiber on the market is a white, synthetic filament that resembles hog bristle, although it is not as tough. Synthetic fiber is becoming more and

High quality, flat, synthetic brush.

more popular among artists as it is made in all types and thicknesses.

TYPES OF BRUSHES

There are as many types of brushes as there are types of fiber, although we can make a broad classification based on the shape of the ferrule and the way the fibers are arranged. A flat ferrule can be used for fibers that are flat-tipped, almond-shaped, or bell-shaped. A round ferrule can contain fibers that are flat-tipped or come to a point. The use of the brush depends entirely on the fiber used. There are multi-purpose brushes and others that are manufactured and used only for specific functions, as is the case of fan-shaped brushes.

In addition to brushes classified according to the shape of the fiber, we should also mention the recent introduction of rubber-tipped brushes.

ROUND BRUSHES

Round brushes have a conical ferrule to grip the fibers, so the brush can be rotated in all directions. Round oil brushes are designed for painting fine lines or, in the case of the higher-numbered brushes, thick brushstrokes that can later be retouched as the work develops. Oils are a very thick medium, thus the brush needs to be of good quality so that it will retain its shape. The only way to know if a cheap brush is suitable is by trying it.

RUBBER-TIPPED BRUSHES

Rubber-tipped brushes with a conical ferrule have recently appeared on the market. They obviously have no retention, so it is necessary to dip them repeatedly into the paint. However, the potential of this kind of brush is extraordinary because it can be used to produce any kind of brushstroke the artist requires. A characteristic feature of this kind of brush is the obvious lack of hair marks in the paint.

FLAT BRUSHES

Flat brushes are the most commonly used in oil painting. The ferrule flattens the hairs, so they tend to hold less paint than round brushes. They are excellent, nev-

ertheless, for profiling. There are two types: flat-tipped or filbert.

FLAT-TIPPED BRUSHES

In this type of brush, all the fibers are exactly the same length and are perfectly arranged. They are the most versatile brushes for oil painting because they can be used to create a wide variety of brushstrokes. They maintain the same pressure throughout the brushstroke and are therefore ideal for even, continuous lines, in much the same way as a housepainter's brush. The edge can be used for fine lines that can be thickened slightly by pressing a little harder on the canvas.

This type of brush can be used for painting dots by employing one of its corners.

Three flat brushes: different sizes and fibers.

Ox hair brushes.

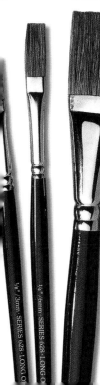

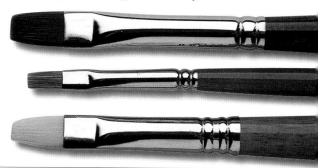

70

60

50

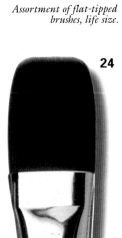

Bell-shaped brush.

Assortment of flat-tipped brushes, life size.

BELL-SHAPED BRUSHES

Bell-shaped brushes fall between round and flat brushes. As the name suggests, they form a continuous curved line from the tip to the ferrule and can hold a great deal of paint. It is somewhat soft, but useful for non-detailed brushwork. This kind of brush is not one of the most frequently used in oil painting.

FILBERT

This type of brush has almond-shaped fiber. It is a flat brush that combines the advantages of the flat-tipped and round brushes, although it is much more precise. It can be used for painting straight, even lines the width of the ferrule; if the tip is used, the result is similar to that of a round brush.

Within this category there are variations of sizes, to be used as the work requires.

30

24

20

18

16

14

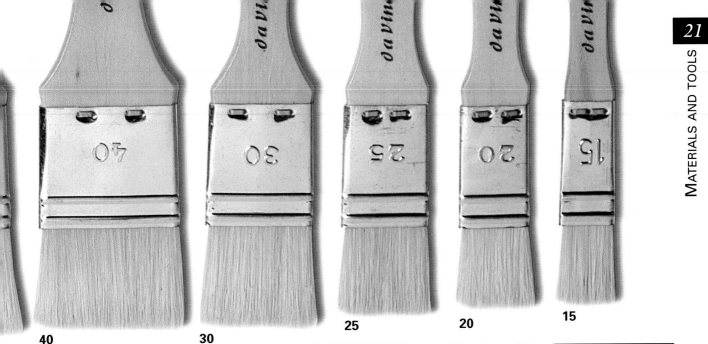

40 **30** **25** **20** **15**

Range of wide flat brushes, shown life size.

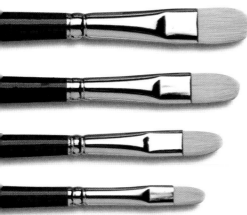

Walnut-shaped or filbert brushes.

FAN-SHAPED BRUSHES

This kind of brush, with fibers arranged in the form of a fan, has a limited use in oil painting. Their shape makes them suitable for glazes or soft fusions of color, but not for applying thick layers of paint.

LARGE FLAT BRUSHES

The large flat brush is one of many artists' favorite brushes. The hairs appear to be a continuation of the shape of the handle, which is flat, not round, making it easier to mount the hairs. Like a house painter's brushes, these are far larger than normal oil brushes, and can be used to cover large areas, to blend colors, and to create careful gradations.

Large flat brushes can retain a large amount of paint and, despite their size, can be used for detailed work provided the fibers are of good quality.

It is advisable always to use good quality brushes that will not lose their shape or shed hair.

NUMBERING SYSTEM OF BRUSHES

This numbering system is international and applies to most brands. The brush is numbered according to the width of the ferrule, which in turn determines that of the fibers. This measurement is printed on the handle and goes from the 10/0 of the Da Vinci brand up to 36, although not all brands cover such a wide range of sizes. They usually range from 000 to 18.

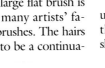

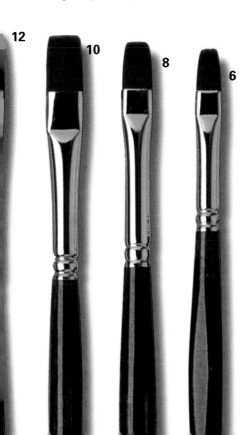

12 **10** **8** **6** **4** **2**

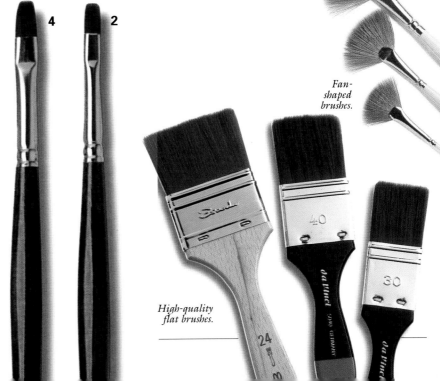

Fan-shaped brushes.

High-quality flat brushes.

Additives for Oil Paint

Oil paint basically consists of oil and pigment. However, since its invention centuries ago, artists have experimented by adding other ingredients to its composition in order to give oil paint other characteristics, such as a glossy finish or faster drying time.

The medium for oil paint is, of course, oil, yet there is a wide variety of oils, which can be grouped into volatile oils and fixed oils. The first type is used for mixing and thinning paint. These are volatile oils, which evaporate on contact with the air (as does turpentine). Fixed oils, on the other hand, never evaporate; they gradually harden on contact with light and air. This is the type of oil used for making oil paint.

Fixed oils are obtained from the pressing of materials such as linseed or walnut. Volatile oils may be vegetable or animal in origin. In addition to oils, there are other substances that can be incorporated into the oil painter's work.

Drying agents (siccatives) facilitate the oxidation of oil. Although the oils generally used in manufacturing paint eventually harden by themselves, certain pigments can slow the drying time so it becomes necessary to add these catalysts to counteract their effect.

Medium, a liquid with which pigment is mixed by the artist, makes it unnecessary to use raw oils that might alter the paint's composition. Composed of resins, medium mixes with oil and binds the pigment without changing its color.

There are also additives that can be used to create or eliminate texture. Minerals, such as powdered marble or hematite, can also be added. The fineness or coarseness of the grind will, of course, determine the effect on the canvas.

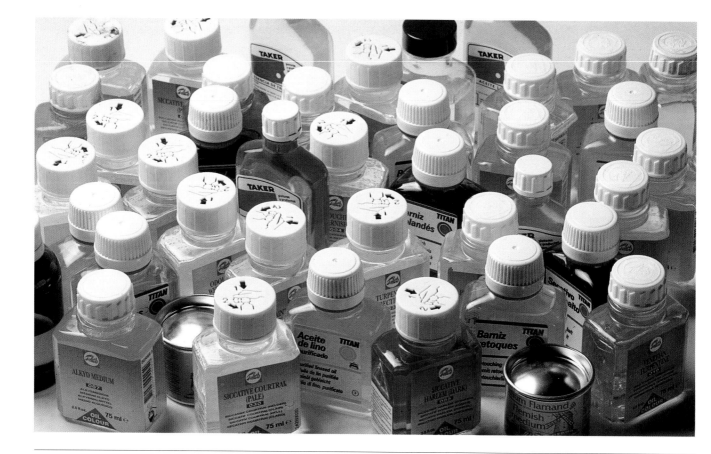

OILS

Oil is the principal component of oil paint. When it is exposed to air, the natural drying capacity of oil causes the paint to harden and become glossy, although there are different types of oil that are used to produce different effects. The color of oil is determined by the nature of the vegetation or plant from which it was extracted. When it oxidizes and hardens, this color varies in accordance with the quality of the material it was derived from.

A good oil should dry well, be somewhat elastic, and transparent.

LINSEED OIL

This is the most commonly used oil in oil paint due to its stability and durability. Nevertheless, once it has dried, linseed oil has a marked tendency to turn yellow, thus affecting certain colors. Some shades of blue will turn green if they are mixed with linseed oil. For this reason linseed oil should be used primarily with dark colors, which would not be affected by this characteristic.

REFINED LINSEED OIL

Refined linseed oil is luminous, dries well, and thins the paint as desired. It is a traditional additive used in oil paints, although it does tend to yellow more than the others. Also, if too much is added, the paint becomes greasy and produces wrinkles.

BLEACHED LINSEED OIL

This oil is produced by a special refining process that produces a very pure type of linseed oil. Like refined linseed oil, bleached linseed oil dries very well but it has less tendency to turn yellow.

BOILED LINSEED OIL

This is oil that has been boiled and condensed with resinous polymers. This produces a highly dense oil, quick drying and with little tendency to yellow. It is also highly elastic and durable. Boiled oil is so thick it should not be used alone but mixed with other oils. Neither should it be used in the first layers of paint.

PURIFIED LINSEED OIL

This oil increases and improves the fluidity of oil paints when they are mixed, which makes it an ideal medium to use for applying glazes. Care should be taken not to use too much, however, as the layer of paint may become extremely yellow and wrinkled.

OTHER OILS

In addition to oils added to oil paint for thinning or mixing color, there are other oils that may be added to alter its drying time or transparency. These are always quick drying vegetable oils.

SAFFLOWER OIL

This is a very light colored oil that dries much more slowly than refined linseed. The yellow tone it acquires, however, is so faint that it can be added to even the lightest of colors. It is used for making white and blue paints.

POPPY-SEED OIL

Obtained from poppy seeds, this oil is slow drying. It is also used in light colors because it yellows only slightly.

WALNUT OIL

Boiled walnut oil is very dense and is one of the fastest drying oils. It has excellent qualities, especially when used to make dark colors. It is ideal for applying the first areas of color and outlines because it dries in just a few hours. It should be diluted with two parts of turpentine. It enriches the paint it is mixed with and enables it to dry thoroughly.

STAND OIL

This oil does not affect the drying time nor the tone of the colors, but does increase their brilliance, elasticity, and transparency. Universal, or stand, oil is slow drying with very little tendency to yellow, therefore it can be added to whites and blues.

VOLATILE OILS

Volatile oils are used to dilute paints and make them more fluid. They produce clean colors that are ideal for applying the later layers of paint. Some volatile oils are used to stop bubbles from forming.

They are sometimes derived from vegetables, in which case they are distilled; some are extracted from crude oil.

RECTIFIED TURPENTINE

This is manufactured from the resinous sap of pines and other conifers. It is the most popular solvent. When it is mixed with oil paints, it makes the oils softer and creamier yet consistent at the same time. Turpentine is suitable for sketches and the preliminary layers of paint. It is also used for cleaning brushes and palettes, although a cheaper grade of turpentine may be used for cleaning.

Assortment of oils used in the making and enriching of oil paints:
1. Purified linseed oil. 2. Universal oil.
3. Linseed oil. 4. Boiled linseed oil.
5. Bleached linseed oil. 6. Poppy-seed oil.
7. Purified linseed oil. 8. Stand oil.

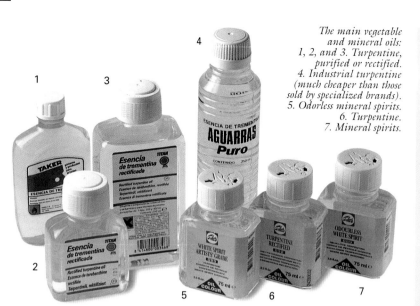

The main vegetable and mineral oils:
1, 2, and 3. Turpentine, purified or rectified.
4. Industrial turpentine (much cheaper than those sold by specialized brands).
5. Odorless mineral spirits.
6. Turpentine.
7. Mineral spirits.

LAVENDER OIL

This is obtained from the distillation of the male lavender flower. It is not very volatile and is therefore recommended for those occasions when the artist wishes to work for long sessions.

Adding lavender oil to the paint makes it creamy, ideal for soft, broad brushstrokes. Its diluting power is more effective in the underlying layers of paint that are still fresh, making it easier to blend them together. To reduce this diluting power, it is advisable to mix this oil with odorless mineral spirits.

ODORLESS MINERAL SPIRITS

Odorless mineral spirits has been used in oil paints since the seventeenth century. It is refined and purified from petroleum and is completely transparent and odorless.

It is much more resistant to change when exposed to air than vegetable oils, and it does not form a resinous film after evaporating.

Odorless mineral spirits evaporates completely, leaving no trace. It penetrates well into the paint and is especially useful for artists who are allergic to turpentine.

MINERAL SPIRITS

A by-product of petroleum, mineral spirits resembles an essence more than an oil. However, it is nonvolatile, that is, the artist can work with fresh paint for as long as necessary.

ADVANTAGES AND DISADVANTAGES

When vegetable oils come into contact with the air they turn into resins. This, in turn, means that they become fatty, sticky, and viscous. This can happen when a bottle is accidentally left open. It is advisable to close these bottles tightly and clean any containers used during your painting sessions.

Petroleum by-products are best for cleaning brushes to keep them from becoming sticky.

Mineral oils, if used to excess, make the paint too matte and fragile.

OIL SOLVENTS AND THINNERS

These are liquids used to dilute oils, resins, and other mediums that are used in oil painting. Their function is to reduce the viscosity of the paint without altering its appearance.

These thinners do not destroy the layers of oil paint over which they are applied. Solvents, however, are used to dissolve the paint when cleaning brushes and other tools. Certain substances such as turpentine are used both as thinners and solvents.

DRYING AGENTS

The oils used in oil paint naturally gradually dry out as they oxidize, from the surface down to the deepest layers of paint. However, certain pigments, such as ivory black, lamp black, vermilion, and ultramarine blue, slow down the drying process, so drying agents are used to compensate for this effect.

COURTRAI DARK SICCATIVE

Courtrai siccative is the most powerful type of drying agent because it combines lead and manganese oxide. Properly used, it quickens and stabilizes the drying process; however, if too much is added, it will cause irreparable damage to the painted surface.

COURTRAI PALE SICCATIVE

This is obtained solely from lead oxide and is completely colorless, making it suitable for light colors. It also has far less drying power than Courtrai dark siccative.

COBALT DRIER

Cobalt drier speeds up the drying process of the oil paint but also adds a slight violet tinge to the lighter colors. As with all the other drying agents, great care should be taken when adding it. It should represent only five percent of the volume of the paint used, that is, about two or three drops for a walnut-sized amount of paint, and only with colors that do not dry well. It should be carefully mixed with the paint before application.

Industrial solvent, only suitable for cleaning tools.

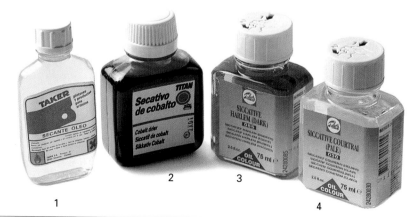

Drying agents:
1. Universal oil siccative.
2. Cobalt drier.
3. Dark Courtrai siccative or drier.
4. Pale Courtrai siccative or drier.

ADVANTAGES AND DISADVANTAGES

Paints that dry too slowly cause many undesirable effects, from dry spots to cracks. The addition of mineral drying agents such as cobalt or lead help the paint to dry evenly and completely.

These driers should be used with care; if the surface dries too quickly, the underlying layers of paint could be sealed off, which could cause wrinkles.

MEDIUMS

Medium is a liquid substance with which pigment is mixed in order to bind and harden it, while allowing the pigment to maintain its chromatic properties.

If raw oil rather than a medium were used, some of the pigment's properties may be altered; therefore, compatible, resin-based mediums have been developed that can be added to oil paint without producing any undesirable effects.

Medium is available in a liquid and in a thick, buttery form.

FLEMISH MEDIUM

One of the oldest mediums that exist, Flemish medium is composed of copal resin, linseed oil, and turpentine. This combination vitrifies the pigment particles,

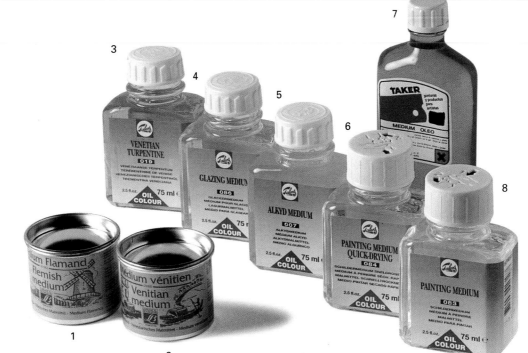

1. Flemish medium. 2. Venetian medium. 3. Venetian turpentine.
4. Glazing medium. 5. Alkyd medium. 6. Quick-drying medium.
7. Universal medium. 8. Painting medium.

making it extremely hard when dry, in addition to making the colors considerably brighter. It is only suitable for dark colors because it has a very strong tone. There is another variety of this medium called Harlem drier; it is a little paler and dries more slowly.

EGG MEDIUM OR TEMPERA

Egg medium has been used for centuries. It consists of oil, egg, and water. In this emulsion, the egg causes the oil to combine with the water. This product is fully compatible with paste, making it solidify faster and more thoroughly, thereby allowing the artist to choose a matte or gloss finish. It should be added to tubed paint on the palette. If you want a matte appearance, add eight drops for every walnut-sized lump of paint. For a glossy appearance, five drops are enough.

VENETIAN MEDIUM

This is a very thick medium composed of boiled oils, lime, lead ochre, and wax. It creates a matte finish and is also excellent for applying impasto. It is quick drying and mixes well with any oil color.

PAINTING MEDIUM

This medium is totally colorless and is composed of acetone, boiled linseed oil, turpentine, and mineral spirits. One of the best mediums available, it combines the qualities of the best varnishes. Because it is quick drying and produces a deep gloss, it is therefore ideal for applying glazes.

It is also used as a solvent for oil colors by mixing it with 50 percent lavender oil.

OLEOPASTO

This medium is an alkyd-based resin mixed with silica.

Because it is consistent and enlivens the oil colors it is mixed with, it can be used to create thick masses of paint.

It is available in bottles, or tubes like oil paints, making it easier to handle and model.

Oleopasto can be bought in tubes, making it much easier to handle.

Ground alabaster and marble.

White underpaint is used for grounds that are then covered by other layers of paint.

TEXTURAL ADDITIVES

Oil paint possesses many different qualities of its own, nevertheless there are many products available that are used for no other purpose than that of altering the texture of oil paint. Some of these are used for modeling a background in relief, others are mixed with the paint itself, while others are used to modify the appearance of the paint after it has dried.

Many artists often use sand or powdered minerals to vary the texture of the paint. These are simple additives that have no coloring power.

GROUND MARBLE AND ALABASTER

Powdered minerals are obtained from grinding the minerals. Those most commonly used for lending texture to oil paint are marble and alabaster; the latter, being softer, is easier to grind. Some powdered minerals are available in neutral colors.

Hematite and washed sand.

ABRASIVES

Carborundum and hematite are extremely hard substances. Even so, they mix well with oil paint and do not form lumps, so they are ideal for creating textured surfaces. Ordinary sand that has been washed is also a good textural additive for oils. It can be used to create areas of low relief when well mixed with the paint, or used primarily to add interest to the surface of the paint.

PRIMING THE SUPPORT

The supports used for oil paint should be properly protected so that they do not come into direct contact with an oily medium. However, many different textural effects can be created on the painting surface itself by using modeling pastes and a variety of other media such as gesso and acrylic gel.

VARNISHES AND FINISHES

Varnish is used not only for its esthetic effects, but as protection for the finished oil painting as well.

Varnishes, which are composed of resins diluted in oils or alcohols, form a transparent film that brings out the colors while protecting the painting from dust, scratches, insect excrement, or other agents that could damage it.

Varnish acts like a protective film. However, it should be possible to remove a coating that has deteriorated with age. Varnishes should only be applied when the oil paints are totally dry, which depends on the thickness of the paint and the colors the artist has used.

Varnish can be matte or gloss; in either case, it serves to integrate the surface of the painting.

Sand can be added by hand to the oil mixture.

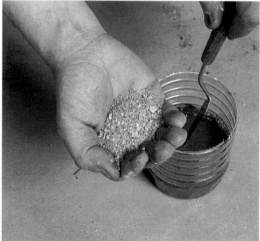

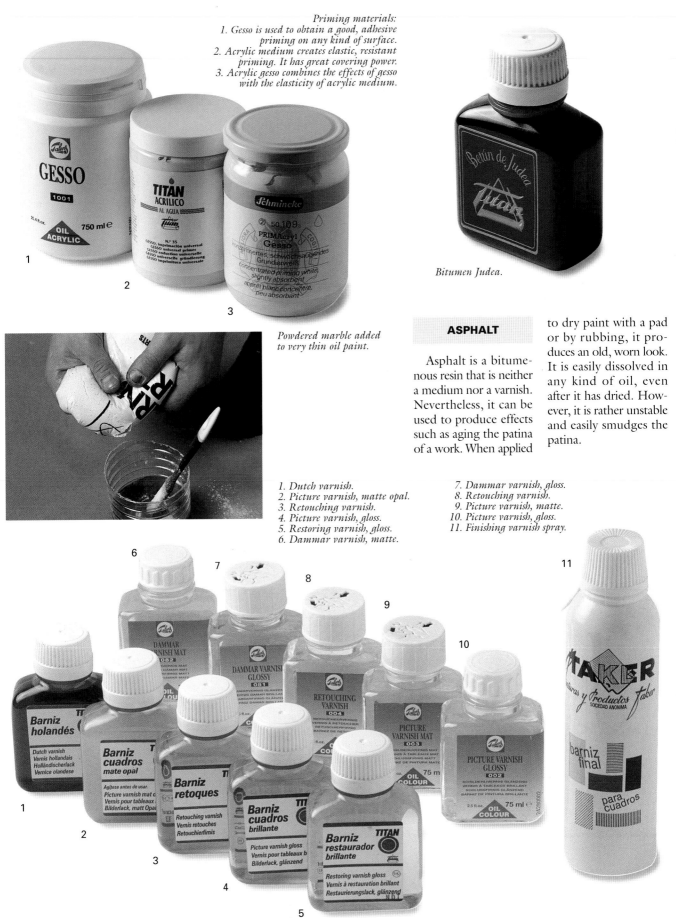

Priming materials:
1. Gesso is used to obtain a good, adhesive
* priming on any kind of surface.*
2. Acrylic medium creates elastic, resistant
* priming. It has great covering power.*
3. Acrylic gesso combines the effects of gesso
* with the elasticity of acrylic medium.*

Bitumen Judea.

Powdered marble added
to very thin oil paint.

ASPHALT

Asphalt is a bitumenous resin that is neither a medium nor a varnish. Nevertheless, it can be used to produce effects such as aging the patina of a work. When applied to dry paint with a pad or by rubbing, it produces an old, worn look. It is easily dissolved in any kind of oil, even after it has dried. However, it is rather unstable and easily smudges the patina.

1. Dutch varnish.
2. Picture varnish, matte opal.
3. Retouching varnish.
4. Picture varnish, gloss.
5. Restoring varnish, gloss.
6. Dammar varnish, matte.

7. Dammar varnish, gloss.
8. Retouching varnish.
9. Picture varnish, matte.
10. Picture varnish, gloss.
11. Finishing varnish spray.

Paintboxes and Cases

The most practical way of arranging tubes of oil paints is in a paintbox, of which there are many kinds to be found in fine arts stores. They vary in shape and are made of different materials, depending on their intended use. Some are designed for studio work and others for carrying.

Introductory set for the novice.

Tin paintbox with turpentine and oil, with good quality oil paints in a complete range of colors.

Small set of oils for promotional purposes.

ECONOMICAL CASES

Tubes of oil paint can be bought individually or in small assortments of several colors, usually the basic ones. These simple sets are usually intended as product promotions or as gifts. It is unusual for professional artists to buy this kind of packaged set.

EMPTY PAINTBOXES

It is not necessary to buy a paintbox with the tubes of oil paint included and there are many types of paintboxes of different sizes, qualities, and prices on the market.

Empty paintboxes are ideal for specialized artists who have their own materials and merely want to replace their old paintbox. They are also useful for those people who want to include specific materials, perhaps combining different brands and qualities of oil paints.

Empty paintboxes can be bought in all sizes and qualities, to be filled as the artist chooses.

1. Guide strip for canvases. 2. Palette. 3. Corner reinforcement. 4. Plastic compartments for different tools. 5. Complete range of colors. 6. Turpentine and linseed oil. 7. Double palette cups. 8. Foldable stop: allows the artist to raise the lid 90° to act as a lectern stand for pieces of canvas-covered cardboard. 9. Reinforced handle.

A simple box with metal interior.

A double paintbox that contains all the necessary accessories for oil painting.

Outdoor paintbox with extending easel.

COMPLETE PAINTBOXES

Complete paintboxes contain different ranges of oil colors; other tones chosen from the color chart can be added as the artist's work requires. These complete paintboxes generally include a jar of oil and another of turpentine, together with palette cups.

Good quality paintboxes are made of varnished beech wood, with brass hinges. The best quality boxes have a firm locking action and extended handles made of steel.

Inside these boxes is a metallic or plastic moulding divided into compartments, although some good quality paintboxes have wooden strips forming the compartments. Most include a palette that fits snugly into the lid. In double paintboxes, the palette acts as a separator while in the simpler boxes the palette is inserted into guide strips fitted on either side of the lid. These guide strips have one or more slots to prevent wet pieces of canvas-covered cardboard from touching each other.

These complete paintboxes are available in a wide variety of models and their quality depends on both the box itself and the oil paints it contains.

OUTDOOR EASEL-BOXES

Outdoor easel cases combine in the smallest possible space all the artist needs for oil painting. Their size varies depending on the amount of material they need to contain and they include a practical lectern-type easel to hold the canvas at a comfortable height. Unlike ordinary cases, the handle is located on one of the shorter sides to accommodate the canvas holder. There are also very practical French style easels. Extending legs that can be adjusted for sitting or standing allow the artist to paint comfortably.

French style easel, folded and opened.

Simple but practical outdoor paintbox. It does not have a lid and is closed by sliding the palette into the guide slots and folding down the easel. This is also ideal as a tabletop easel.

Palettes, Palette Knives, and Cups

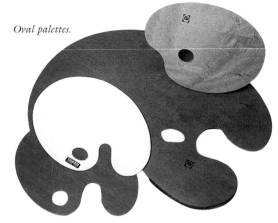

Oval palettes.

An artist needs a surface on which to mix oil paints; a palette is made specifically for this purpose. Palettes come in all sizes and are generally made of wood or plastic. Their shape also varies according to the preference and needs of the artist. Palette cups are attached to a palette in order to keep solvents handy.

There are many other accessories for oil painting depending on the kind of painting the artist is working on. Palette knives allow the artist to accurately model forms and are available in many different shapes and sizes.

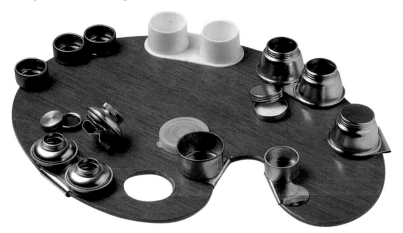

ing before use; these are generally made out of simple five-millimeter-thick plywood. A fine quality palette has a good finish, usually varnished beech wood, and rounded edges. The edge of the thumbhole is anatomically slanted.

OVAL PALETTES

An oval palette is a typical workshop, or studio, palette. They are available in all sizes, some larger than the square type. Round or oval palettes are the easiest to handle and allow an artist to arrange the colors as he wishes.

The largest palettes have counterbalances and are reinforced underneath with crossbars. Plastic palettes are also available and are more suited to school use or for small works.

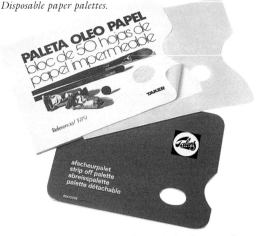

Disposable paper palettes.

PALETTES

A palette is the surface on which oil paints are mixed and held until they are applied to the canvas. Traditionally they have an ergonomic design that enables an artist to hold them with one hand while painting with the other. The size and shape of a palette depends somewhat on the range of colors the artist uses. Palettes are generally made of wood or plastic, although disposable palettes also exist. Prices depend on the size and the finish.

SQUARE PALETTES

Square palettes are usually made in this shape so that they will fit more easily into paintboxes or cases. They come in as many different sizes as there are paintboxes.

They also vary as to the finish. Some are sold without any finish and need oiling or varnish-

Improvised palettes: a plate, a piece of wood, or formica.

Different square palettes.

PAPER PALETTES

These come in block form and are practical for outdoor painting because after each session you can simply tear off the used sheet and throw it away.

IMPROVISED PALETTES

Any smooth surface can be used as a palette: a plate, a piece of waxed cardboard or wood are all suitable surfaces for mixing colors.

PALETTE KNIVES

A palette knife is a knife-shaped tool used to transfer paint from a palette to a painting. The same instrument can be used in place of a brush for modeling.

A palette knife has a flat, stainless steel blade and a handle that is usually varnished or oiled to prevent rusting. It also has a small ferrule that strengthens the joint between the blade and the handle.

Assorted palette cups.

Palette knives can be used to produce interesting variations to the painting surface. A completely smooth surface may be created with a palette knife or a sensation of volume and texture can be produced by adding areas of color.

In addition to palette knives there are painting knives that are used to mix colors quickly. They are also used to clean a palette after use.

PALETTE CUPS

Palette cups are small containers that can be clipped onto the palette and hold oils and other liquids ready at hand.

Palette cups can be made of metal or plastic, which, of course, is simpler and more economical. The best type of cup has a screw-on lid so the artist can interrupt his painting session without the contents going to waste. They are ideal for outdoor painting sessions. Palette cups can be single or double, conical or oval-shaped.

Palette knives may be trowel-shaped, with a rounded blade; irregular with one corner of the blade cut off; flat tipped; triangular or pyramid-shaped. The illustration shows a wide range of palette knives alongside a ruler which enables us to judge their size.

Inexpensive nylon palette knives.

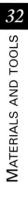
Easels and Seats

Oil painting is a precise technique, therefore stable and firm support is needed so the canvas will not move as you paint. The best way of holding the canvas in place is by using an easel. There are easels designed for all kinds of situations, as well as specially designed seats that enable the artist to work more comfortably.

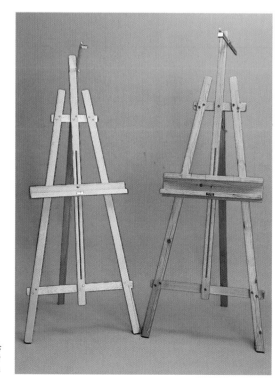

On the left, a folding studio easel that uses notches to adjust the height. On the right, a French style outdoor easel with built-in paintbox.

STUDIO EASELS

A studio easel is heavy duty and very stable. It is made of thick bars and joints that are either screwed or glued together.

All easels have a system for adjusting the height of the canvas as well as an upper canvas holder that can be adapted to paintings of any size.

Studio easels are available in folding or fixed designs. A folding easel is more economical since it is designed for artists who have limited space. Fixed easels usually have wheels to make them easier to move about and a screw-type brake.

The height adjustment system is located on the upright, to which a box tray and canvas holder are also connected. The height is adjusted by using either notches or wing nuts, though notches are more reliable. The angle of the canvas can also be adjusted on the best studio easels.

LIGHTWEIGHT FOLDING EASELS

These easels are practical because they take up very little space when folded.

They are not designed to support much weight, nor are they as stable as studio easels. Many different versions of this type of easel are available depending on an artist's requirements. There is a simple type, consisting of a tripod, as well as outdoor easels complete with paintbox.

Though folding easels are less stable than studio easels, this disadvantage is offset by the far lower price of the former.

TABLETOP EASELS

There is a wide variety of tabletop easels that are ideal for small works. They take up very little space and are designed solely to act as a support on high, flat surfaces such as a table.

METAL OUTDOOR EASELS

Outdoor easels are fully folding and take up a minimum amount of space. They are designed to be used outdoors and when traveling. They are built from solid, lightweight materials such as aluminium. Despite being

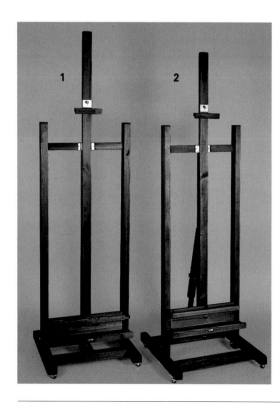

1. Studio easel with height adjustment system.
2. Studio easel with height and tilt adjustment system.

Folding studio easels with wing-nut height adjustment.

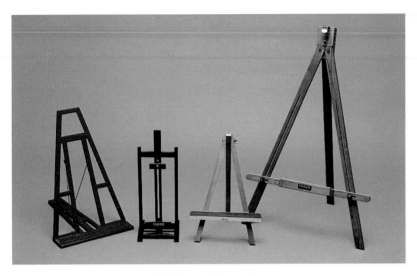

Different tabletop easels.

Metal outdoor easels.

lightweight, they have feet and an adjustable upright bar and paintbox holder.

STOOLS

A stool is the most practical and comfortable seat for a painter. It has no arms so that an artist has freedom of motion and it is usually made of varnished pinewood.

Stools can be fixed or adjustable. The former are simple and economical, while adjustable stools have a screw system that

allows the artist to raise or lower the seat. This screw can be made of wood or metal, which is more durable.

FOLDING SEAT

A folding seat is ideal for painting outdoors. Though simple, it is strong and resistant because it is made from steel tubing and has a leather seat.

One of the most common types of folding seat

is similar to beach chairs. Though of poor quality, they are very economical.

CANVAS HOLDERS AND SEPARATORS

To make it easy to carry freshly painted works, there are a number of highly practical yet simple accessories. A canvas holder consists of a handle with clamps, and allows you to carry two paintings without their touching.

Separators are a kind of double nail with a plastic wheel in the middle. They are placed on each corner of the canvas and allow one work to be stacked on another without touching. The canvases are prevented from sticking together if the paint is still wet, and air is allowed to circulate between them.

Folding seat.

Fixed stool.

Adjustable stool.

Canvas holder with handle (1) and simple version (2).

Separators.

Other Materials and Accessories

Hand cream.

Oil painting requires an assortment of additional items that help keep everything clean and orderly. A selection of apparently simple objects make painting a simpler, more pleasant activity. Without these objects, colors would become muddied, sketches would be difficult to make, and the canvas would not be firmly attached to the stretcher.

CLEANING UTENSILS

These are used to degrease and remove the color from objects with which the paint has come into contact. These different cleaning materials are used for the simple but essential purpose of keeping the painting tools, your hands, and your workplace clean.

Cut-up newspaper.

RAGS AND PAPERS

Absorbent material is essential for cleaning up thick paint stains and spilled liquids. Oil is a greasy substance and cannot be removed with water. Paint should be wiped around in a circle with a dry rag until it gathers in the center and can be wiped off.

The best rags are cotton pieces cut from worn-out clothes (for example, T-shirts).

Rags and absorbent paper are used to wipe excess paint from the brush before mixing pure colors.

SPONGES

Like rags and paper, sponges are highly absorbent, but they can retain much more liquid.

NEWSPAPER

Newspaper is ideal for cleaning brushes, palette knives, and palettes. It has a rough texture that easily removes excess paint from the artist's tools. A convenient way to keep newspaper handy is to cut and stack it in several sizes.

SOLVENTS

Solvents are essential for removing traces of paint, both from brushes and hands, as well as from the studio painting area. They are used with rags and pieces of paper. Turpentine, the most common solvent, is available in different quantities, though it is always best to buy the largest sizes. You should always use pure or rectified turpentine for cleaning and be careful not to confuse it with a turpentine substitute.

HAND CREAM

Cleansing cream is useful for removing paint from the skin. It penetrates deep into the pores and breaks down the paint without drying the skin. It can also be used for removing fresh stains from clothing. It is practical for artists who often get paint on their hands.

OTHER PAINTING ACCESSORIES

These are simple, practical accessories that are necessary for the artist, both when preparing the work and when starting to paint.

DUSTING BRUSH

Oil paintings are almost always based on a charcoal or pencil sketch. This usually leaves traces of charcoal dust or graphite that could dirty

Rags and absorbent paper.

Solvents in different sizes.

Sponge.

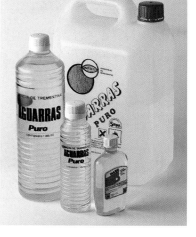

Bristle brush.

Metal stapler and staples.

the paint colors if they are not removed. In addition, when charcoal is used to draw a preliminary sketch, any mistakes are corrected by erasing, which leaves a faint outline on the canvas. The eraser itself also leaves particles that need removing. A brush for dusting excess charcoal or eraser particles should be thick and soft, preferably of hog bristle, and used only for cleaning.

ERASERS

Charcoal sketches on canvas or wood often need correcting by removing the medium from the primed surface. Usually it is sufficient to

brush this off with a cloth, but when the lines are deep, a kneaded eraser or a plastic eraser makes it easier to lift out white areas and make corrections.

JAR FOR BRUSHES

A jar for brushes is particularly useful when you need to interrupt a painting session. It has a clip that holds the brush by the handle, leaving the bristles submerged

in turpentine without touching the bottom. A grid-like filter separates the dissolved paint from the clean solvent.

PENCILS AND CHARCOAL

These drawing tools are essential when starting any pictorial work.

Many artists prefer charcoal for sketching on canvas, because it can be corrected as often as desired. Pencils are more precise, but pencil lines are more difficult to erase.

STAPLER, PLIERS, KNIFE, AND SCISSORS

Most artists use a stapler to mount a canvas on a stretcher. There are many different models, qualities, and prices, it is

advisable to buy a strong, metal stapler. Even though it is more expensive than the plastic type, they last much longer. Good quality staplers can use different size staples while the simpler types are only suitable for one or two sizes.

Canvas pliers make it easier to stretch the canvas. They pull the fabric evenly, so less force is required to mount the canvas on the frame.

Assorted pencils.

Canvas pliers.

Cleaning jar for brushes.

Charcoal.

Kneaded eraser and plastic eraser.

An artist's studio should always have cutting instruments, such as scissors or knives. They are used for different purposes, including cutting the canvas, sharpening drawing instruments, or cutting out stencils.

OIL TECHNIQUES

Stretching Canvas on Stretcher Bars

O il painting requires a stable surface on which to paint, a surface smooth enough for the brush or palette knife to be used easily. Stretchers provide a rigid, strong structure and smooth surface necessary to support the canvas. It is impossible to paint on loose canvas or a piece of paper; these painting surfaces have to be attached and stretched on the firm support of a stretcher. Each kind of canvas requires a different stretching technique by which it is pulled taut over the entire surface, preventing wrinkles or sagging.

STRETCHERS

STRETCHING CANVAS WITH STAPLES

To stretch a canvas on stretcher bars you need a stapler, special pliers for stretching, canvas, and a stretcher.

1. Canvas should be cut so that it is about 1 1/2 inches (4 cm) larger than the stretcher frame. The canvas is placed on the floor with the primed surface face down, the stretcher frame is then placed on top. The smooth surface of the stretcher should be face down so that when the canvas is stretched, there are no marks caused by rough wood.

2. The stretching and stapling should be done in the form of a cross, that is, first one side of the canvas is folded over and stapled. The canvas can be stapled to the side of the stretcher or, as in this case, to the back of the stretcher.

3. This is repeated on the opposite side, using canvas pliers to help you pull the canvas tight.

5. Once both sides of the canvas have been fastened, the same operation is repeated on the remaining two sides. The canvas should be pulled taut in the center of each side so that it is evenly stretched to the opposite side.

6. Now that the four sides are taut and stapled at the center, the rest of the canvas can be stretched on each side, working from each middle staple toward the corners. The staples should be close together so that the canvas pliers do not pull out the staples already attached.

4. Care should be taken when stretching the canvas so as not to tear it. The thickest jaw of the canvas pliers should rest on the wood and the handle tilted in order to grip the canvas, which is then held and stapled.

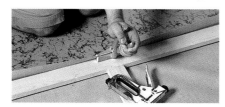

8. Use your fingers to bring together the two loose flaps of canvas around the sides of the stretcher, creating a fold at the corner. Raise the flap and slip one side under the other so that the canvas lies flat against the side of the stretcher.

9. Use the canvas pliers to stretch the canvas and staple the side of the corner to remove most of the wrinkles. Finally, stretch the remaining side to remove the wrinkles completely.

7. The corners are always stapled last. Any wrinkles are removed when the corners are stapled. Enough canvas should be left at the corners so that the pliers can be used.

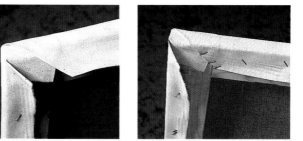

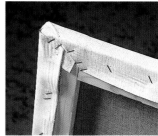

STRETCHERS — STRETCHING CANVAS WITH TACKS

Stretching a canvas with tacks is more time consuming, but produces a much more even and taut surface. You will need tacks with a wide, flat head and also a hammer. There are two basic ways to mount a canvas with tacks: one is to follow the same procedure used with staples, and the other consists of driving tacks in immediately after stapling the canvas, to produce an even tension of the stretched fabric.

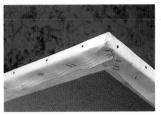

Tacks are driven in after stretching and stapling the canvas, making it easier to hold and nail at the same time.

STRETCHERS — STRETCHING PAPER

There are two systems of stretching paper on the stretcher. The first is by using thumbtacks or staples. The paper is moistened and, after placing it on a flat surface, the stretcher is laid on top. The paper should be at least 3 to 3^1/$_2$ inches (8–10 cm) larger than the stretcher so that it can be folded over the edges.

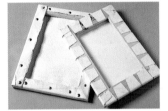

1. The paper is moistened.

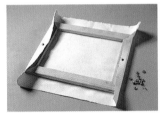

2. One side of the wet paper is folded over the edge of the stretcher, then attached in the center with a thumbtack. The same is done on the opposite side and the two remaining sides. Remember that the paper should still be wet.

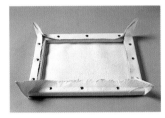

3. Thumbtacks are pushed in all around the edges of the stretcher. Not many are needed; one every four or five inches (ten or twelve centimeters) is quite enough. The corners are folded over and attached. This system can be used to temporarily secure the paper to a piece of board while painting, and then removing it when it is painted and dry.

The second system is much more time consuming, but produces better results. The shape of the stretcher is drawn on the paper, and flaps are cut out all around the edge of the paper. It is then moistened and white glue is applied to the flaps. The stretcher is then placed on the wet paper and the flaps folded over to stick to the stretcher. Both systems produce good results. When the paper dries, it becomes taut as the fibers contract.

STRETCHERS — PLYWOOD

Plywood is easily mounted on a stretcher and because it is rigid, it does not need to be tightened with wooden wedges. You need white glue, sandpaper, and headless nails. You can also use a good quality stapler that uses nail-shaped staples.

1. To mount a panel on a stretcher, the plywood should be slightly larger than the stretcher itself. The stretcher is coated with glue and placed on the wood, pressing down to ensure good contact all around.

2. Both are turned over and the plywood is nailed to the stretcher, keeping all the nails the same distance apart.

3. After a few hours the glue dries and a knife is used to cut away excess wood. Any rough edges are smoothed with the sandpaper.

STRETCHERS — CARDBOARD

Rigid cardboard can be mounted on a stretcher in exactly the same way as plywood. Cardboard, though, has a tendency to lose its shape no matter how thick it is, so it is advisable to mount it using thumbtacks or staples.

A SOLUTION FOR SLACKENING

A canvas that has been properly mounted on a stretcher may become slack and sag due to the painting process itself, changes in temperature or simply to irregularity and unevenness of the surface. Before taking the canvas off the stretcher, a possible solution is to dampen the back of the canvas with a spray or a wet cloth. The moisture will soften the canvas, creating the same tension level over the entire surface. When it dries, it will become taut again.

Priming

Oil paint is a fatty medium and should never come into direct contact with any painting surface of organic material because the oil would eventually rot the vegetable fibers. In addition, any unprotected or unprimed surface will absorb oil from the paint, thus diminishing the brightness of the colors and the consistency of the paint. In order to prevent the deterioration of the painting, all of the surfaces to be painted on should be protected from direct contact with the oil. There are different methods of doing this, depending on the kind of support and the quality of finish desired.

WHAT IS PRIMING?

Priming is a neutral layer of a substance which is applied to a painting surface in order to prevent it from absorbing the paint, and spoiling the character and appearance of the oil paint colors. There are many types of priming, depending on the absorbency of the surface and what the desired final effect is.

A simple and relatively effective priming system for pieces of cardboard, wood, or paper used for quick studies or oil sketches includes rubbing the surface with a clove of garlic. Garlic exudes a viscous liquid that acts as a priming.

MAKING YOUR OWN PRIMER

Painters have traditionally prepared and applied their own primers for oil painting supports which they would then paint on. Today there are many kinds of prepared primers available in art supply stores. Even so, many artists still prefer to prime the canvas or wood with their own preparations.

MAKING YOUR OWN PRIMER

PREPARING RABBITSKIN GLUE

Powdered chalk or Spanish white forms a white paste that is specially designed for priming rigid supports.

One of the most traditional primers is made from this paste and rabbitskin glue, which is obtained from the animal's skin. It can be bought in bar or granular form, both in specialized art stores and large drugstores. Rabbitskin glue, like other organic gelatins, is highly sensitive to the proportions used. If you want the result to be a good quality primer, pay special attention to the amounts you add.

Place $2^2/3$ ounces (75 grams) of rabbitskin glue in a glass jar with $30^1/2$ fluid ounces (900 cc) of water. If the glue was bought in flakes, it should be broken up first. The glue should be left in the water overnight, after which time it will have soaked up the water and become soft, ready to be warmed. The glue will swell to three times its original volume, so the jar should be wide and deep. The container is then warmed in a hot water bath (bain-marie style) and shaken now and then to prevent sticking and clogging. After it cools, it should turn into a firm, though not hard, form of gelatin. If you hold your index finger and thumb together, place them into the mixture and then separate them, a rough, not smooth, groove should be left. If the consistency is correct, the glue is heated again without boiling and then added to a container with powdered chalk or Spanish white; stir this mixture—also known as gesso—continuously until it reaches a creamy, homogenous consistency. The density of the glue can be adjusted by adding a little water. Many painters prefer to use liquid, almost watery glue.

Rabbitskin glue in granular form and powdered white chalk, the basic ingredients of primers.

After soaking overnight, the glue is warmed in a hot water bath (bain-marie) without boiling it.

When the glue is hot, it is added to a container with powdered chalk and stirred until the priming becomes white.

MAKING YOUR OWN PRIMER

MAKING RABBITSKIN GLUE FOR CANVAS

The process for mixing rabbitskin glue and water is identical to that for mixing gesso, although the proportions of glue and water differ.

There is no single formula for making a primer for canvas, because it depends largely on the quality of the glue itself. Approximately 1³/₄ ounces (50 g) of rabbitskin glue is sufficient per quart (liter) of water. The process is the same as the one described for making gesso, except that the resulting gel is more liquid.

Rabbitskin glue should not be stored for too long because it putrefies and develops an extremely unpleasant odor.

Rabbitskin glue with Spanish white or powdered white chalk.

PRIMING CANVAS

Canvas is one of the main supports used in oil painting.

There is a wide variety of canvas of varying quality made from different vegetable fibers, but none of them will last long in contact with oil paint.

Primers for canvas should preserve the flexibility of the support, in addition to sealing it.

A canvas that has been properly primed allows the colors to glow and ensures that the oil paint will dry evenly and without problems.

PRIMING CANVAS

APPLYING RABBITSKIN GLUE TO A CANVAS

Rabbitskin glue should be applied by covering the entire surface with vertical brushstrokes. This is left to dry and another layer applied with horizontal brushstrokes.

If a fine priming is wanted, it is advisable to sand the surface when the second layer is dry.

Glue should be applied in layers, the thinner the better, to a canvas mounted on a stretcher without any wrinkles. Many painters apply a very liquid first layer that is totally transparent and that penetrates the weave of the canvas entirely. Canvas should be primed by applying long, overlapping, parallel brushstrokes; a soft bristle paintbrush is ideally suited to this purpose. After the first layer has dried, a second layer of rabbitskin glue, with powdered white chalk (Spanish white) added, is applied perpendicular to the first layer. When this layer has dried, it can be sanded using very fine sandpaper and a final layer is applied, perpendicular to the last. This is again sanded if necessary. It is only really necessary to sand when the artist wants a totally smooth surface without any texture.

PRIMING CANVAS

ACRYLIC PRIMING

Acrylic resin is a polymer in an aqueous solution. When dry, it seals the primed surface entirely. One of the main characteristics of acrylic is its great elasticity, making it one of the best products for sealing canvas. Acrylic resin is sold by weight in certain specialized art stores. A little water can be added to it without diminishing its binding properties.

Preparing acrylic primer involves thinning the medium slightly until it has a milky consistency that will penetrate deep into the weave of the canvas. It can be applied with a wide paintbrush or a roller. The first layers are quickly absorbed by the canvas, and additional layers are applied until the canvas is thoroughly covered. Alternating vertical and horizontal brushstrokes will ensure that the entire surface is well covered. When the second layer is dry, a third, much thicker layer can be applied to create a textural effect.

Application of acrylic priming to untreated canvas. This preparation has great covering power.

Acrylic priming suitable for any surface.

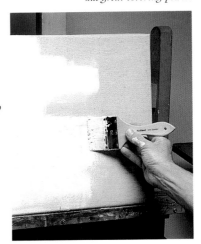

OIL TECHNIQUES

LATEX

Latex is a watery resin of vegetable origin which, when dry, produces a dense, varnish-like coating. It is a medium similar to acrylic and is applied in the same way if used for priming.

Latex is sold in most drugstores and fine arts stores. Be careful to buy only the best brands to ensure good quality.

As with any other primer, the first layer should be well diluted with water in order to saturate the canvas properly.

Latex and acrylic can be tinted and used for priming any kind of surface. Here we are priming a piece of paper mounted on a stretcher.

PRIMING WITH TURPENTINE

Good quality priming can be made by mixing turpentine and zinc oxide. Use 1 pound (.5 kg) of zinc oxide to 3 ounces (90 ml) of turpentine. This mixture has a creamy consistency that can be applied with either a palette knife or a paintbrush. When applied to the unprepared surface, it should completely fill the pores of the woven surface. To produce a good finish, soft, straight, smooth brushstrokes are lightly applied following the direction of the weave. This first priming takes three days to dry, after which any rough areas are gently sanded down. The process is then repeated with brushstrokes perpendicular to the first layer, and again it is left to dry.

In the past, this kind of priming was done with white lead. This produced better results than zinc oxide but toxic products are not used in art supplies today.

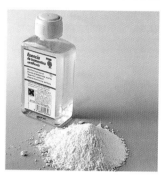

Turpentine and zinc oxide. Mix 1 pound (.5 kg) of zinc oxide to 3 ounces (90 ml) of turpentine to obtain a good priming.

LEFTOVER PAINT

Oil paint left on a palette after a painting session can be used to reprime a painting surface. Simply scrape off all the remains of paint, add a little turpentine and apply this mixture to the previously primed canvas or wood. This provides not only a good surface but also a colorful background.

By mixing together turpentine and any paint remaining on the palette, you can obtain a colored priming. This can be done only when the surface has already been primed by using any of the methods described.

PRIMING WITH COLOR

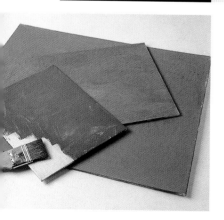

Different colored primers made by mixing the base priming with colored pigments.

Many artists, irrespective of the priming method they use, prefer to start a painting with a base color rather than the usual white ground.

A base color can be mixed by combining the left over paint on the palette or by preparing an oil color with turpentine. The reason for adding turpentine is to mix a base color less oily than the painting medium itself.

The color of the priming can be varied by adding other pigments or acrylic paint if the priming is water soluble.

It is not advisable to repaint oil canvases as you may encounter areas that have dried differently and have different absorption capacities. These defects could show up through the overlying color after it has dried. White oil paint should not be used as a primer either, as it dries very slowly and layers applied later may crack.

Tinted primers also provide the artist with a ground that helps create a harmonic chromatic range. (See *Background Color,* pages 64, 65.)

PRIMING RIGID SUPPORTS

The primer used for rigid surfaces can be less flexible than those used for canvas or paper, and thus may contain a larger amount of dry matter. Primers used for canvas are also applicable to wood or cardboard.

Substances can be added to gesso or rabbitskin glue primers to create different textures or to smooth the texture of the surface itself.

These textural primings should be applied in thin layers so that the support does not have to absorb large amounts of moisture.

PRIMING RIGID SUPPORTS

GESSO

Rabbitskin glue should always be applied hot, though not at boiling temperature.

Gesso can be obtained already prepared or you can make it yourself from rabbitskin glue, as described earlier in this chapter. Pre-prepared gesso is applied cold, using a wide paintbrush and vertical brushstrokes. When they have dried, the operation is repeated using horizontal brushstrokes. The first layers should be thicker than the later ones.

The gesso layer can be sanded to the desired texture once it has dried. Very fine sandpaper should be used only to remove any roughness. Usually a couple of layers of gesso is sufficient, though there are artists who prefer to apply several layers of primer. If the support is semi-rigid, such as cardboard, thick layers of gesso should not be applied because they may eventually crack.

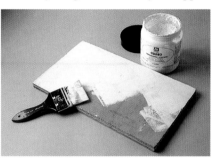

Gesso applied to wood; it has great covering and sealing capacity.

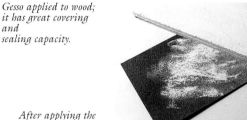

After applying the necessary number of layers, the support is gently sanded.

PRIMING RIGID SUPPORTS

ACRYLIC AND LATEX PRIMING

Rigid, porous supports such as cardboard, canvas panels, plywood, or ordinary wood are all perfect for resinous primings, but the best supports are plywood and canvas panels. Cardboard tends to warp after being primed, but this effect may be counteracted by priming both sides. Coatings that use latex or acrylic resins should be thinned with water before coating rigid supports so that the primer dries quickly and does not soak the support.

PRIMING RIGID SUPPORTS

WHITE UNDERPAINT

White underpaint is a very thick paste designed solely to produce a heavy coat of dense priming for oil paints. It is highly compact, and so more successfully applied with a palette knife or stiff, flat bristle paintbrush. It is easier to apply an even layer when you use a palette knife, and a wide-bladed palette knife is best suited to spread the underpaint over the support.

A piece of board primed with white underpaint, a dense priming that dries slowly but is effective.

PRIMING RIGID SUPPORTS

RIGID SUPPORT WITH MUSLIN

Muslin is a light fabric used to cover rigid surfaces, giving them a canvas-like texture.

An artist does not need to use muslin unless he wants to experiment with it since all types of canvas-covered cardboard are available in the stores. To prepare a support with muslin, you will need the cloth, the support (cardboard or wood), glue, white chalk, and a paintbrush or palette knife for applying the glue.

Preparing a rigid surface with muslin is not complicated but does require a certain amount of care. The cloth should be cut slightly larger than the support and then ironed to smooth out any wrinkles. The glue should not be too thick so that it can be easily spread over the surface with a brush or palette knife. The cloth is placed on the glued surface, taking care that no wrinkles form and the weave is not twisted. Once the cloth is correctly positioned on the surface, it is smoothed out using the paintbrush and slightly thinner glue. The edges are then folded over and glued to the back of the support.

Muslin, cardboard, glue, pigment, and palette knife.

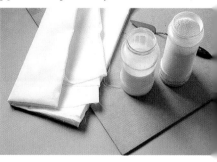

Using a Brush

A brush is one of the main instruments the artist uses to transfer oil paint to a painting. The way it is used depends largely on the artist's artistic requirements and experience. The type of pictorial "language" the artist uses depends on the position of the brush, the amount of paint the brush retains, and the pressure the artist uses when applying paint to the support.

The way the brush is held also varies from one artist to another, and results in a personal style as individual as the act of writing. In painting, however, the range of possibilities is much wider because the marks the artist leaves on the canvas depend on the density of the paint, its transparency, the mark of the brush's fibers, and the pressure applied by the painter.

USING A BRUSH HOW TO HOLD IT

There is no established way of holding a brush. It all depends on the kind of brushstroke the artist wants. Although each artist has his own way of holding the brush, the most common method is to take it in the palm of the hand when long brushstrokes are required, as it is the arm and wrist that are acting. For short strokes and detailed work the brush is held like a pencil. When free, flowing strokes are wanted, it can be held like a sword, giving more freedom to the wrist. Lastly, if the artist wants to create a

textured effect, the tip of the brush handle can be used to scratch the surface of the paint.

Each artist develops his own way of holding the brush, depending above all on the style of the painting and the slope of the support; since painting on a vertical surface is not the same as painting on a flat one.

A brush can also be held as if it were a palette knife in order to transfer large amounts of paint to the canvas and then extending it or flattening it.

Oil paint is a thick medium that can be used to produce many varied effects depending on how the brush is handled. With a brush held inside the hand, medium to large brushstrokes can be controlled and the wrist can rotate and cover a large area of the painting. The wrist can also control short, directional brushstrokes. If the forearm is used, longer, wider, and continuous brushstrokes are easier to apply.

Holding a brush loosely in the palm of the hand between the index finger and thumb, is ideal for spontaneous, light brushwork as the brush can be easily moved up and down.

If a brush is held like a sword, gestural brushwork is made easier since it is the movement of the arm that controls the strokes.

Brushes can be used in many ways. The tip of a brush handle can be used to "draw" in a thick layer of fresh oil paint.

USING A BRUSH PRECISION

On the many occasions when an artist needs to produce fine, detailed work, it is helpful for him or her to have some kind of support on which to rest the hand that is holding the brush.

A painter's hand cannot be allowed to touch the wet painting as it could spoil the areas already painted. The solution for this is a mahlstick, a rod topped with a small ball that can rest on the clean surface to provide a point of support for the hand or the brush while painting details; or precise, straight lines can be made by using the mahlstick like a ruler.

When painting lines parallel to the sides of the painting, the artist can use one brush placed against the vertical edge as a guide and paint the line with another brush dipped in paint.

When a brush is held as if it were a pencil, the index and middle finger—not the wrist—control the movement of the brushstroke, making this grip ideal for detailed work.

A mahlstick is indispensable for precise, detailed brushwork or for painting a series of straight lines. With the ball resting on the outer edge of the painting or against any unpainted area, the entire length of the rod can be used as a point of a support.

When you do not have a point of support for painting a detail, you can stretch out your little finger and rest it on the canvas. You are, of course, limited to working within the range of your index, middle finger, and thumb.

Placing a second brush and the index finger on the side of the painting, you can draw straight, parallel lines. This is very useful when painting subjects in which straight, vertical or horizontal lines are important, such as buildings, the masts of boats, and so forth.

HINTS

HOW MANY BRUSHES SHOULD YOU USE?

Each artist has his own preferences concerning the range of brushes to use. In general, however, it is not necessary to have a large number because each brush can be used to create different effects or for different purposes.

The brushes you choose should vary in stiffness in order to produce different kinds of brushstrokes, which will vary according to the stiffness of the fibers. For example, if you want to paint a large, smooth surface without any marks, you need a soft-fiber paintbrush, preferably a high quality, synthetic one. A hog bristle brush, on the other hand, would leave its characteristic mark.

Each brush has its own particular qualities and each artist must find a range that best suits his or her style. A possible range of brushes would be the following:

A. A medium sized flat hog bristle brush. This brush, similar to those used by house painters, leaves a characteristic mark on the canvas, although it can also be used for painting subtle blends of color and gradations. Its strong, tough fibers enable you to control and spread paint easily. There are many different qualities of paintbrushes, and the cheaper kinds tend to

lose their fibers and shape quickly. If you do use cheaper brushes, allow the bristles to soak for a day, without the water reaching the ferrule, so that the wood will expand and grip the fibers more firmly.

B. A good quality, wide, flat brush with synthetic fibers. This is useful for blending colors and finishing large surfaces that have been painted with hog bristle or stiff bristle brushes. Good quality, synthetic flat brushes are ideal for painting large areas, but be careful not to take up too much paint with them since their soft fibers could become clogged. The advantage of using this type of brush

is its durability, softness, and flexibility.

C. A flat or flat-tipped synthetic no. 14 brush. This has characteristics similar to those of a good quality, wide flat synthetic fiber brush, but can be also used for more detailed work.

D. A small, flat, synthetic fiber no. 4 brush. This brush, with its shorter hair, can be used for retouching small details as well as for painting small, flat brushstrokes.

E. Two good quality, round, synthetic fiber brushes, no.'s 4 and 6. These brushes, which don't leave fiber marks, are good for details and retouching work. Good quality sable or mongoose

hair brushes can also be used for this, although the result may not be worth the higher cost of these brushes.

F. Hog bristle, filbert brushes, no.'s 10, 12, and 18. Filbert brushes are among the most commonly used in oil painting because they are very versatile. They can be used to paint flat brushstrokes, areas of blended of color, soft brushwork, or direct, spontaneous strokes.

G. A set of round, hog bristle brushes, no.'s 4, 12, and 20. Round brushes are widely used for creating texture and modeling forms and are almost always alternated with both flat and filbert brushes.

A basic range of brushes for use by any artist.

A

B

C

D

E

F

G

TAKING CARE OF BRUSHES

HOW TO CLEAN THEM

Brushes are delicate instruments that need to be cared for. Oil paint is a fatty medium, therefore an artist needs to pay special attention to protect the fibers from drying out or deteriorating, as they will if not carefully cleaned. Taking care of brushes is one of the basic precautions an artist must take after each painting session. Oil paint dissolves easily in soap, though it needs repeated soap-

ing and rinsing to remove all traces of paint and all the soap remaining between the hairs or inside the ferrule.

1. There are two basic ways of cleaning brushes. The traditional method is to remove the paint by wiping the hair or bristles with newspaper until most of the paint has been removed.

2. Then the brush is placed in turpentine and stirred around to dissolve any remaining paint.

3. Then it is thoroughly washed in soap and water, and the brush is gently turned around in the palm of the hand so that the soap will penetrate.

4. Lastly, it is rinsed well to remove any remaining turpentine or soap.

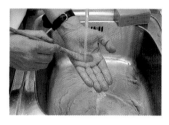

Another way to clean a brush is to hold it under a faucet. After removing most of the paint with a rag or a piece of paper, the brush is held under a stream of water and a small amount of liquid soap, such as dishwashing soap, is applied. This soaping and rinsing is repeated until all the remains of paint and soap have been removed.

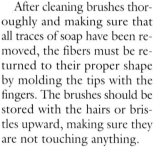

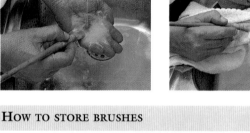

5. It should then be carefully dried with a clean cloth, making sure not to twist or deform the hairs.

MAINTENANCE

HOW TO STORE BRUSHES

After cleaning brushes thoroughly and making sure that all traces of soap have been removed, the fibers must be returned to their proper shape by molding the tips with the fingers. The brushes should be stored with the hairs or bristles upward, making sure they are not touching anything.

When carrying brushes from one place to another, it is advisable to wrap them all together in cardboard or paper, providing extra support for the tips. There are also items that can be bought specially for carrying brushes such as small, flexible mats or hermetically sealed containers.

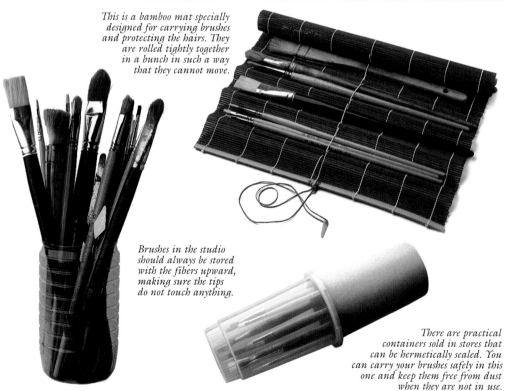

This is a bamboo mat specially designed for carrying brushes and protecting the hairs. They are rolled tightly together in a bunch in such a way that they cannot move.

Brushes in the studio should always be stored with the fibers upward, making sure the tips do not touch anything.

There are practical containers sold in stores that can be hermetically sealed. You can carry your brushes safely in this one and keep them free from dust when they are not in use.

BAD HABITS

MISTAKES TO AVOID

Brushes are much more delicate than they appear. Beginners, especially, are prone to acquiring bad habits that can contribute to the deterioration of their brushes. A ruined brush is useless, but if you take care of your brushes from the beginning and avoid the following bad habits, you will save a lot of money: good brushes are always expensive.

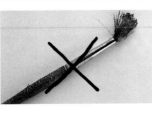

If the surface of the handle starts to flake off, this is a sign that the brush has remained too long in liquid.

You should not leave dirty brushes to dry after finishing a painting session. Although oil paints dry slowly, brushes should be cleaned immediatley since clogged hairs will permanently ruin the shape of a brush. This can also happen if they have not been properly cleaned. A brush may appear clean yet still have accumulated paint near the ferrule.

Never leave a brush in water or turpentine that covers the ferrule; the liquid soaks into the wood and spoils the varnish, causing the ferrule to loosen and shed the brush hairs.

VERSATILITY

DIFFERENT KINDS OF BRUSHSTROKES

Different brushstrokes can create an endless number of effects depending on the quality of the brush, the condition of the oil paint, and how it is used. The tip of the brush can be used to paint wide or narrow lines, light strokes, or heavy, textured brushmarks.

A single brush can be used to create a wide variety of effects. Flowing or controlled brushstrokes, blended or patchy surfaces; it all depends on the brush you are using, the amount of oil paint, and the pressure with which it is applied to the support.

Graded and blended colors made with a good quality, flat synthetic brush. The artist has used horizontal brushstrokes, gently spreading the paint without leaving the marks of the brush.

Brushstrokes made with a no. 3 a round, hog bristle brush over a white ground. Not too much pressure has been used so as not to remove the paint from the background. Several brushstrokes have blended into this white background; the most luminous ones were painted rapidly.

Pointillist type brushmarks made with a no. 6 round, hog bristle brush. The small patches of color are applied directly to the canvas without being modeled.

Another example of the pointillist technique, this time made by painting small, short brushstrokes with a no. 8 flat brush.

Rubbing over the canvas; an old brush and a little paint rubbed on the surface produce this characteristic mark of a worn out brush.

Superimposing planes and blending them. The background was painted with a wide flat synthetic brush. A bluish layer was then applied using a no. 18 round brush. Then white was applied with a no. 10 filbert brush, the brushstroke extended until it merged with the underlying color.

A brush can be used to model paint already on the canvas, revealing the mark of the bristles and the movement of the hand.

A layer painted and rubbed over a dry surface. A flat, hog bristle no. 12 brush was used to paint this. The preliminary layer was left to dry before applying a thick layer of paint. After all the paint in the brush was used up, the layer was rubbed, allowing the underlying color to show through.

Flowing brushstrokes painted with a round, no. 12 brush over a wet background. The first brushstroke deposited the paint on the surface and then the paint was drawn out and slightly blended with the base color.

A filbert brush can be used to produce all kinds of brushstrokes; here one color has been superimposed over another and the tones blended.

Using a Palette Knife

A palette knife is a painting instrument that enables us to create a "language" of expression that differs from a brush techique. The thick, creamy consistency of oil paint is ideal for being mixed on the palette or canvas, applied to the painting, and modeled using this knife-shaped instrument.

The pictorial potential of a palette knife in oil painting is enormous; it can be used to create all kinds of different effects and textures, though like everything else, this mastery of the palette knife involves a lot of practice.

With a palette knife, thick oil paint can be used quite effectively.

USING A PALETTE KNIFE

WAYS OF HOLDING A PALETTE KNIFE

A palette knife consists of the blade and the handle. There are different ways of holding this tool, depending on what it is being used for. The entire blade of a palette knife can be used in different ways. Even though the flat part of the blade is flexible, the sides can be used to paint precise, distinct forms. It can be held as if it were a pencil to scratch the surface with the edge, although it is more common to hold the handle inside the hand. Held this way it can be used like a bricklayer's trowel, to create impasto and spread paint with great accuracy.

Holding a palette knife like a pencil.

Holding the handle inside the hand allows the artist to apply all kinds of impasto and spread the paint using different degrees of pressure.

USING A PALETTE KNIFE

MIXING COLORS

A palette knife is a versatile instrument that can be used to make even mixtures of color quickly. Although this requires some practice, blending with a palette knife results in precise mixtures of color. Colors

can be mixed in several ways, either to obtain an even color or to create "half-mixtures" that have a mottled effect.

1. The edge of a palette knife is scraped upward to collect the desired amount of paint, which is then deposited in a clean area for mixing. Both the flat side of the blade and the edge are used for this.

2. A small amount of a second color is added in the same way.

3. This second color is mixed into the first color, and blended until it takes on a uniform color.

4. A third color can be added in the same manner.

5. This third color is then blended into the previous combination. Additional amounts of any of the colors may be added until you have the desired color.

USING A PALETTE KNIFE

APPLYING PAINT

Palette knives can be used in many ways to create effects such as those illustrated here. The different effects are created by alternating between modeling and spreading the paint with the palette knife.

A mottled effect created by using the edge of the palette knife to spread a light color over a wet background.

Using the tip of the palette knife to press down on wet paint.

Superimposing mottled planes; the grayer plane has been merged into the background.

Small marks made with the tip of a palette knife over a dry background, pointillist style.

Superimposing planes and gradations. Long smooth planes made with a palette knife.

Lined effect created using the edge of a palette knife as if you were cutting the paper.

Textural effects. A palette knife has been used to dab paint onto a wet background.

All the effects that can be created with a palette knife vary according to the pressure applied to the surface.

Large amounts of paint applied and mixed on the canvas with a palette knife.

TAKING CARE OF PALETTE KNIVES

Even if it is made of good quality steel, a palette knife requires careful maintenance. A palette knife is rendered useless if any part of its blade becomes damaged. It will last longer if it is well cared for; for instance, small lumps that have dried and hardened on the blade will leave unwanted ridges on the surface of future paintings. Maintenance is simple but necessary.

TAKING CARE OF PALETTE KNIVES

CLEANING A PALETTE KNIFE

When you have finished a session, a palette knife should be carefully cleaned to prevent paint from drying on it and spoiling the surface of the blade. You will need newspaper, solvent or turpentine, and rags.

1. Hold the blade firmly between the sheets of newspaper and pull it through to remove most of the paint.

2. Then use a rag soaked in turpentine to remove any paint still stuck to the knife.

3. If the paint is already dry, you can use another palette knife to scrape it off.

TAKING CARE OF PALETTE KNIVES

STORING A PALETTE KNIFE: BAD HABITS

Because they are metal, palette knives need protection from humidity and air. So when you are not going to use them for a period of time, they should be rubbed with lubricant (neither acid, nor drying oil; olive oil is suitable) and then wrapped in newspaper.

A palette knife can last a long time if properly cared for. Below are examples of bad habits that can damage your palette knife.

Oil and newspaper are the best way of protecting your palette knives from rust if they are not going to be used for some time.

You should never wet palette knives, but if you do they should be dried thoroughly; otherwise they will rust.

Palette knives are not for opening cans; this can break the tip and deform the edge.

Never try to bend a palette knife too much because you could break it.

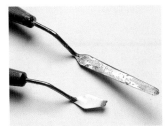

How to Make Oil Paints and Use the Palette

T raditionally, painters were accustomed to preparing their own painting supplies and materials, a custom that has disappeared today. There is a wide variety of fine arts products on the market that save us the time and trouble of making paints and other arts materials ourselves.

However, making your own oil paints has its charm, and although you will never be able to achieve the same quality as tubed paints for many colors, there are certain ones such as earth colors and blues that can be more than acceptable.

And whereas making oil paint is a complex process, making other supplies such as a palette, can be quick and simple.

MAKING OIL PAINT

HOW TO MAKE OIL PAINT

To make oil paint you need pigment, linseed oil for dark colors or safflower oil for light colors, a smooth, flat surface such as a slab of marble or glass, a wide palette knife, a glass pestle if possible (if not, the palette knife itself), and wide mouthed jars with a screw on lid or other hermetic seal.

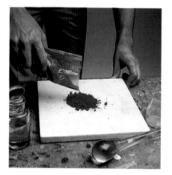

1. A certain amount of pigment is placed in the center of the flat surface forming a small heap. The finer the pigment, the better the results when mixed. Some pigments may not be ground fine enough and will need grinding with the pestle or palette knive until they attain the desired texture.

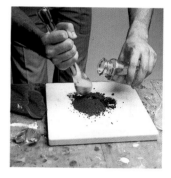

2. A small amount of oil—linseed for dark colors, safflower for light—is poured onto the pile of pigment. The first amount of oil is simply to soak the pigment. Use the palette knife to prevent the mixture from spreading all over the slab, and to keep it in the middle. Add the oil to the mixture slowly, in small amounts as needed, until it begins to hold together compactly.

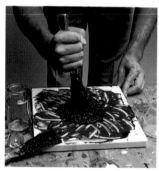

3. The mixture of oil and pigment should now have a lumpy, but compact appearance. Using the palette knife and the pestle, continue to grind the mixture to bind the pigment and oil together. The longer you spend doing this, the better the results; the finer the mixture, the higher the quality.

4. Now the mixture is blended with the palette knife and then stored in wide-mouthed glass jars. You should be aware that pigment shrinks in volume when wet, so quite a lot is necessary to make a useful amount of oil paint.

USING A PALETTE

MAKING A PALETTE OUT OF PLYWOOD

Plywood can be used as a substitute for solid wood panels when making a palette. Plywood consists of very fine layers of wood, arranged in a criss-cross fashion, glued, and pressed together. Because of the alternating direction of the different layers of wood, plywood is strong yet, at the same time, easy to cut, even with a knife. So, with a minimum number of tools and a piece of plywood, you can make a simple painting palette. You will need a 1/4 inch (5 mm) piece of plywood, a drill with a small bit or a punch, and a round file.

The size of a palette varies according to the artist's requirements; it should fit inside a paintbox so it can be easily carried when painting outdoors. Plywood is easy to cut by simply drawing a knife across several times to cut through each layer of the pressed wood. For a good, clean, straight cut, it is advisable to use a metal ruler.

Draw an oval shape in one corner of the plywood, 1 1/2 inches (3.8 cm) from the shorter side and 2 inches from the longer side. Then use a drill to make a series of holes along the line you drew, keeping them close together.

Now all you have to do is just push out the shape with your thumb and smooth the rough, inside edge with the round file.

It is important to varnish the wood so that it will not absorb the oil in the paint. Because linseed oil is a siccative or drying agent, it can be used to seal the surface. Two layers should be sufficient to seal the surface provided that you wait for each to dry completely.

USING A PALETTE
ARRANGING COLORS ON A PALETTE

Each artist has his own system for arranging colors on a palette, though there are certain arrangements, following a chromatic order, that seem more natural.

The order the colors follow on a palette should correspond to the artist's color requirements, while eliminating colors that are unlikely to be used.

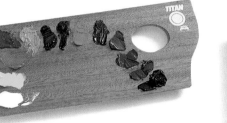

Many artists arrange colors on a palette from left to right: first white, then the warm colors, and lastly the cool colors.

Another possibility is to arrange colors in a series of graded tones from cool to warm.

USING A PALETTE
CLEANING A PALETTE

After each painting session, a palette should be cleaned in order to prevent any layers of oil paint from accumulating and leftover paint from drying on the palette.

Cleaning is simple provided it is done as soon as you have decided to finish your work; just use a palette knife or a piece of newspaper to remove most of the paint. Then wipe the wooden surface with a rag soaked in turpentine. If you want to clean the palette more thoroughly, wipe it several more times with the turpentine-soaked rag.

After removing most of the paint with a palette knife or a piece of newspaper, pour some turpentine over it.

Then the surface may be smoothed with medium-grain sandpaper for the rougher areas and fine-grain when the surface is practically smooth.

If the paint has already dried, scrape off any lumps with a knife, taking care not to cut into the wood.

Scrub the palette with a rag.

One Color

Oil paint is perhaps one of the most versatile mediums because it can be used as a transparent or opaque color, in fine layers or in thick impasto, and because the colors are unchanging when dry. It is precisely because oil paint is so versatile that it is more complicated to master than other mediums. First, oil paint takes a long time to dry so it is not uncommon for beginners to smudge the colors when they apply them, to encounter problems when mixing paints, or to waste paint. Therefore, to become accustomed to the consistency of oil paints and to learn how they react to solvents and other colors, it is a good idea to start painting in only one color and discover the range of tones it produces when mixed with white and black.

HOW TO PAINT A GRADED COLOR

Grading a color means lightening it from its darkest values to its palest in a gradual way.

In oil painting there are several methods for grading a color from its purest tone, as it comes out of the tube, to a slightly tinged white. No one system is better or worse than the others and each is used by the artist in accordance with his style or the requirements of the particular work.

GRADATIONS

GRADING WITH TURPENTINE

This method consists of gradually thinning out the paint with turpentine as you paint from the top to the bottom of a canvas. This produces a gradual lightening of the color from the deepest value down to the most transparent tone, an ideal way of preparing a background. Turpentine also shortens the drying time, making the background even easier to paint.

1. Dip the brush in the paint.

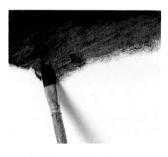

2. Paint a stripe about one quarter of the size of the area you intend to gradate.

3. Before continuing, remember to wipe the paint from the brush with a rag.

7. We have repeated the process with a hog bristle brush to produce an effect in which you can see the marks left by the bristles.

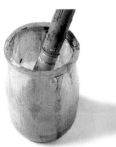

4. Dip the brush in turpentine.

5. Start to paint over the color on the canvas with the brush dipped in turpentine.

6. Continue to paint to the edge of the canvas.

GRADATIONS

GRADING WITH WHITE PAINT

Grading a color with white paint is one of the most complicated methods of lightening oil colors. Unlike other methods of gradations, the resulting color is opaque, due to the use of the white paint. Remember also that certain colors such as alizarin crimson (which turns pink) change when white is added.

Unlike gradations using turpentine, gradations with white paint should not be used as a background until it is perfectly dry (several months or even a year). This is because the white has been bound with safflower oil and so dries more slowly than other colors. If it is not dry, the white may cause the top layers of paint to crack.

1. Dip the brush in the paint.

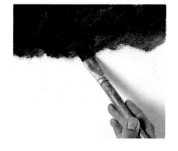

2. Paint a stripe about one quarter the size of the area to be painted.

3. Pick up some white paint with the same brush.

4. Work the white on the palette so that it mixes with the emerald green.

5. Paint another stripe below the previous one, slightly merging the colors where they meet.

6. Then clean the brush with a rag to remove any excess paint from the bristles.

7. Paint another stripe, darkening the white with the remains of the green on the brush while the lowest part is painted using nearly pure white.

8. To blend the two areas together, use a soft hair brush and dip it in turpentine.

10. The result is an opaque grada-tion using quite a lot of paint. Take into account that a grada-tion using white paint takes a long time to dry, or if it is used as a background, the upper layers of paint should be very oily so the paint will not crack when dry.

9. Brush lightly over the color, making sure not to rub away the paint already applied.

NOTE

If you want a softer gradation, paint more stripes, in thinner layers, before blending the tones.

White paint gradations are oily, so if they are used as a back-ground, the subsequent layers of paint need to contain a lot of oil to prevent the paint from cracking when dry.

GRADATIONS GRADING OVER AN OILY SURFACE WITH WHITE

Linseed oil is used as a sol-vent for oil paint, in addition to its function as a binder for the pigment. This means it can be used as a base for grading a color, since the paint can be spread much more easily over this kind of surface.

6. Then go over the entire surface again from top to bottom with a soft brush. The result will be a gradual, semi-transparent gradation. The oil lends a special shine to the paint, though it does take a long time to dry.

1. Dip the brush into linseed oil.

2. Cover the surface well with the oil.

5. Paint from the bottom to the top, blending the two colors with horizontal brushstrokes.

3. Paint the color to be lightened on the upper part.

4. Apply pure white to the lower section of the stripe.

VALUE

A value is a degree of intensity of a given color. The scale of intensity ranges from the lightest to the darkest value that a color can possess without actually becoming a different color.

This tone and variety of value enables artists to paint an entire work in a single color; a work in which the shapes are revealed by the light. Thus, as with drawing, volume is suggested by the contrast caused by juxtaposing different values, since contrasts between different colors is obviously impossible in a monochrome painting.

Value ranges are one of the basic "tools" an artist uses to resolve a work, so it is important to familiarize yourself with them and learn to control them since the expressive capacity of a work depends in large part on the overall tonal and value balance of the painting.

VALUE AND HUE

Do not confuse the hue of a color with the value.

A hue is the main tone of a color that distinguishes it from others. We refer to hue when one color starts to change into another, that is, when it is no longer a pure color. We could say that violet, for instance, is color with bluish hues. Mauve, on the other hand, has mainly reddish blue hues.

VALUE

There are two basic methods in oil painting for creating the value scale of a color. The simplest method is to dilute the color, which produces the purest results without altering the original color or incorporating hues that are not associated with it. This method cannot always be used in oil painting because thinning out paint makes it more transparent; therefore it is best used for painting backgrounds or painting glazes.

CHANGING VALUES BY DILUTING THE PAINT

To create a color's range of values using turpentine, the paint must be gradually thinned by increasing the proportion of turpentine for each new value you paint.

By diluting the paint with turpentine you can create the entire value range of any color with the purest results.

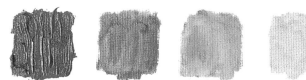

VALUE

Unlike value scales obtained by diluting the paint, changing values by mixing in black and white produces opaque colors that have great covering power. This is one of the main advantages of this system, because if you want to paint with one of these values in a more transparent state, you only have to thin it out with turpentine.

Even so, adding black or white to a color creates a problem with the hues and even the identity of the color itself, as some colors can change entirely. Alizarin crimson, for example, mixed with white turns pink, and mixed with black becomes brown. So practice constructing value scales with different colors in order to know whether the way in which they react will be an advantage or a problem when you begin a painting.

CHANGING VALUES BY ADDING BLACK AND WHITE

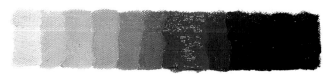

The value range of vermilion does not maintain the purity of the color because when white is added, it turns pink, and when it is mixed with black, it turns brown.

The range of values of ultramarine blue light is fairly correct when mixed with white; however, when mixed with black, it turns into a color very similar to Prussian blue. Notice how it is possible to mix many light values of a dark color like ultramarine, but fewer dark values.

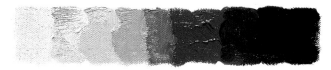

Yellow is also prone to change color; when mixed with black, for example, it turns into a neutral green.

This value range of medium yellow was mixed by lightening the color with white and darkening it with ochre. Ochre was used to avoid the abrupt change in hue that black produces.

Unlike ultramarine blue, yellow is a light color; consequently, more dark values can be mixed than light values.

Black can be used for darkening colors and increasing the chromatic range. One way of preventing the colors from changing suddenly is by mixing colors that are related.

MONOCHROME PAINTING

In monochrome painting, forms and volume are suggested by the contrast between different values of the same color.

Although this type of painting cannot make use of color contrasts, it can be highly expressive and occupies an important position in the history of art. Oil painting is one medium in which monochromes have never been very popular, since their appeal lies in the quality of the color and its permanence. Monochrome works are more often done on paper using other media, such as watercolor, for example, with which changes of value may be achieved by transparency.

Despite this, oil paintings using a single color plus white can be of the same quality as any other work that uses a profusion of color. Leaving artistic questons aside, it is advisable to do exercises with a single color plus white because this forces you to construct forms using changes of value, helping you to become fully familiarized with them.

Mastering the value balance of a work is crucial to its expressive capacity and strength. Otherwise, it would appear unbalanced and lifeless. This monochromatic exercise is the best way of gradually becoming familiar with this technique, since you can work with paint and learn how it behaves without the problems caused by different colors.

NOTE

When doing the exercises using only one color of oil paint, it is advisable to mix the color with white instead of diluting it. Changing values with white enables you to work with the paint at its normal consistency. When you dilute the color, it becomes more like other types of painting, such as watercolor or ink paintings.

ONE COLOR RAW UMBER AND WHITE

To paint a work in a single color plus white, you should choose a dark color, because the vlaue range you can mix will be wider than that of a light color. In this case we are going to use raw umber.

NOTE

When mixing a color with white for a monochrome painting, remember that lacquers are semi-transparent and therefore not the best paint for this type of exercise. An opaque color is a better choice.

We have chosen this vase with a bunch of dried grain stalks with its overall medium value as our subject. It is a good exercise because it does not have extreme contrasts of value.

In monochrome painting, forms are built up by controlling the light and dark values of a single color since contrasts between colors are not possible.

1. First, a sketch is made on the canvas using raw umber, semi-diluted in turpentine. This first stage establishes the light and dark areas.

5. The stalks have been painted a medium value, leaving the dark tips laid down in the sketch visible through the brushstrokes.

2. The values established in the sketch call for a medium value to paint the background. The painted background helps to resolve the rest of the work since it determines the values to be used during the later stages. (See Background Color, pages 64, 65.)

6. To finish, a few highlights have been painted on the bottle and a few details have been added to the bunch of stalks.

3. The table and the reflections of the vase are painted. This establishes the values that surround the vase, making it easier to paint because the values that will be used to introduce contrast have already been laid down.

4. The mat has been painted pure white with a few shadows painted with the color of the table.

Two Colors

Mixing colors in oil painting is so basic to this medium that it is an exercise an artist performs continuously while painting. As an introduction to color, it is best to begin by working with only two colors and experiment with different proportions, since mixing paints can be complicated until, after much practice, it becomes something you can do instinctively.

It is important to discover the possibilities of mixing colors and to learn that two colors, when mixed, not only produce a third, but an endless range of different hues.

GRADING TWO COLORS

Painting a gradation with two colors is a slow and complicated exercise that requires practice and skill, since any mixture of two colors always produces a third color. Care must be taken to prevent this third color from appearing as a separate border or stripe, which would detract from the effect of the fusion of the two graded colors. This requires the use of several brushes that are absolutely clean.

GRADING TWO COLORS

Grading two colors in oil painting is a complicated task since it inevitably gives rise to a third color. Moreover, this new color should not appear as a solid stripe, which would spoil the gradated effect.

YELLOW, BLUE, AND GREEN

We are going to paint a gradation by blending blue and yellow to produce a green.

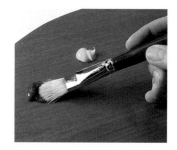

1. Take some blue from the palette.

2. Spread the paint on the canvas. To extend it, it is best to dilute it with a little turpentine on the tip of the brush.

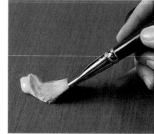

3. After applying the first color, clean the brush well in turpentine.

4. Dry the brush on a rag to remove any trace of paint, or use a new brush.

5. Dip it into the yellow.

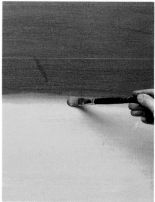

6. Paint the yellow until it meets the blue.

8. This green is applied to the area where the yellow and blue meet, blending them together.

7. Mix both colors together on the palette to obtain a light green.

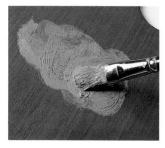

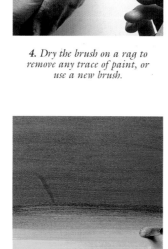

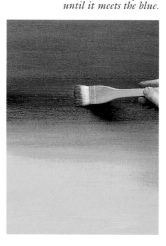

9. Go over the surface with a soft brush, working from the lightest color to the darkest.

NOTE

To paint a gradation of this kind it is important to paint with clean brushes; otherwise the colors would smudge, producing a poor gradation with too even a color. The blue would smear into the yellow creating a green gradation.

10. *The paintbrush is cleaned in turpentine and then in soap. When clean, it is dipped in turpentine. Use clean turpentine to keep the colors pure.*

11. *The entire surface is again gone over, grading from the yellow toward the blue.*

12. *You can see that the gradation of two colors inevitably produces a third, so blending two colors really involves grading three.*

EXERCISE IN TWO COLORS

EMERALD GREEN AND VERMILION, PLUS WHITE

Painting a subject in two colors is a good exercise for learning how colors react when mixed, how they are transformed, and how an apparently limited palette has enormous expressive potential.

In this exercise we are going to use vermilion and emerald green, with white to create value changes.

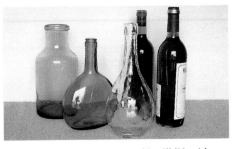

For this exercise we have chosen this still life with bottles, since it will be easy to suggest the colors it contains with the two colors we have chosen.

1. *After sketching the subject matter in charcoal we have painted the background in white mixed with green and a touch of vermilion for certain areas of the wall. Mauve has been mixed for the table by simply adding more vermilion to the previous mixture. The second bottle from the left has been painted emerald green with a little white.*

2. *To suggest the glass of the first bottle, emerald has been mixed with white, the background with emerald and a touch of vermilion. To paint the transparent glass bottle, the background color was used.*

3. *The bottle of red wine has been painted by mixing equal parts of vermilion and emerald, which produces an almost black color.*

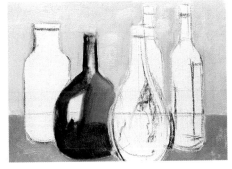

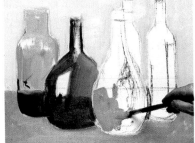

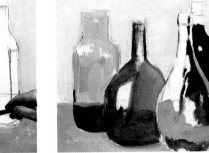

4. *A fine brush is used to suggest the transparency of the clear bottle in the foreground, and for the rosé we have used vermilion with emerald for the darker areas.*

5. *The highlights left unpainted are made more luminous by brushstrokes of pure, soft white making sure not to smudge the underlying colors. The entire range of hues present in the still life has been represented using only two colors.*

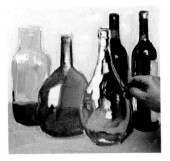

NOTE

To paint a subject in two colors plus white, it is not necessary to use colors that are similar to those of the model, because the play of contrasting color and value are expressive enough to suggest the volume and the forms.

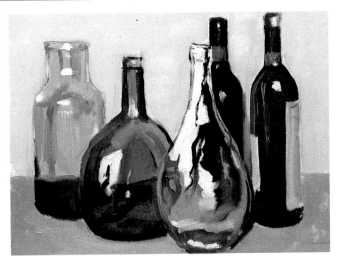

Three Colors

Color is light, that is, the color of an object is the color of the light it reflects. The difference between light colors and dark ones is determined by the amount of light they reflect; the former reflect more light than the latter.

It is important to distinguish between two types of colors: the colors of light waves, which lighten when combined, and the colors of pigment, which darken when combined.

Within the infinite range of colors that the human eye can distinguish, three are known as the primary colors, which when combined in various mixtures are capable of producing all the colors in nature. These primary colors exist as light waves and also in pigment, although they behave in opposite ways.

It is fundamental to oil painting to be aware of this difference, apart from mastering the three primary colors of pigment, as they are the key to all other mixtures.

COLOR CHARACTERISTICS OF LIGHT

Colored rays of light may be combined to produce other hues. The three primary colors of light are red, green, and blue violet, which produce luminous white light when mixed together. Red and green light produce yellow; green and blue violet, cyan; and violet and red, magenta. This system is called *additive*, meaning that the mixed hues are obtained by adding light waves.

COLOR CHARACTERISTICS OF PIGMENT

An artist works with pigment colors. When pigment colors are mixed, the new hue subtracts or absorbs more light waves than the first color did. This is known as the *subtractive* process because when pigment colors are mixed, less light is reflected off the combination.

This is why combining two of these colors produces a third, duller color, less bright than either of those used in the mixture. It is this phenomenon

White light is the result of mixing together the three primary colors of light.

A mixture of the three primary pigment colors produces the color black.

that makes the primary pigment colors correspond to the secondary colors of light and the secondary pigment colors correspond to the primary colors of light. Mixing the three primary pigment colors produces a total subtraction of light, that is, black.

PRIMARY COLORS

Primary colors are those that can be used to produce the infinite range of colors that the human eye can discern. As pigment colors absorb or subtract light, the only color that cannot be produced with primary pigments is white, the color that contains the greatest quantity of light. Primary colors in oil painting can be used to mix many different colors, but not all. The primary pigment colors are: yellow, red, and blue.

OIL COLORS

NOTE
The names of pigment colors are not standardized. Each manufacturer chooses designations that may differ from those used by other manufacturers for a similar hue. The names used in this presentation may also differ from those used on any particular brand's color chart.

CADMIUM YELLOW LIGHT

YELLOW

ALIZARIN CRIMSON

RED

CERULEAN BLUE

BLUE

SECONDARY COLORS A MIXTURE OF PRIMARY COLORS

Different combinations of the three primary colors produce three secondary colors: orange, green, and violet.

To obtain the secondary colors in oil paints, take into account the proportions used, as unequal proportions will create different hues.

In theory, the secondary colors illustrated here are the result of mixing two primaries in equal parts.

In practice, however, these proportions can vary as oil colors are not completely pure and you will probably have to vary the quantities to obtain the desired secondary color. Controlling the proportions of color used is practically impossible, so you will have to experiment until you produce the right secondary color and not a tertiary one.

When mixing colors, it is advisable to add small amounts of the darker colors to the lighter ones.

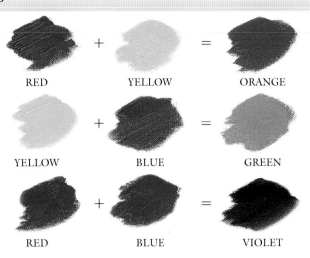

RED + YELLOW = ORANGE

YELLOW + BLUE = GREEN

RED + BLUE = VIOLET

TERTIARY COLORS A MIXTURE OF PRIMARY AND SECONDARY COLORS

Mixing primary and secondary colors produces nine colors, six of which are called *tertiary colors:* yellow orange, red orange, yellow green, blue green, blue violet, and red violet.

The three remaining colors are grays, produced by combining complementary colors.

Some of the tertiary colors are similar to primary or secondary colors, so the true hues of these colors may not be fully noticeable in the colors reproduced on these pages.

NOTE

It is important to mix colors from the three primary colors since this is the best technique for learning how colors behave when they are combined. This practice also provides valuable information regarding the proportions needed to produce certain colors; it is easy to create tertiary colors when you are trying to produce secondary ones if an excessive amount of one of the colors is added.

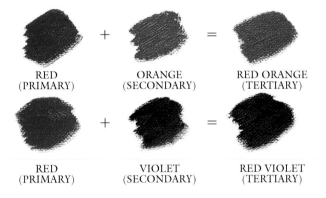

RED (PRIMARY) + ORANGE (SECONDARY) = RED ORANGE (TERTIARY)

RED (PRIMARY) + VIOLET (SECONDARY) = RED VIOLET (TERTIARY)

Tertiary red orange, produced by mixing primary red and secondary orange, is a warm color. Red violet, on the other hand, has cool hues produced by the blue used to obtain the secondary violet.

Only warm colors are used to create yellow orange. Yellow green has some cool tendencies caused by the blue used to obtain the secondary green.

The two tertiary colors produced by adding blue are cool colors because though producing the blue green called for yellow to obtain the secondary green, the proportion of blue in the blue green is far greater.

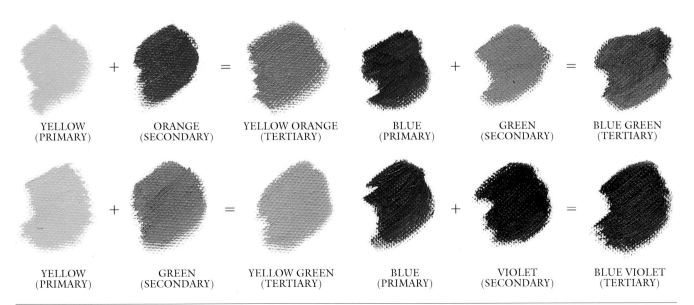

YELLOW (PRIMARY) + ORANGE (SECONDARY) = YELLOW ORANGE (TERTIARY)

BLUE (PRIMARY) + GREEN (SECONDARY) = BLUE GREEN (TERTIARY)

YELLOW (PRIMARY) + GREEN (SECONDARY) = YELLOW GREEN (TERTIARY)

BLUE (PRIMARY) + VIOLET (SECONDARY) = BLUE VIOLET (TERTIARY)

CONTRAST | **COMPLEMENTARY COLORS**

Complementary colors are those that are opposite each other on a color wheel. Complementary colors are special because when one is placed next to another, they produce the maximum possible contrast of color. Combining two complementary colors, however, does not produce a third, pure color, but a neutral gray with cool or warm tendencies, depending on the mixture.

To find any color's complement, just consult the color wheel: each color has its complementary. However, to avoid having to look up these colors while you are working on a project that calls for color contrasts, it is important to know which complementary colors correspond to the three primary colors: the complementary color of red is green; of yellow is violet; and of blue is orange.

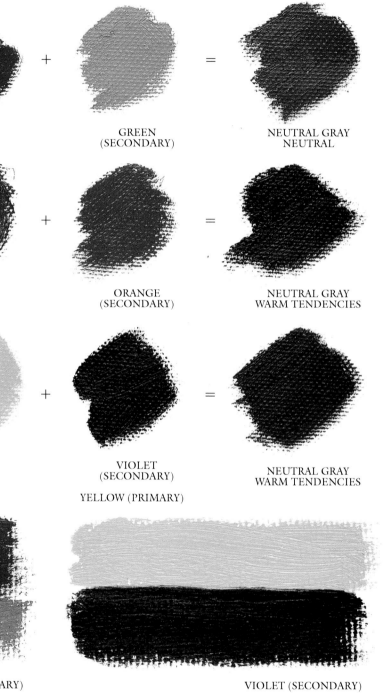

RED (PRIMARY) + GREEN (SECONDARY) = NEUTRAL GRAY NEUTRAL

BLUE (PRIMARY) + ORANGE (SECONDARY) = NEUTRAL GRAY WARM TENDENCIES

YELLOW (PRIMARY) + VIOLET (SECONDARY) = NEUTRAL GRAY WARM TENDENCIES

The mixture of complementary colors produces neutral grays, not pure colors, because the three primary colors are used in unequal proportions.

RED (PRIMARY)

GREEN (SECONDARY)

BLUE (PRIMARY)

ORANGE (SECONDARY)

YELLOW (PRIMARY)

VIOLET (SECONDARY)

Complementary colors produce the maximum contrast of colors.

NOTE

Mixing the three primary colors in equal parts produces black. When the mixtures use unequal proportions, they produce neutral colors, as do mixtures of complementary colors.

MIXTURES

There are two important reasons why mixing colors is necessary in oil painting. One is that however great the range of colors produced by a given manufacturer, it can never cover all the hues present in nature; sooner or later an artist will have to obtain a certain color by mixing others. The other reason is that too many colors on a palette can be cumbersome and impractical. An excessive number of greens, for example, only wastes time since the artist has to stop and pick out the desired tone. An additional reason for mixing your own colors when painting in oils is that it enables you to create your own personal range of hues—in other words, your own palette. In this way, all your works will take on a personal, unmistakable quality.

MIXTURES

METHODS FOR MIXING OIL PAINTS

There are five basic methods in oil painting for mixing colors. No one is better than the others, and different techniques can be used to create the visual effects the artist wants.

ON THE PALETTE

Mixtures made on the palette produce perfectly defined colors that can be applied to the canvas just as they are, or mixed again on the support.

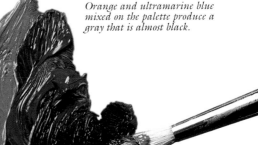

Orange and ultramarine blue mixed on the palette produce a gray that is almost black.

A semi-diluted yellow glaze over blue produces green.

GLAZES

Mixing colors with glazes is done on the canvas using semi-diluted transparent oil paint. When one color is applied over another, they then produce a third. (See *Painting over Dry Paint,* pages 70, 71.)

producing an optical combination of colors. (See *Tricks of the Trade,* pages 82–101.)

MOTTLING, *ALLA PRIMA*

Another commonly used method for mixing colors on the canvas is *alla prima* or rapid painting. This involves applying one color over another in such a way that the brush fibers rub into the ground color, allowing it to show through. In this way, the two colors are mixed, partly by the physical act of blending together, and partly due to the optical illusion that they have been combined. (See *Painting over Wet Paint: Painting* alla Prima, pages 68, 69.)

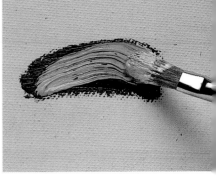

A streaked sky blue effect over brown to create a neutral gray.

is not mixed physically in the paint, but is the result of an optical effect. (See *Oil Painting Techniques,* pages 78, 79.)

The vermilion dots combined with ultramarine dots create a sensation of garnet.

COLOR FROTTAGE

Another system of color mixing is frottage, a technique in which color is partially applied, allowing the underlying color to show through, thus

BROKEN COLORS AND POINTILLISM

Broken colors are those produced by mixing colors on the canvas in the form of small dots. In accordance with the theory of pointillism, the color

Ultramarine blue has been applied as a frottage over light green, creating an optical effect of emerald green.

Yellow applied as a frottage over red produces this orange color.

OIL TECHNIQUES

THREE COLORS AND WHITE

A STILL LIFE WITH VEGETABLES

On the three previous pages we discussed how an unlimited range of colors could be obtained by mixing the three primary colors. Although this is true, when we start to paint a subject using only the three primary colors, we find that when varying the values we have only two options: either dilute the paint and use it like watercolor, painting transparent films of color; or add white to the mixtures and paint with an opaque medium. Oil painters generally prefer to add white to their colors since this allows them to paint either in thin layers or in thick impasto layers. Oil paint can then be diluted, increasing the artist's range of techniques.

For this exercise we will use the three primary colors: yellow, red, and blue, plus white.

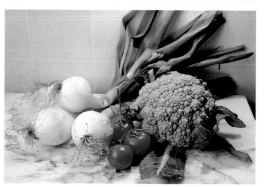

Using the three primary colors we painted a still life that offered a wide variety of values and strong color contrasts.

1. After sketching the subject in charcoal, the background was painted. Using a mixture of the three primary colors, this dark color was created to paint the shadows. It was well diluted so that it would dry quickly and not muddy the colors that were painted over it. A mauve was mixed by combining blue and red, plus white and a touch of yellow. This was used for the upper part and the shadows on the table. The green was a result of mixing mostly blue over yellow that had been toned down with a little red. The ochre was an orange made by mixing red and yellow, with a little blue and then lightened with white.

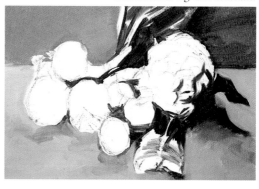

2. Yellow and blue were mixed to produce the green for painting the stems of the onions and the cauliflower. To add more hues and darken it, some red was also added. The tomatoes were painted in red and the shiny reflection was created by removing paint with the brush.

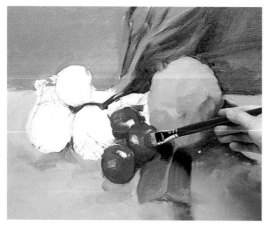

3. The onions were painted ochre, similar to the color used for the table.

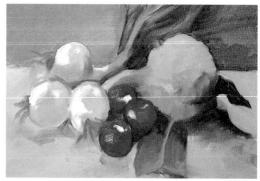

NOTE

You can see that the three primary colors have been used to mix most of the intervening colors. They may appear different on your painting due to the varying proportions used in the combinations.

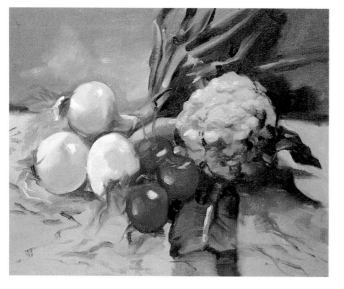

You can clearly see the remains of the mixtures on the palette.

4. In the finished exercise you can see how the details have been retouched using these values and how the highlights on the tomatoes have been brightened with touches of white, which, when mixed with the red, have taken on pinkish hues.

SEVERAL COLORS

By mixing primary, secondary, and tertiary colors, an artist can obtain an unlimited range of colors, but not white. Thus an oil painter could paint any subject using just the three primary colors plus white. Despite this fact, artists always use a more complete palette because, although mixing colors is an integral part of oil painting, there are some commonly used colors that the artist buys in order to avoid having to make these basic mixtures and to save time and space on the palette when working.

A SUGGESTED PALETTE

Here we suggest a palette that contains 14 colors with which any subject can easily be painted, since the colors have been specially chosen to produce any desired range of colors. All the exercises in this book have been painted with this palette.

BLUE

RED

YELLOW

Whatever palette you choose, the three primary colors will always be useful.

NOTE

The palette that appears on this page is only a suggestion; you will have to try out the colors and choose the brands of paint that best suit your style and make you feel most comfortable when painting.

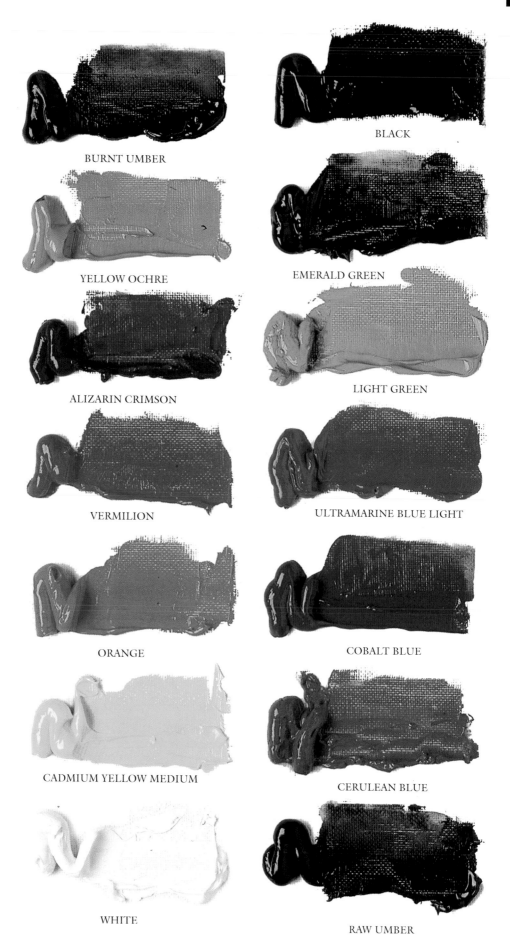

BURNT UMBER

YELLOW OCHRE

ALIZARIN CRIMSON

VERMILION

ORANGE

CADMIUM YELLOW MEDIUM

WHITE

BLACK

EMERALD GREEN

LIGHT GREEN

ULTRAMARINE BLUE LIGHT

COBALT BLUE

CERULEAN BLUE

RAW UMBER

RANGES

A thorough knowledge of the palette is one of the most important skills an oil painter can possess.

So it is a good idea to create a series of color ranges as an exercise since this is the most practical method of learning how the colors behave and what various mixtures are capable of producing.

Three ranges of colors have been developed here using the 14 colors we suggested earlier. Those ranges are classified by the sensation they produce in the observer and by the atmosphere they create in the work: warm, cool or neutral, muddy or intermixed neutrals.

RANGES

Warm colors are those that transmit a sensation of warmth and proximity. They include all the yellows, oranges, reds, carmines, ochres, and earth colors.

We already explained that the color of an object depends on the color of the light that falls on it; therefore, depending on the time of day, a landscape may appear bathed in cool or warm tones.

A cloudless scene at midday usually produces warm hues. At dusk the cool blue of the sky becomes suffused with pure warm colors such as orange, pink, and yellow. As a result of the atmosphere, objects that are closer to the observer appear in warmer colors. Using warm colors in the foreground of a painting is one of the effects an artist employs to create a sensation of proximity and depth.

NOTE

Although greens are usually considered cool colors, some can appear warm if there is a predominance of warm colors in its composition.

WARM COLORS

A little alizarin crimson has been added to the vermilion to produce this red.

A little yellow and vermilion created this intense orange color.

Ochre is produced by mixing vermilion, yellow, and a touch of cerulean.

This brown was obtained by adding a touch of emerald green to the vermilion.

Indian yellow is just medium yellow with a touch of orange.

This dark brown that looks like burnt umber was made by mixing yellow, ochre, and alizarin crimson.

This acid green was mixed by adding yellow and white to light green.

Mauve is obtained by mixing alizarin crimson, white, and a little ochre.

This cream color was obtained by mixing yellow, a touch of orange, and white.

RANGES

As their name indicates, cool colors are those that produce a sensation of coolness and distance. The cool colors include all the blues, most greens, and violets that are predominantly blue.

Cool colors are those that appear during the first hours of the day when the sun is not at its full intensity, and also the color of the shadows in the evening, when the sun's light is fading.

COOL COLORS

The air that comes between the observer and the observed makes objects in the distance appear gray, and the most distant ones take on bluish tones. Thus in a landscape, the objects in the foreground are more distinct and become more blurred in the mid-ground. Farther in

This light turquoise was made by mixing ceruleau blue, white, and a little emerald green.

This sky blue, almost cerulean blue, was made with just cobalt blue and white.

Prussian blue can be mixed by adding a little black to ultramarine blue light.

the distance, objects become blurred and tend to take on a uniform grayish blue.

Using warm colors in the foreground of a painting is a good technique for creating a three-dimensional sensation, whereas the use of blues and grays in the distance helps to create a sensation of depth and realism.

A cool gray obtained by mixing ultramarine blue light, a little ochre, and white.

A dark violet mixed from cobalt blue and alizarin crimson.

This green contains emerald green, a touch of raw umber and a little white.

NOTE

The fact that warm or cool colors should predominate at any one time of the day does not imply you cannot use other colors, as it is the contrast between them that enables an artist to construct a painting.

Another, light violet is obtained from alizarin crimson, ultramarine blue, and white.

This cobalt blue was obtained by mixing cerulean blue and ultramarine blue light.

This pale green was made by mixing cerulean blue, yellow, and white.

RANGES

NEUTRAL COLORS

Neutral or *broken* colors are impure colors with a dirty look as they contain the three primary colors. Neutral colors are also called grays. Any color can be made neutral by mixing it.

Neutral colors are to be found everywhere in nature; in fact, there are more neutral colors than pure ones. You only have to glance around and ask yourself if that blue, for example, is really pure, or is it neutral because of the effect of a shadow. Neutral colors are used all the time in oil painting, because, when they appear next to pure colors, they create important effects of light and shadow.

This green was made with cerulean blue, yellow, white, and ochre.

Payne's gray obtained by mixing burnt umber, white, alizarin crimson, and ultramarine blue light.

This earth color was made by a mixture of ultramarine blue light, ochre, and white.

A dark, neutral gray obtained from mixing ultramarine blue light and raw umber.

Adding white to burnt umber produced this beige.

This bluish gray was made by adding ultramarine blue light to the beige made earlier.

NOTE

To create neutral colors, the best method is to use the remains of paint on the palette to dirty pure colors.

A reddish earth color made by mixing cobalt blue, alizarin crimson, and ochre.

This lead gray was made by a mixture of cobalt blue, black, and white.

A mixed gray made from emerald green, alizarin crimson, and white.

Background Color

Background color is of major importance in oil painting because even if the paint is applied thick and opaque, it can still remain visible through the subsequent brushwork, thus altering the final appearance of the work. A colored background can be used as a feature of the work to bring the elements of the painting together.

BACKGROUND COLOR — WHITE BACKGROUNDS

When a white background is needed, it is usually painted directly over the primed surface since most canvases sold in stores are already white. White backgrounds increase the luminosity and saturation of colors, keeping them pure. Thus, the work appears luminous since the white can be left visible through the subsequent brushwork, increasing the sensation of light or the play of contrasts in that part of the painting.

On the other hand, an intense, white background can disconcert a painter and lead to the application of colors that are too dark for the light values, or vice versa; this mistake may not be realized until the entire canvas has been painted.

So when painting over a white background, the main areas of color are usually defined first as a guide to prevent an artist from using the wrong values. In addition, a white background means using more paint, which itself causes problems, since an artist is continually forced to conceal the areas between the brushstrokes if he or she does not want the white background to show through.

Colors appear as pure as possible when painted over a white background, because they absorb part of the light from it. This effect is even more evident when lacquers or semi-transparent colors are used. You can see how the black appears more intense due to the contrast and the yellow appears duller than it really is.

BACKGROUND COLOR — COLORED BACKGROUNDS

Colored backgrounds have been used throughout history by countless artists, because they are not as dazzling as white ones and thus can be used as another element in the composition of the work. When using free brushwork, a colored background saves an artist from having to continually apply too much paint in order to conceal the white background. Also, the color of the background that shows through the subsequent work serves to integrate all the different elements of the painting.

To obtain a colored background, color can be added to the priming for the canvas, or after the canvas is primed using acrylic paint or oil paint diluted in turpentine, which dries quickly.

Colored backgrounds in oil painting can be made transparent by diluting the paint or made opaque by using quick drying acrylic paint. Transparent background color lets the white priming show through, so colors applied over them will appear brighter.

The color an artist chooses for the background depends on his own preferences and the subject being painting. To paint vegetation, for example, a green background could be suitable and for water, a blue background color. Neutral colors are preferable.

A light, opaque background highlights pale colors.

An opaque background in a medium value is suitable for incorporating into the composition of the work.

A dark, transparent value can be used to represent the light that emerges from the white priming.

The brightness of the white canvas shows through this clear, transparent background color.

A transparent background color in a medium value appears lighter; the colors applied later absorb the white of the canvas.

A dark, opaque background highlights luminous spots by contrast, though it does tend to lend the entire work a medium dark value that may force the artist to apply more paint to represent the light.

The background becomes a major part of the composition of the work as an artist paints with free brushwork, making use of the background color as an intermediate tone.

BACKGROUND COLOR

COLORING A BACKGROUND

Acrylic paint can be used to color a background for an oil painting since it dries very quickly and can be painted over in a matter of minutes. Although oil paint adheres perfectly to acrylic, remember that acrylic paint will not stick to an oil base color—so take into account how the canvas has been primed.

A canvas can also be colored with oil paint. It is generally used in a well-diluted state so that it will dry more quickly. White is generally avoided because the oil used to bind it takes longer to dry and can cause cracks in any subsequent layers of paint.

The background can be colored using thick oil paint or paint diluted with turpentine. This latter method is the best as it dries quickly and follows the rule of painting fat over lean.

A background can be colored using the same brush used for painting the rest of the work, or you can use a wide flat house-painters' brush to save time.

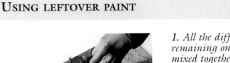

A roller is a good tool for painting the background because you can cover the canvas quickly.

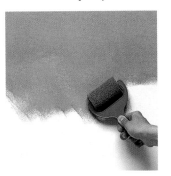

A rag can be used to color the background while experimenting with two colors and creating special effects that will remain visible through the subsequent brushwork.

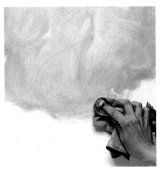

BACKGROUND COLOR

USING LEFTOVER PAINT

A good way to use up any paint remaining on the palette after a painting session is to mix all the colors together with a palette knife and use this neutral, usually dark color to paint the background of another canvas.

1. All the different colors remaining on the palette are mixed together using a palette knife; unless you choose only certain colors the result will be a dark, neutral value.

2. The background is painted with this mixture to create a suggestive background. The same color can be semi-diluted with turpentine and applied with any type of instrument to create special effects.

BACKGROUND COLOR

RE-USING A CANVAS

If you have painted a work you are not satisfied with and want to re-use the canvas already mounted on the stretcher, you can wait for the paint to dry and paint over it, or remove the paint while it is still wet and start over with a clean canvas.

1. Scrape off the wet paint with a palette knife.

3. Rub the canvas with the paintbrush soaked in turpentine to dilute the remaining paint.

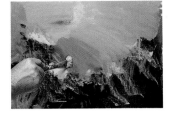

2. Dip a paintbrush into turpentine.

4. Clean with a rag.

NOTE

If you are going to paint a background with acrylics, take into account how the canvas has been primed. If it has been prepared for oil paint, acrylic paint will peel when it dries.

MORE ABOUT . . .

In the section *Subjects for Oils* you will find exercises in which the color of the background is used as a major element in the composition of the work.

To remove a background color that is still wet:

5. Dip the rag in oil (any cooking oil can be used as an economical alternative).

6. Clean the canvas with the oil-soaked rag. This will produce a smooth surface, quite adequate for oil paints.

OIL TECHNIQUES

Oil Painting Procedures: "Fat over Lean"

Although every artist develops his own style of painting, there is an established procedure for painting in oils. This chapter will be concerned with the traditional procedure that allows the artist to paint a picture while avoiding fundamental errors that can lead to the deterioration of a canvas once it has dried.

"FAT OVER LEAN"

The expression "fat over lean" is the golden rule in oil painting and should be followed in order to produce successful oil paintings.

"Fat over lean" means that a picture should always be painted over a base that is less oily than the paint you are applying. An oil painting takes a long time to dry; it may need as much as six months to a year to dry thoroughly. During this period of time the paint dries by oxidization and hardens in such a way that the surface shrinks slightly. If you have painted "lean over fat," that is, if you apply a layer of paint thinned with turpentine over a layer of oil paint, the diluted or lean layer will dry faster than the undiluted "fat" one, thus producing cracks or peeling in the painting. For this reason an artist should always remember the "fat over lean" rule, that is, gradually increase the amount of oil in the paint or reduce the density of the paint that is applied during the first stages of an oil painting.

THE PROPORTION OF OIL

There are various ways to paint "fat over lean." It is up to the artist to choose a method that best suits his style.

The easiest and most commonly used method is to dilute the paint with turpentine when laying down the background and painting the first applications of color. In this way, you can proceed by painting fine layers of paint straight from the tube or diluted in oil, leaving the impastos for last.

It is important to bear in mind that white oil paint takes longer to dry than other colors, and so it is essential to avoid painting white backgrounds since subsequent layers of other colors will cause the painting to crack with time. Furthermore, it is also important to remember that adding too much drying agent (siccative) may cause dry paint to crack.

Another method of applying paint consists of doing the first layers with acrylic paint, since it dries quickly, and then beginning work with oil paint and thus avoiding the risk of cracks.

MORE INFORMATION . . .

Background Color (pages 64, 65) explains how to paint a base color with semi-diluted paint and discusses the effect on the work.

PROCEDURE

The procedure for painting in oil consists of gradually applying layers of paint. To do this correctly it is essential to begin with paint diluted with plenty of turpentine for the first layers, and gradually increase the thickness of the paint, leaving the thickest layers or impastos for last.

One reason for this system is to prevent the paint from cracking or peeling when it is dry; another important reason is to prevent the colors from becoming muddy when they are painted over other extremely wet colors.

To paint a picture it is advisable to start by covering the canvas with several initial areas of color to block in elements of the composition within the space and, to allow the artist to establish from the outset the tonal values of the colors. This is the reason most artists begin by painting the background.

Once this has been achieved, a painter can then begin work on the volumes and masses, leaving the details, the highlights, and the darkest shadows for last.

PROCEDURE A PAIR OF BOOTS

In this exercise we are going to follow a traditional oil painting procedure: applying successive layers of paint according to the "fat over lean" rule and covering the canvas with color before working on the details and the highlights and shadows.

The first color is painted with plenty of turpentine so the result is somewhat transparent, in other words, "lean." It will dry quickly so that it will not muddy the color that will be applied on top.

We are going to paint a pair of boots using the traditional procedure of applying the first layers of paint diluted in plenty of turpentine and gradually increasing the thickness of the paint.

1. We begin by drawing the basic outline of the forms in order to block them in on the canvas.

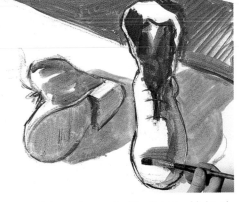

2. We dip a brush in turpentine in order to dilute some alizarin crimson on the palette.

3. We draw with a brush and thinned down paint over the preliminary sketch in such a way that the original charcoal lines can be seen when we begin to paint in thicker layers. We also establish from the outset areas of light and shadow, leaving the canvas unpainted for the former but painting the darker values of the latter.

4. Some ultramarine blue light is added to the alizarin crimson used to paint the shadow cast by the warm-colored boots. Then the volumes are built by adding vermilion to the alizarin crimson. Note that we are still working with paint diluted with turpentine. Once this stage is completed, it is important to take a break for a while and do something else in order to take your mind off the painting. Then, when you return to it, you will see it in a fresh light.

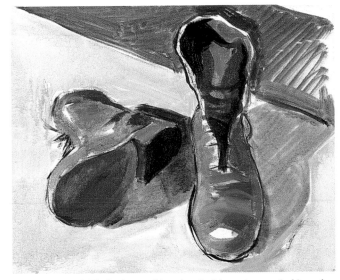

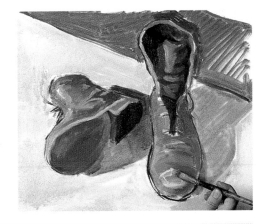

6. Having painted the shadows, we begin on the highlights with white, allowing the white paint to blend slightly with the background color.

5. The background is painted with a mixture of white, ochre, and ultramarine blue diluted with plenty of turpentine. Note how the value of the boots is influenced by the background color. This allows us to obtain the correct value of light and dark areas.

NOTE

When painting in oils it is important to take short breaks now and again. Failure to do so may cause an artist to lose perspective and therefore not recognize errors until the painting has been finished. Oil paints takes a long time to dry and the colors do not alter during this time, so there is no excuse for avoiding such breaks or even continuing the painting on the following day.

7. The final touches consist of painting the background shadow, which heightens the light parts of the work, and adding details with a fine brush.

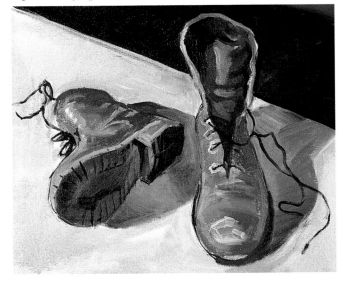

Note the mixtures of paint on the palette. The different tones have been mixed by taking advantage of the remains of previous mixtures. In this way the work as a whole takes on a homogenous tone since all the colors possess a part of their surrounding colors.

Painting over Wet Paint: Painting *alla Prima*

Painting over wet paint, or painting *alla prima,* is another oil painting technique that can be used for the entire work or merely certain stages of its development. Painting over wet paint requires a steady hand and a mastery of both the technique and color.

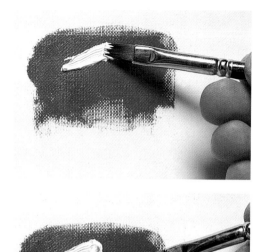

When painting over a wet base, the artist must use the brush deftly and the paint must be applied thickly and freely to avoid muddying the colors.

Painting over a wet layer allows the artist to mix colors directly on the canvas. (*See* Three Colors, *pages 56–63.*)

PAINTING OVER WET PAINT

An artist who works quickly and wishes to finish a painting in a single session is forced to paint over wet layers of paint, a technique known as *painting over wet.*

The results of painting over wet paint are very different from what is achieved when painting over a dry layer of paint, since, when you paint over a layer of wet paint the colors can muddy each other. To avoid this the paint must be applied in the form of impasto and free brushwork.

It is possible to paint an entire work over wet paint, a part of it, or merely the final layers.

Painting on a wet base requires a steady hand and mastery of brushwork in order to keep the colors clean. Furthermore, painting over wet paint allows you to mix colors directly on the canvas, permitting the paint of the top layers to mix with those of underlying ones. This technique requires a certain grasp of color mixing skills in order to avoid blots or smudges.

PAINTING *ALLA PRIMA*

To paint *alla prima,* meaning "at the first try," involves painting over wet layers of paint.

The technique emerged during the Impressionism movement and entails finishing a painting in a single session by applying one layer of paint over another recently applied one. For this reason the layers are applied with a certain amount of impasto. When we refer to the *alla prima* technique we mean, in addition to painting over wet paint, that the forms are simplified, avoiding details and painting with loose, vigorous brushwork in an attempt to convey visual impressions rather than that of just line or form.

PAINTING OVER WET PAINT

A STILL LIFE OF LITTLE CAKES

Painting over wet paint consists of applying one layer of paint over another that still hasn't dried. This technique allows the artist to blend the two colors together in order to create intermediate values or to superimpose one color over another.

In this exercise we will exploit the versatility of oil paint, since paint is applied both diluted and thick, and we will mix colors both on the palette and on the canvas.

We are going to paint this still life in one fast painting session. Instead of using drying agents or waiting for the first layers to dry, we are going to paint on a wet base.

1. Painting the cakes begins by mixing and applying ochre and orange in different proportions, depending on the value. The first areas of paint are applied in thin layers or diluted with a small amount of turpentine.

2. Now painting with thicker paint, we use the direction of the brushstroke to render the texture of the cake. Note how, although the paint is applied in its natural consistency, the color is extended in order to avoid excessively thick layers at this stage.

3. Cerulean blue and alizarin crimson are added to the mixture in order to paint the basket. The shadow cast by the basket has been painted by darkening this value with more blue. Using pure white, we begin to paint the tablecloth, to which we will add touches of golden ochre and yellow at a later time.

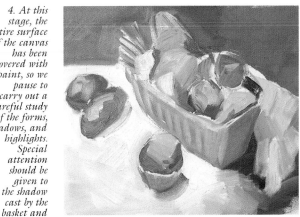

4. At this stage, the entire surface of the canvas has been covered with paint, so we pause to carry out a careful study of the forms, shadows, and highlights. Special attention should be given to the shadow cast by the basket and to the way this color blends into the white tablecloth; in this case, the medium values have been achieved by mixing the color on the canvas.

6. In the finished painting we can see how the forms have been given highlights and shadows with impastos, lightly applied on top to keep them clean.

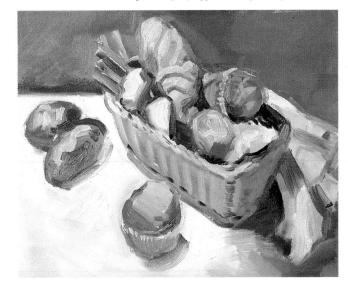

5. The shadows inside the basket are painted with burnt umber mixed with vermilion. This is one of those times when the paint must be lightly applied in order to prevent the shadow's color from muddying the light colors of the cakes.

PAINTING OVER WET PAINT

DETAILS OF THE PROCEDURE

These two close-up photographs provide a graphic example of how paint behaves when painting over wet oil paint. One of them shows how one color is applied softly over another, the other illustrates how a color is mixed directly on the canvas.

These two different techniques can be used to get the most out of painting over wet color by taking advantage of the versatility of oil paint.

White and yellow with a touch of ochre are used to suggest the highlights on the cakes. This is lightly painted over the underpainting, carefully avoiding mixing the different layers of color.

The intermediate values between the light tone of the tablecloth and the previously applied color of the shadow cast by the basket have been mixed on the canvas by blending the light and dark values together.

Painting over Dry Paint: Painting in Stages

The method for painting over dry paint is completely different from what an artist does when painting over a wet base, since the latter entails painting a picture in a single session. Painting on a dry base means painting in stages or sessions, for the artist has to wait for the first layers of paint to dry before proceeding. This gives the painter more time to develop a painting, rectify errors, and include precise details.

PAINTING OVER DRY PAINT

Painting over dry paint simply means painting oil colors on a dry surface, regardless of whether it is a background color or underlying layers of paint.

To paint over dry paint an artist has to wait for a layer of paint to dry before applying another. Therefore, unless you use a special drying agent (siccative), it is rather difficult to finish a painting in a single session.

The main advantage of painting over dry paint or in stages, is that you never muddy the colors or create undesired blends; once the underlying layer of paint has dried it cannot absorb wet paint. Therefore, the inter-mediate tones are created on the palette rather than on the canvas. In contrast to painting over wet paint, painting on a dry base results in more elaborate work, since greater detail and finer layers of paint can be added.

Some painters who want to paint a picture on dry paint but do not have enough time to wait for each layer to dry use drying agents to speed up the drying time. This is a common practice when painting outdoors. Nonetheless, drying agents should be avoided whenever possible since they tend to produce cracks in the paint and reduce its shine, thus creating slightly duller colors.

PAINTING IN STAGES A TABLE WITH A BOTTLE

Painting on dry paint involves painting in successive sessions. If oil paint is allowed to dry for one or two days, the artist can paint over it without muddying the colors.

By painting over a dry base the artist can take as much time as necessary to carefully examine the subject matter and determine the best way to develop a work. An artist can work in greater detail with more complex colors or add impastos as desired.

Painting by stages allows an artist to work at a more relaxed pace, and encourages meticulous attention to details.

This garden table on the terrace and the items on it is the still life we have chosen to paint in stages.

1. The background, created with layers of paint lightly diluted in turpentine that were then left to dry, reflects a sense of atmosphere.

2. This picture was painted in the summer so that, due to the heat and the application of thin layers of paint, the background dried quickly. By the following day it was ready for a sketch in charcoal. Then the book was painted with a mixture of ochre and yellow.

4. A finger was used to blend the corner of the terrace with the background.

3. *The book was completed by suggesting the texture of its pages. This was accomplished by applying the paint with a dry brush technique, which avoided a hard line. Note how the part of the table closest to the bottom has been given more light. Two other interesting aspects worth noting are the way in which background color has been included in the color of the book's cover, and the way the shadow cast over the book by the bottle has been left unpainted. If more time were available, the artist might have painted the entire book in yellow and, after it dried, painted in the shadow.*

5. Work was begun on the bottle by applying colors gradually, knowing that the background was dry.

6. The final work on the bottle entailed painting the detail of the label with a fine, soft-hair brush.

7. The glass was painted thus completing the items on the table. Note how the work was painted in sections, each element developed separately, without the need to paint it as a whole. Here the background color was a reference point for establishing the correct values. The meticulous painting of the glass was made possible by the unhurried method of painting over a dry base.

NOTE

When painting over dry paint, it is not advisable to use drying agents because this will later produce cracking. It is always best to allow the layers of paint to dry from one day to the next in a dry and well-ventilated place.

8. To finish, the background behind the table was painted by blending light and dark greens in order to create a sense of distance.

Painting with Diluted Oil Paint: Painting with Glazes

Painting with diluted oil paint consists of reducing the concentration of oil in the paint so that you can use it like gouache or watercolor. This way you can paint colors with glazes.

PAINTING WITH DILUTED OIL PAINT

Painting with diluted oil paint is a technique developed by painters toward the end of the eighteenth century. It consists of reducing the amount of oil in the paint by diluting it with turpentine, and normally painting it on unsized cardboard or paper so that the oil is absorbed. Although today some artists continue painting in oils on unsized cardboard, this practice is not recommended since the oil penetrates the support's vegetable fibers, causing it to rot over time. Therefore a work executed in this manner will have to be restored at some point.

Painting with diluted paint is nothing more than painting with oil paint thinned with turpentine. Diluted in this way, the color becomes transparent and loses its characteristic shine, thus taking on a gouache-like appearance.

Diluted oil paints can be applied to a primed surface even though it will not absorb the oil. The painting will maintain some of its shine and will take longer to dry. This type of work can be done on paper or cardboard without previous priming or sizing, and is an excellent technique for sketches or quick studies, since these supports are cheap. However, if you want to paint a finished work, it is better to prime the support or at least apply a layer of latex or rabbitskin glue. (See *Priming*, pages 38-41.)

GLAZES

A glaze is a very thin layer of paint applied to achieve a transparent effect. Glazes are often used when painting with diluted oil paint in order to intensify a tone or create a color. (See *Three Colors*, pages 56–63.)

In order to paint with glazes it is essential that the surface on which they are applied be completely dry so that the two colors do not blend together or muddy each other. Furthermore, it is important to bear in mind the effect the background color will have on the color applied over it. If you want a luminous result the background should be light. When you want to work with glazes, or transparent layers, you can dilute them with turpentine, which dries fast and gives the paint a matte quality. If you paint with an oil medium, on the other hand, the result will be an intense shine. It is also possible to prepare a special glaze by mixing walnut oil and turpentine together in equal parts. Several special mediums are now available for diluting paint and applying glazes. The method chosen depends on the result that the artist wants to achieve. (See *Additives for Oil*, pages 22–27.)

MORE INFORMATION . . .

Unlike linseed oil, which dries by oxidization, turpentine is a volatile oil that dries through evaporation. More information on this subject can be found in *Additives for Oil*, pages 22–27.

When working with glazes, the artist applies thin layers of paint through which the luminosity of the background emerges. A second application of a tone will intensify it—if it is applied after the first layer is thoroughly dry.

PAINTING WITH DILUTED OIL PAINT

PAINTING A BASKET OF POTATOES

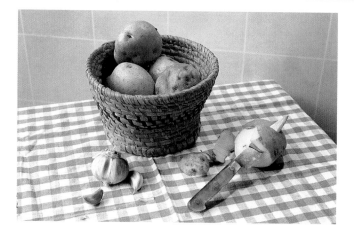

We are going to paint this basket of potatoes with oil paint diluted in turpentine. The liquid consistency renders the color more transparent and matte.

Oil paint loses its shine when diluted with turpentine and attains a transparent and matte appearance. So, painting with diluted oils as a pictorial technique is closer to watercolor or gouache than to the classic oil technique. There are several advantages to painting with diluted oils: you save paint since it is thinned with turpentine; the colors acquire transparency and luminosity when applied on a white background; you practice painting all the colors with the same intensity, for it is not common to apply impasto on top, although it is possible; and you gain the opportunity to try out a new technique while using the oil medium.

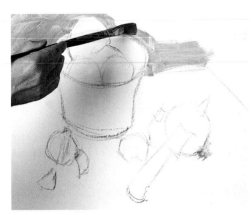

1. Having sketched the subject in charcoal on a canvas primed with white, we begin to paint the wall with a mixture of cobalt blue, burnt umber, and white diluted with turpentine.

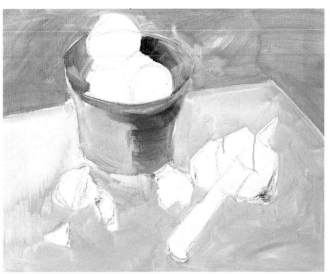

2. The table and the basket are painted. The color of the latter is a mixture of ochre, orange, and burnt umber applied in varying intensities, that is, very diluted and with very little burnt umber in the lightest parts, and slightly less dense and with a greater proportion of umber in the darkest areas.

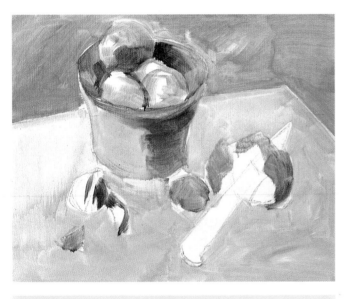

3. The potatoes and the garlic are painted with the same color, but with a touch of alizarin crimson added.

4. By the time we painted the knife, the preliminary layer of the tablecloth had dried so we then painted the checkered pattern of the tablecloth with a fine layer of emerald green toned down with turpentine.

NOTE

In order to paint with layers of glazes it is essential to allow the underlying layers of paint to dry. Remember, if you are painting with diluted oil paint on an umprimed or unsized support (canvas, paper, cardboard) with time the oil will rot the vegetable fibers and the work will flake when touched.

6. Once the paint has dried, all that remains is to apply touches of green to complete the intersections. Then the detail of the basket is painted with a fine brush loaded with burnt umber. Several final details such as the screws in the handle of the knife are added and the painting is finished.

5. The transverse lines are now added to finish the pattern. Since the first lines were still wet, the brush has lifted the underlying paint thus preventing the green in the intersections from intensifying.

Painting with a Palette Knife

In addition to correcting, altering, and transporting paint to the palette and creating effects, a palette knife can be used as a painting instrument. It can be used to build up areas of paint and create texture by incorporating its characteristic mark.

CHARACTERISTICS OF PAINTING WITH A PALETTE KNIFE

A greater amount of paint is used with a palette knife than with a brush. Therefore, the cost of such a painting is considerably higher than one painted with a brush.

The characteristic geometric mark left by the palette knife on the canvas can be eliminated by softly stretching the paint and avoiding impastos. Nonetheless, we can also take advantage of this to create relief and suggest different types of texture.

A picture painted with a palette knife can be done in one or in several sessions, but only if the underlying layers of paint are still wet; it is difficult to work over thick paint that has dried.

Painting with a palette knife is an interesting and educational exercise for an oil painter because it requires an artist to resolve the work by means of visual applications while leaving details aside.

It is precisely for this reason that a painting executed with a palette knife can be so fresh, vibrant, and spontaneous.

TIPS FOR PAINTING WITH A PALETTE KNIFE

Painting with a palette knife requires the use of more paint than when working with a brush. To create mixtures on the palette, we suggest you begin with a generous amount of paint so you are not left short and then have to make a new batch, which will take up a lot of time. Furthermore, keep in mind that it is often very difficult to mix exactly the same color the second time around.

One of the advantages of painting with a palette knife is that the implement is easy to keep clean. Simply wipe the instrument with a rag or, if you are going to use it often, with old newspaper that can be thrown out after use, thus allowing you to keep the rag relatively free of paint.

The size of the palette knife you use will depend on the format of your canvas. It is important to remember that details cannot be painted with a palette knife, and that it is difficult to reach corners or create texture with a large palette knife. So it is advisable to have several types and sizes of knives at hand.

The procedure for painting with a palette knife is similar to that of painting in oil with a brush. When you apply the final layers of paint for the highlights and the shadows, you should deposit them carefully over the underlying colors in order to avoid lifing the background color.

Though designed to combine colors on a palette, the palette knife is also useful for mixing color on the canvas—either for creating homogenous tones or for optical mixtures by means of streaky or mottled effects.

MORE INFORMATION . . .

In the chapter *Using a Palette Knife*, pages 46–47, you will find more information on the use and maintenance of this painting implement.

PAINTING WITH A PALETTE KNIFE

THE SMOKER'S TABLE

Painting with a palette knife requires a certain degree of mastery since the instrument is not versatile and is not appropriate for painting details. For this reason, an artist must rely on visual impressions, rather than emphasizing form and detail. Nonetheless, the fact that we can use this implement to create texture allows us to suggest direction and to create lively rhythms.

We are going to paint this still life by applying impastos and creating texture with a palette knife in order to obtain a vibrant and daring texture.

1. Having drawn the sketch in charcoal, we begin to paint the background with vermilion and create texture with the palette knife. Even though there are no creases in the actual tablecloth the technique lends a vibrant air. At this point, we are working with a small palette knife.

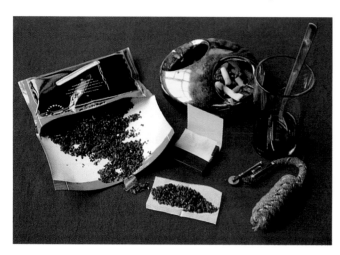

2. Once the entire background has been painted, we paint the ashtray with several directional strokes of the palette knife that suggest the shape of the highlights. Close inspection reveals that the intermediate values are the result of mixing one color over another on the support.

3. We continue painting with a small palette knife, adding texture to the areas that require it and creating the smooth surface on which the tobacco sits.

4. The glass is painted by scraping the palette knife across the surface. This sgraffito technique is also used to paint the spoon by extending the paint vertically.

5. To finish we have painted the lighter by suggesting the pattern of the rope with a more intense color and with curved lines scratched out with the palette knife.

PAINTING WITH A PALETTE KNIFE

DETAILS OF THE RESULT

In addition to the attractive result when the painting is viewed from a distance, the parts scraped with the palette knife are particularly interesting in the foreground of the work. Certain details of the table provide good examples of how the palette knife can be used, its expressive potential, and its ability to produce textures.

On the glass, note the effect created by the paint. In some areas it has been added and in others it has been lifted out, using the sgraffito procedure, thus revealing the white of the canvas, thus finishing the construction of the line. Observe the cigarette lighter and the smoking papers that, besides being painted with different colors, are separated from one another by the directional marks of the palette knife.

In the background next to the wick, the paint has been vigorously dragged, and the lines made by the palette knife left visible. Lastly, note the application of white on the color of the background to create the highlights.

NOTE

Painting with a palette knife entails the use of a lot of paint, so it is important to have a good supply before you start and to prepare a large amount of color when you mix it on the palette.

OIL TECHNIQUES

Painting with Impasto

T he impasto technique allows an artist to create relief and suggest texture by modeling thick applications of paint on the canvas. When painting with impasto, the quality, energy, and direction of the strokes acquire great importance.

Painting impasto involves applying color in thick layers, allowing the mark of the brush to remain visible and create relief.

CHARACTERISTICS OF IMPASTO

The impasto technique consists of applying enough paint to form relief.

Oil paint has the necessary body to maintain the shape it is given with the brush, so the brushmarks, the quality of the brushstrokes, and their direction and energy are of the utmost importance in the construction of the painting. It is the brushstrokes that set the rhythm of the work, creating the general atmosphere and suggesting textures.

HINTS FOR PAINTING WITH IMPASTO

Even though it is possible to apply thick impasto from the outset, it is advisable to draw a sketch of the elements with a brush loaded with semi-diluted paint so that the white of the canvas is completely covered, thereby giving the composition unity.

It is important to remember that impasto requires a considerable amount of paint; when you mix the color on the palette, be sure you make a large amount so you will not be left short and have to mix the color a second time.

The brushstroke is of fundamental importance in an impasto painting because it establishes the rhythm of the painting, suggesting textures and creating the general atmosphere of the work. Therefore it is important to pay special attention to brushstrokes and use them to achieve an expressive and sensual work.

Painting with impasto does not necessarily mean covering the entire canvas with the same thickness of paint. You can play with the thicknesses: the foreground may contain more impasto while the background has less.

PAINTING WITH IMPASTO

Painting with impasto is both fascinating and fun although the execution of this type of picture involves the use of a large quantity of paint. Despite this we suggest that you try your hand at the technique in order to broaden your knowledge of impasto painting, which compels the artist to rely on brushwork to create texture and to effect a sensual painting with oil paint.

A SEWING BASKET

The impasto technique does not always require the application of thick paint from the outset; although many painters do so, we can paint the background with diluted paint and then develop the forms by increasing the thickness of the subsequent layers of paint. Moreover, this is an ideal technique for creating depth, which is obtained by means of maximum relief in the foreground.

MORE INFORMATION . . .

You will find more information on techniques for making corrections in *Tricks of the Trade*, pages 82–101.

1. A sketch was painted with a brush loaded with a mixture of burnt umber, alizarin crimson, and ultramarine blue diluted with turpentine. From the outset, the areas of light and shadow were established.

We are going to paint this sewing basket which presents an interesting assortment of forms, colors, and textures.

2. We begin by establishing some of the lightest areas with a mixture of yellow and ochre, applying thick paint in the form of impasto.

3. The initial underpainting of the still life has now been painted in impasto. The only remaining work at this point is to outline the forms and highlights and the edges of the shadows with a thicker layer of paint.

4. Note how both the texture of the wicker basket and the color contrasts have been developed by adding dark values of impasto. It is essential to apply the right type of brushstroke to suggest the different shapes and surfaces: the basket has been painted with thick lines of paint in contrasting colors, whereas the egg, soft and smooth, is rendered with blended colors applied with short flat brushstrokes.

5. At the end of the exercise we can appreciate the finish and detail of the highlights that had been left for last in order to prevent these light colors from becoming muddy. Note how the final touches of paint have been lightly applied in order to prevent them from lifting the underlying color. Another important point to bear in mind is the difference in the thickness of paint between the objects in the foreground and those in the farthest planes, where the paint has been painted in fine layers, the brush scrubbed over the surface in order to create a sensation of distance.

PAINTING WITH IMPASTO
CORRECTING ERRORS

To successfully paint a picture with the impasto technique an artist needs some mastery of technique and control of the brush since thick paint on the canvas can easily make the colors muddy when they come into contact with one another.

This is a relatively easy problem to resolve by scraping the dirty paint from the surface of the canvas with a palette knife and repainting the affected area.

Although there are other methods for correcting errors, the use of the palette knife is the technique most commonly used since it is the cleanest method.

1. The area painted green is too large and extends over the yellow form of the tape measure, unlike the photograph, which shows the yellow tape measure extending over the green. The palette knife is placed next to the spot that needs to be corrected.

2. The color is carefully removed with the palette knife. The problem has been resolved. If necessary, the area can be repainted with impasto.

Painting with Small Strokes of Color

T he Impressionists worked by painting small strokes of color side by side, or by applying broken color, a technique similar to pointillism. In order to create a visual impression of light and color, they applied the paint with short brushstrokes, which created optical color mixes rather than mixtures on the canvas.

OPTICAL EFFECTS OF COLOR

Instead of mixing colors together, the Impressionists juxtaposed small strokes of different colors that, when observed as a whole, created an optical effect similar to what would be obtained by means of a conventional mixture of pigments. The difference between the optical effect of this type of color mixing and that of colors mixed on the palette is that, thanks to the use of neutral colors, it is possible to create intense, vibrant effects that cannot be achieved with uniformly applied colors. As a result, works painted in this manner have an energetic, luminous, and fresh air about them.

Because it is a fast method of painting, compelling the painter to capture a scene before the light changes, this technique is widely employed when painting from nature. Although this techique was developed for painting outdoors, painting with small strokes of color can be used for any subject. The result is entirely different from that of any other painting technique.

PAINTING WITH SMALL STROKES OF COLOR

Spontaneity is fundamental in painting with broken color because it is precisely the fragmentation of the stroke that gives the work its freshness. It is an intuitive technique that compels the artist to capture a fleeting aspect of a scene on canvas without hesitating.

To achieve the desired effect with dabs of color, it is essential to master the technique and understand the psychology of color. Failure to foresee the reactions of your mixture can create the opposite effect of what you set out to achieve.

The forms in the painting are built up by means of areas containing tiny dabs and patches of color which, when seen close up, look like fragmented forms. But when observed from a distance they form a whole. So it is indispensable to rely on some element that unifies the work, whether it be a background color or the presence of a uniform tone in the painting.

> **NOTE**
>
> Don´t confuse the term broken color technique with the so-called broken or neutral colors, which are those that contain part of the three primary colors. (See *Three Colors*, pages 56–63.)

PAINTING WITH SMALL STROKES OF COLOR

The technique of painting with small strokes and patches of color is ideal for capturing subjects containing a wealth of lively color contrasts. One way of ensuring a balanced result is to work on a background color that will show through the short, energetic brushstrokes of the work. This also allows you to save paint and prevent the colors from muddying one another, something that is unavoidable when

THE LAUNDRY ROOM

painting on a white background. A colored background also serves to check those colors that might appear excessively loud, thus allowing the artist to use such colors without the kind of exaggerated result produced in a painting realized with a different technique, or on a bright white background. (See *Background Colors*, pages 64–65.)

We are going to paint this still life consisting of bottles of detergent on the floor of a laundry room. Aside from being a typical everyday household scene, this subject has an interesting assortment of color contrasts.

1. We paint on a neutral opaque background of a greenish color, which will show through and unify the work, as well as allow us to save paint.

3. We continue painting the bottle with short brushstrokes that look more like small spots of paint; the labels are merely suggested with fragmented lines of color. Note how the floor has been painted with a variety of tones that are subtly blended together.

2. The bottles have been painted with tiny brushstrokes of color, in either lighter or darker values, depending on the color and value of each bottle.

5. In the completed exercise, we can appreciate the spontaneity and the vibrancy produced by the colors applied with small strokes. Note the distance left between each brushstroke and the role played by the background color as a unifying factor.

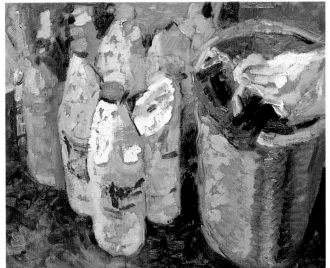

4. The clothes in the laundry basket are rendered with longer brushstrokes, which are especially effective for suggesting creases and folds. Patches of the background color are also blended in.

PAINTING WITH SMALL STROKES OF COLOR

DETAILS OF THE PAINTING

A close study of a painting done with small strokes of color reveals the technique and the way in which these small touches of color appear haphazard and coherent. It is difficult to believe that seen from a distance, the seemingly chaotic color and abstract rendering of details could ever come together to define specific objects in the composition.

The texture of the basket's wickerwork is also rendered with small brushstrokes, although their order and direction produce a completely different effect.

When seen close up, the composition of bottles looks more like an abstract painting than a figurative painting. Note the interplay of tones and hues, and the way the fragmented color suggests the smooth surface of the plastic.

Painting over a Base of Oil: Creating Atmosphere

Vegetable oil is the medium with which pigments are bound together in order to produce oil paint. The use of a base of oil on the support then, is ideal for allowing the paint to flow easily, which in turn, helps to blend the colors together and create a hazy atmospheric effect.

OIL AS A BASE

The vegetable oil used to bind the color pigments in oil paint is an ideal medium both as a solvent and as base to paint over.

By applying a fine layer of linseed oil—or any other oil compatible with oil paint—over the support, subsequent applications of oil paint become more ductile, allowing the artist to create transparent and atmospheric effects. The layer of oil moistens the canvas, allowing colors to flow and merge with adjacent colors, creating subtle, soft fusions of color that are perfect for giving a painting atmospheric, *sfumato*-like effects.

The main drawback of this method is the amount of time needed for the oil base to dry as compared to that of a picture painted on a dry base.

ATMOSPHERE

Atmosphere in a painting is defined as the interposing air between the spectator and the elements of the painting. The farther away the elements are from the viewer, the more evident the intervening atmosphere becomes. A good example of this can be seen in a landscape, where the elements in the foreground are sharp, while those in the farthest planes become blurred and take on a bluish-gray tone.

But atmosphere can also been "seen" in enclosed spaces, such as a smoked-filled bar or a room in which the light shines in such a way that particles of dust suspended in the air are revealed.

Because atmosphere is a reality, it must be interpreted by the oil painter as an element of the composition. To do this it is important to take into account three basic points:

1. Objects located in the foreground have the most striking color and value contrasts, and their colors appear to be warmer than those farther away.

2. As objects recede into the distance, the contrasts soften and the colors take on cool grayish tones.

3. In the farthest planes, the contours of objects become blurred due to the effect of the atmosphere, and assume a uniform color without contrasts.

MORE INFORMATION . . .

For more information on the most suitable oils for use with oil paint, *Additives for Oil Paint*, pages 22–27.

The *sfumato* technique can be carried out in a number of ways. See *Tricks of the Trade*, pages 82–101.

PAINTING OVER AN OIL BASE

Painting over a layer of oil medium makes it easy to create subtle impressions of objects in delicately blended gradations of color.

THE ATMOSPHERE OF A LANDSCAPE

This technique is particularly appropriate for suggesting atmosphere and the presence of haze or mist in a landscape. The result achieved by painting over an oil base is akin to *sfumato*, a technique that produces a similar effect. However, *sfumato* never produces the sort of transparency and brilliance that can be achieved with oil. Furthermore, an oil base lends a silky appearance to a painting that cannot be obtained with other media.

Before painting this landscape on a primed canvas, we will first apply a layer of oil. As you can see in the photograph, the misty atmosphere makes the theme more attractive.

1. We paint a thin layer of linseed oil over the canvas with a brush.

2. We begin by painting the sky with cobalt blue mixed with white. Note how the oil base allows the paint to flow smoothly over the canvas, creating a nebulous transparent effect.

3. A slightly darker value of the same color is used to outline the most distant mountains.

4. We begin to add touches of alizarin crimson to the mixture to gradually increase the instensity and warmth of the colors of the nearest mountains. This accords with the rule on the proximity of objects and their color. We then add a touch of emerald green to the mixture in order to paint the hillock in the foreground, always applying the color smoothly.

6. The vegetation is painted with emerald green toned down with raw umber by skimming the brush over the surface to suggest textures.

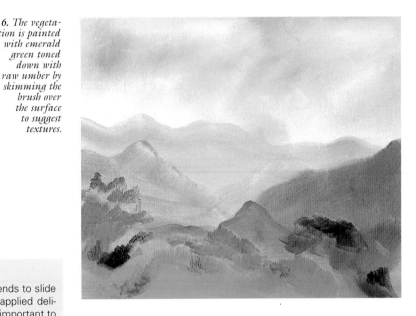

5. We lightly blend some medium green with the background to suggest the grass. Note how the intensity of the color automatically makes this area appear closer to the observer, thus heightening the sensation of the distance of the mountains.

NOTE

When oil paint is applied over oil medium, a brush tends to slide smoothly across the canvas, allowing the paint to be applied delicately, and permitting gradations and color blends. It is important to bear in mind when working with this technique that the oil takes a long time to dry.

7. Some touches of yellow, lightly blended with the background, are used to indicate the highlights.

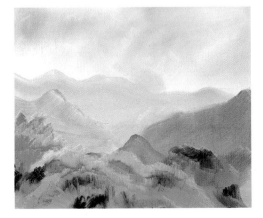

8. Finally, some white is painted on the surface of the rocks and is used to blend the horizon line with the sky.

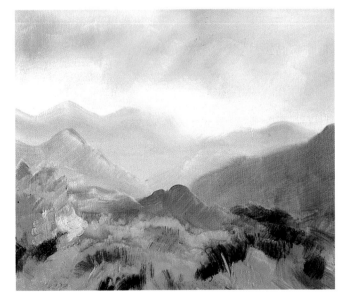

Tricks of the Trade

T he malleability and versatility of oil paint allows you to make corrections and experiments, as well as to create unusual effects and textures. All of these procedures with oils are simply tricks of the trade. An artist can use these techniques to heighten his creativity and enrich his work. These tricks of the trade are techniques that can help an artist perfect his style and expand his knowledge of oil painting, which will augment his mastery of the medium and the creativity of his work.

CORRECTIONS

The versatility of the oil medium makes it very attractive to painters since the paint can be manipulated and its density changed if necessary. It can be applied in impasto or in thin layers or glazes. It can be molded with a palette knife, used to cover large areas, or to paint with transparent glazes. Above all, the great advantage to painting with oil is the artist's ability to correct errors no matter how large or small, or whether the paint is wet or dry.

CORRECTIONS ON WET PAINT

Before you have sufficient mastery of oil paints, it is not unusual to apply either too little or too much paint. In the first case, the error is easy to correct: simply add more color and continue painting. In the second, excess paint could pose a problem since the paint will take longer to dry and the value of the color may be too dark. The solution to this problem is to use a medium that will reduce the color's density. Use turpentine if you want the paint to dry quickly, or vegetable oil or some other oil medium if you prefer it shiny and do not mind a longer drying time.

REDUCING THE PAINT'S DENSITY

1. Sometimes an artist will load too much paint on the brush and thus apply too much to the support. As a result, the painting will come out too dense and very dark.

3. Apply the turpentine to the paint; note how it dilutes it.

2. To dilute paint that is already applied to the canvas, load your brush with a bit of your chosen medium, in this case, turpentine.

4. By diluting oil paint, one can reduce its thickness and increase its transparency. This allows an artist to play with the direction of the paintbrush's bristles. The excess paint will accumulate at the edges of the brushmarks, forming suggestive lines.

CORRECTIONS ON WET PAINT

DARKENING A COLOR

Once you have applied various colors, or at some point before finishing your picture, you may realize you have made an error in the value, or you may wish to change a certain color. Resolving this problem is simple. To darken a value, apply a darker color on top of the color you wish to change so that both are blended on the canvas.

1. After painting an area, you decide that the color's value is too light.

2. To darken the value, use a color that is deeper than the first color; in this case, we have chosen black. Use the same brush you were using previously without cleaning it.

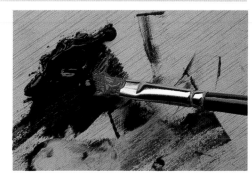

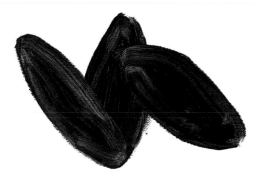

3. Apply the black on top of the red, blending both colors with a stiff brush, which adds the texture of the brush hairs.

4. The result is a darker value than the original one, and a certain change of hue. Note that we have deliberately avoided overmixing the colors in order to create this streaky effect. For a completely blended color simply continue to brush over the paint until you obtain an even tone.

NOTE

When darkening a color, it's a good idea to use colors of the same family (when using yellow, try ochre; when using red, try alizarin crimson). Black, on the other hand, is very strong and may produce muddy colors. It can alter a color's character by creating a secondary color or a neutral color (red mixed with black becomes brown). See *Three Colors*, pages 56–63.

CORRECTIONS ON WET PAINT

LIGHTENING A COLOR

There may be times when you use a color that is too dark in value, but you do not realize it until it has been painted on the canvas. The way to correct this error is to add a light value of the color over the dark one to create an intermediate value. Bear in mind however, that it is always easier to darken a value than to lighten one.

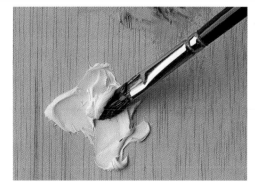

1. These three brushstrokes of the same color are darker than we anticipated.

2. To correct the value and lighten the color, take some white from your palette.

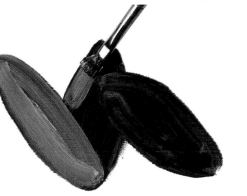

3. Apply the white directly to the wet paint allowing both colors to mix in some parts, but letting the white predominate in some of the brushstrokes.

4. The third dark value has been lightened only slightly by adding a little cerulean blue. Note the difference in color and value between the dark value treated with white and the one treated with blue.

OIL TECHNIQUES

CORRECTIONS ON WET PAINT

CORRECTING WITH A CLEAN BRUSH

The boundary between two colors can be a problem when painting too quickly or when you momentarily lose your concentration. To remove a color that has been painted over another accidentally, you will need a clean brush. For best results, use a hog bristle brush or one with stiff fibers. These are better suited to remove the color. When using this type of brush, remember that it may remove some of the background color as well.

1. While painting two juxtaposed colors, we have accidentally painted a bit of red over the area of green, thereby blurring the forms.

2. To correct the error, we use a clean hog bristle brush to remove the unwanted color.

3. A touch of green has been painted over the correction to improve the result.

CORRECTIONS ON WET PAINT

CORRECTING WITH A FINGER

An artist's hands are an extra tool for painting. Not only can they be used for applying paint, but for removing it or for making small corrections as well. An advantage to using your hands is that they are a quick and convenient resource; the drawback is that they will get dirty.

1. While drawing a line on the canvas, you have used too much pressure with the brush. As a result, the line is too thick at one point.

NOTE

When making corrections on wet oil paint, remember that some of the background color will always be removed if it is still wet. Therefore, you may have to repaint that part of the work. Regardless of whether you are correcting with brushes, fingers, rags, or palette knives, it is important to use clean utensils. Otherwise they may muddy the colors on the canvas and create undesired results.

2. To correct the thickness of the line, remove the excess color with a finger. While doing so, follow the brushmarks to maintain the correct form.

3. While removing the excess paint some of the wet background color has come off. Reapply the background color in this area to restore the area to its appearance before you made the mistake.

CORRECTIONS ON WET PAINT

CORRECTING WITH A RAG

A rag is an indispensable aid in oil painting. Not only can it be used to clean hands, clothes, brushes, and palettes, but used on the painting itself, to create textures, to work on the background, or to correct errors by removing paint with it.

A rag is better suited for correcting large areas than for small details (even though artists heavily rely on it because it's always at hand). In any case, it's always important to

1. The shape of this toy ball appears distorted where the orange paint was smeared.

have clean rags available, free of fresh paint, in order to avoid muddying other colors.

In the example illustrated, we will carefully make a correction with the tip of our rag in order to avoid removing more paint than necessary.

2. With a rag, the paint is removed while simultaneously correcting the ball's form.

3. Once the base color's tone is restored, you will have a perfect correction.

CORRECTIONS ON WET PAINT

CORRECTING WITH A PALETTE KNIFE

While painting you might notice an area that has turned out badly, which would be impossible to correct by painting over without muddying the wet colors or making the paint too thick. To correct such an error, large or small, that cannot be resolved by applying more color, remove the paint with a palette knife and begin painting again.

For small corrections, the size of the palette knife is important; the smaller the knife, the better it is for eliminating details or treating complex areas. When you need to remove large areas of color, a larger palette knife will allow you to work faster.

1. After finishing this image, we decided to remove one of the yellow forms.

2. The yellow paint is scraped off with a palette knife. This must be done carefully to avoid affecting areas that do not require correction. In this case, use a small palette knife since a large one will not be as precise.

NOTE

Bear in mind that a palette knife has a great capacity for removing paint. When you scrape the surface of your work, the palette knife will also remove the base color if it is not dry.

A palette knife will allow you to make corrections over large areas of the canvas. When this is called for and the space allows, you can complete the correction by removing the remaining bits of paint with a rag lightly dipped in turpentine. See *Background Color*, pages 64–65.

3. Gently repaint the area with the background color. Since small traces of yellow remain, be careful to avoid mixing the blue with it as it would become green, thus spoiling the uniform tone of the background.

4. After making the correction, the painting has turned out just as we wanted, as if the yellow form had never been there.

CORRECTIONS ON DRY PAINT

Some corrections are not done on wet paint; instead, an artist waits until the painting has dried before working on it again. There are various reasons for this. It could be that the artist did not notice a mistake until the paint had dried; or after completing the work, the artist may decide that one part came out poorly or that a section could be improved. Other reasons include an artist's desire to achieve different results or to create a desired special effect.

CORRECTIONS ON DRY PAINT

Depending on the subject matter or the style in which it's painted, you can decide to separate the image into two parts. You could leave one of them more diffused to suggest a lack of light, the presence of a curtain or distance separating some forms from others. In addition, you may decide that the colors you have used are too harsh or do not harmonize with the rest of the painting. If, therefore, you decide to correct these values, there are two ways to do it: either repaint this part with new values or correct the general tone of the area by adding one color to unify it.

In the latter case you must consider the characteristics of the color beforehand and how it might affect the whole work in relation to the colors it will rectify.

CHANGING THE AMBIENCE, CREATING EFFECTS

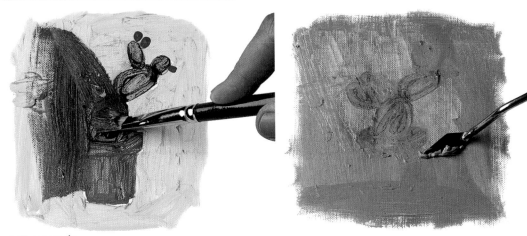

1. To correct the excessive intensity of this image, apply a neutral tone to the dry paint.

2. Remove the excess color with a palette knife.

3. The much darker result distorts the original color blends; it now suggests an area in shadow or perhaps, the presence of a curtain in front of the image.

NOTE

If the painting was done with impasto, the palette knife will continually collide with thick patches of paint. This would leave large patches of color in these parts.

4. Since we originally wanted to correct the tone, let's remove the paint left over from scraping with the palette knife by wiping it softly with a cloth.

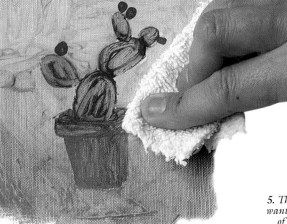

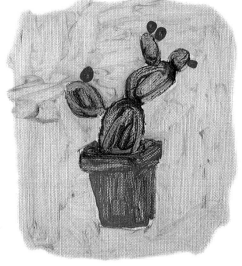

5. The result is just what we want—the general intensity of colors has been reduced achieving a medium tonality.

OIL TECHNIQUES

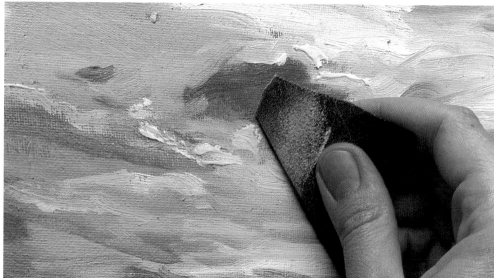

1. Sand down the raised areas created by the impasto.

2. Paint normally, applying the desired color.

The simplest way to carry out a correction on dry paint is to work directly on the dried canvas. However, if you have to correct a part painted with impasto, the thickness and relief of the dry paint could be problematic. To even out the surface of a painted canvas, simply smooth it carefully with sandpaper. Note that you will probably sand more areas than you wish since it's difficult to be precise when using sandpaper.

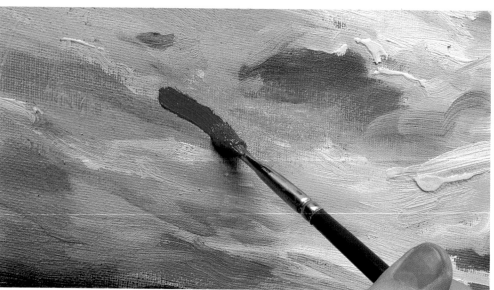

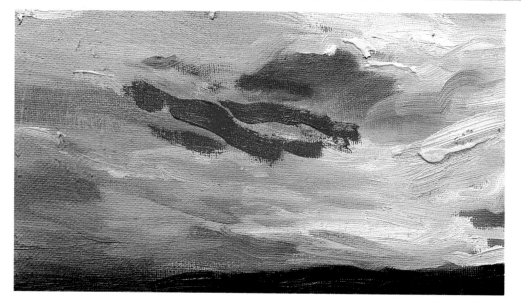

NOTE

To avoid damaging the canvas you should remember not to exert too much force when sanding the dry color. Also, avoid sanding areas that do not require correction.

3. Once the corrections are dry, they will be unnoticeable.

CONTOURS

Painting the contours of a form over a background or in juxtaposition to another form can be difficult when you are not entirely familiar with the technique. Since oil paint takes a long time to dry, painting one color next to another may wipe away or smudge the first color. In addition, you could muddy the tone of the second, especially if it is lighter in value. There are various ways of avoiding this, depending on the result you wish to obtain.

Although these methods will help, an artist should not forget that the best solution for working on contours is a steady hand and good control of the brush.

DIFFICULT CONTOURS

The border between one color and another can present problems in oil painting. For instance, when painting, you might inadvertently blend both colors or smudge a color with your brush, thus distorting the image's form. To avoid this and obtain a feeling of unity throughout the work, you could use a background color. Another possibility would be to compose the work with a brush sketch using a unifying color. This will help you avoid coming too close to the areas you have just painted and will enable you to paint quickly and confidently.

1. Dip your brush in turpentine.

2. On your palette, dilute a bit of color.

ON A BACKGROUND COLOR

3. Sketch the composition on the canvas with a brush.

4. Paint the forms freely since you do not have to connect one border with another. Bear in mind that if the background paint has not dried, you could lightly neutralize the colors with it.

5. In the final result you can see how the color used for the sketch, which served as a guide as you applied the other colors, remains. This color functions as a unifying element since it appears in various parts of the work.

MORE INFORMATION . . .

Diluting the paint you use for preliminary brush sketches is a common practice that is employed in the exercises in *Subjects for Oil*. In *Oil Painting Procedures*, pages 66–67, you will find more information on the advantages of this technique.

SHARPLY DEFINED CONTOURS

JUXTAPOSING TWO COLORS

Another method for maintaining the border between two colors involves painting very carefully to avoid muddying colors and distorting their forms. This method is very common and is used in all art techniques. With a brush, simply outline the contour of the painted form with the new color. Once you have painted the part closest to the form, you can paint freely without fear of spoiling it.

1. Since the background color is dark, we have painted the figures of the person and dog first to avoid dirtying the light colors. Next, we carefully outline the borders. We have used a flat brush, which works well with outlines.

2. At the end of the exercise, you can see how the light colors of the figures have remained intact; their form was not distorted while the background was being painted black. This is due to the extreme care with which we worked.

NOTE

When painting complex borders with this method, it's a good idea to apply light colors before the darker ones. Should the colors get slightly dirty while painting close to a form's contours, it will be easier to blend a touch of light color into a darker one rather than vice versa. You must not forget that a light color will get dirty more easily than a dark one and can lose its purity if you make mistakes.

PAINTING CONTOURS IN STAGES

JUXTAPOSING TWO COLORS

The best way to maintain absolute precision in the outline of an individual element is to superimpose one color over another taking care to prevent the second from muddying the first.

Furthermore, this method creates a sensation of perspective since closer objects are superimposed on those that are farther away.

The secret to keeping the superimposed colors from muddying the base colors is to apply them in impasto, depositing it gently over the background to avoid blending the two colors together.

1. First we have painted a color that suggests a flower, then a background. Once we have completed these steps, we continue working on the flower with more paint. We go over the background color, painting lightly around the edge of the flower in such a way that you do not see the white canvas or the imprecision of the first strokes of color.

2. The result is a greater feeling of dimension created by superimposing the flower over the background color and using thicker deposits of paint.

SHARPLY DEFINED CONTOURS

MASKING WITH LATEX AND AN OIL BASE

Oil is a substance that repels water and does not adhere to acrylic mediums such as latex. The majority of white glues, which are made of latex, can thus be used for masking. The advantage of this method is that you can create forms easily with a brush or finger. The drawback is that the latex must be applied in a thick layer that will not break when pulled off the canvas; therefore, it will be slow drying.

1. Dip your brush in linseed oil or another oil suitable for oil painting.

2. Cover the chosen area with oil. You should remember that if the canvas is very dry, you will have to apply a thick layer of oil so that the support will not absorb it all. If it is absorbed, the latex could permanently adhere to the canvas making it impossible to remove later on.

3. Put a bit of glue on your finger or on a brush.

4. Apply the glue to the support in a sufficiently thick enough layer that will not break when it is removed.

6. Remove the layer of latex. The area it once covered remains free of paint. Note how part of the canvas's surface was also removed with the latex. This happened because the canvas was too dry. It absorbed all of the oil allowing the latex to adhere to the support. Thus, when the latex was removed it damaged the surface of the canvas.

5. Once the glue has dried, you can paint over it easily.

OIL TECHNIQUES

MASKING WITH ADHESIVE TAPE

Masking is practical when you want to preserve a color, paint straight lines, or draw difficult contours.

In oil painting, you can mask areas of a work with many materials, including adhesive tape or latex. However, if you are working quickly you may also mask an area with acetate paper, cardboard, a piece of canvas, or whatever materials you have on hand.

Just bear in mind that the material you use must not dissolve when it comes into contact with oil, nor should it be absorbent enough for paint to penetrate it.

1. To mask with adhesive tape, simply attach it to a dry or semi-dry oil painted surface. (If it's wet, it will not stick.) Then paint over it freely.

2. Carefully remove the tape.

3. Note that the masked area has remained intact. Masking tape is ideal for painting straight lines or precise angles.

MASKING WITH GLUE OVER OIL PAINT

Masking with glue can be done on fresh oil paint since it contains enough oil to prevent the latex from permanently adhering to it. Applying the glue directly from the tube to the picture will allow you to make fine lines as well as draw the forms you want to protect. Moreover, this process lets you keep your brush and fingers clean.

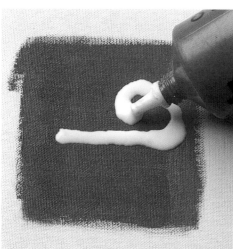

1. Apply the glue directly to the painting, making sure the plastic film is thick enough to remove later without breaking.

NOTE

Wherever the glue has been applied very thickly, it may not have dried thoroughly. Before lifting it, be sure that the part touching the color has dried.

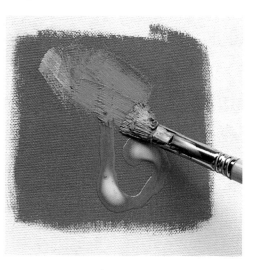

2. When the glue has dried, paint freely on top of it.

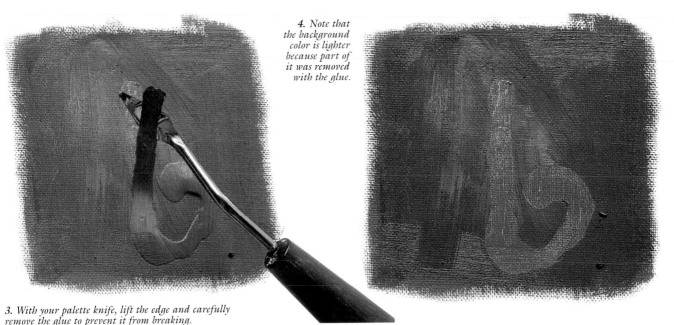

4. Note that the background color is lighter because part of it was removed with the glue.

3. With your palette knife, lift the edge and carefully remove the glue to prevent it from breaking.

INDISTINCT CONTOURS

Depending on the subject and the characteristics of the compositional objects, an artist may decide to incorporate forms with undefined boundaries. Clouds, for example, are often painted imprecisely; a misty countryside, a smoky room, and steamy windows are other examples. Often, objects seen in the distance are left undefined in order to keep the viewer's focus on the foreground. In all of these instances, the artist will want to paint forms with soft, undefined outlines.

Sfumato is a technique used for this purpose. It can be effected using a brush, cloth, sponge, fingers, and so forth. It entails gently diffusing an area of paint with a brush in such a way that the precise edges are blurred and a vaporous effect is created.

INDISTINCT CONTOURS

SFUMATO WITH A BRUSH

A brush is a versatile tool that can be loaded with color and applied vigorously. However, a brush can also be wielded with a light hand and hold just a hint of color, which is applied softly and extended, allowing the base color to show through the new paint and blend with it.

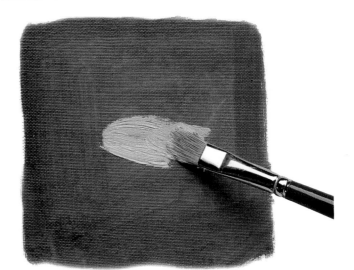

1. Apply color as usual, covering the background with a stroke of color that is smaller than the space you wish to cover.

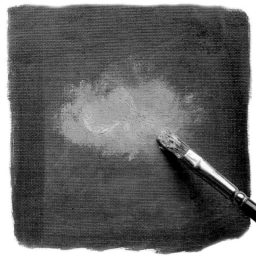

2. Without pressing down on the canvas, gently extend the color around the edges with circular brushstrokes. In this way, the contours become imprecise giving the color a soft and vaporous effect. The colors are lightly mixed in some areas while remaining pure in others.

NOTE

When using the *sfumato* technique, remember the desired dimensions of the diffused color and apply the paint in moderation. The area will become larger when you disperse the color.

OIL TECHNIQUES

INDISTINCT CONTOURS | *SFUMATO* WITH A RAG

Sfumato is a technique that can be achieved with various tools. A rag is useful for blending large areas of color and for creating effects that are slightly different from those obtained with a brush. Depending on the texture of the rag, it will leave some kind of print or another.

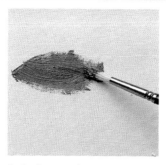

1. Apply some color over wet background paint.

2. Use circular motions with a rag, taking care not to press down on the canvas. If too much pressure is used, the color will be spread in a compact form and the desired effect will not be achieved. Note how the result is slightly different from the one obtained with a brush. In this case, our rag is an old towel that creates a network of tiny lines.

INDISTINCT CONTOURS | *SFUMATO* WITH A FINGER

As we have said before, an artist's hands can be an extra tool in oil painting. You can create *sfumato* effects with your fingers unlike those obtained with a brush or rag. Fingerprints add a special texture to a painting. Pressing down with their delicate surface allows you to spread thin layers of paint and to diffuse the color while extending it.

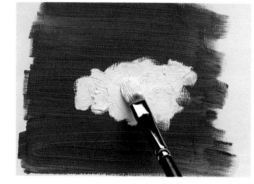

1. Apply color to the background. In this case the background is dry.

2. Press down on the paint with your fingers and spread the color. Because fingers can't carry the amount of paint that a brush can, you must rely on your sense of touch to determine when to return to the deposit of paint. This way you can avoid spreading the color too thinly.

3. We have created a vaporous effect in which the directional strokes of the fingerprint suggests the texture of a cloud.

4. Let's give more substance and color to the cloud. Add a pinkish tone directly with a finger, blending it with the white while making circular motions.

5. The pink color is slightly deeper than we wanted so again, we take white from the palette, and apply it directly with a finger.

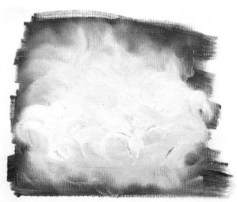

6. Note in the result that the body of the cloud has become more textured when more color was applied. It has become larger as the edges were diffused and softened.

SCRUBBING — WITH A BRUSH

Scrubbing, also known as *frottage* or dry brush, is a technique that allows you to make visual color blends, bring out textures, mix half-tones, and create atmosphere.

Scrubbing is a technique that is useful for composing a work or suggesting a form. In some ways it is similar to *sfumato* since it involves gently spreading paint over a color background. The difference, however, is that the *sfumato* technique can be used on both wet and dry surfaces, while scrubbing must be performed on a dry surface to attain the desired effect: fragmented colors.

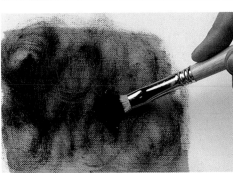

1. In order to scrub with a brush, load some color from your palette.

2. It's a good idea to wipe off any excess color before painting if you think you have taken too much.

3. Gently rub the brush over a dry background in circular motions so that the result resembles lace or an obscure nebula.

SCRUBBING — WITH A RAG

A rag is another item that may be used by oil painters for scrubbing in color. It is useful for covering large surfaces. If this is the goal, use a large rag. A rag is very useful for small areas, especially if it has a rough texture like a towel, which leaves a specific mark.

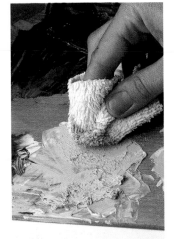

1. Load some color on a rag.

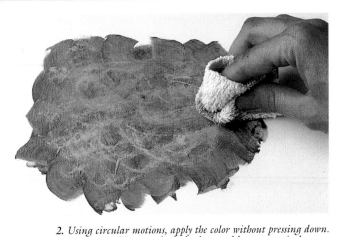

2. Using circular motions, apply the color without pressing down. Note how in this example the background has some raised areas; thus the paint accumulates on the elevated parts of the work.

DRY BRUSH — FAN BRUSH

One way to bring out linear textures such as grass or hair is to use a fan brush. If a fan brush is unavailable, take any flat brush and spread the bristles open by pinching them with two fingers until they stand out like a fan brush. The main drawback to this substitution is that the painter will get his fingers dirty; on the other hand, any brush can be used this way.

By using a brush with the bristles separated and spread out, it is easy to paint soft parallel lines that suggest textures such as grass or hair.

Load a brush with a little color; if you use too much paint you will leave a compact bristle mark. Pinch the brush between your thumb and index finger so that the bristles open out like a fan. Paint gently without pressing.

SGRAFFITO — SCRATCHING THE PAINT

The *sgraffito* technique is performed by scratching images in a layer of paint. This can be done using the handle of a brush, a fingernail, a toothpick, a palette knife, or any other instrument, depending on the result you want to create. The scratches can reveal the primed surface of the canvas itself or a background color that will show through the scratched layer.

1. We apply a layer of paint over a dry background.

2. The lines scratched out with the edge of a small palette knife reveal the underlying color.

3. The result is extremely interesting, ideal for creating textures.

4. We can go one step further and remove whole patches of paint allowing the background color to show through as an element of the composition.

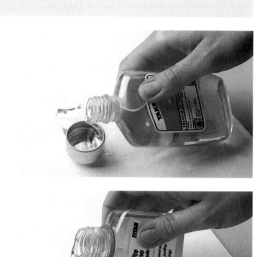

5. This image has been achieved with the sgraffito technique by both scratching and scraping, just two of a number of creative possibilities that the oil medium offers.

GLAZES — DILUTING PAINT

In oil painting, glazes are thin layers of paint that are applied in a transparent state. Unlike lacquers and other special colors, oil paint is opaque so in order to paint a transparent layer it is necessary to dilute it with a medium.

There are various mediums available on the market for diluting oil paint and painting glazes, although the most commonly used solvents are oil and turpentine. A good medium for making oil paint transparent is a mixture of turpentine and linseed oil in equal parts. The turpentine speeds up the drying time while the linseed oil preserves the brilliance of the color.

Oil paint can also be diluted by using only turpentine or only oil. In the first case, it is important not to forget that the base over which you are applying the color should not be oily, since paint diluted with turpentine becomes lean; in other words, remember to follow the "fat over lean" rule.

It is important to make sure the color over which you are painting a glaze has had time to dry thoroughly in order to prevent the two colors from mixing and causing a dull, clouded effect. Glazes are useful for correcting values, suggesting shadows, and painting transparent objects, such as glass.

1. Pour some turpentine into a palette cup.

2. Add an equal amount of linseed oil and you have a perfect medium for diluting oil paint.

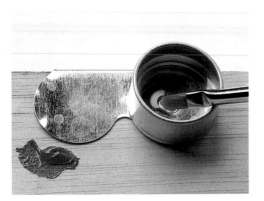

3. Load a touch of the medium on the brush.

4. Thin the paint on the palette.

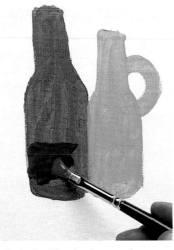

5. Apply the diluted paint over the dry paint.

NOTE

It is essential to remember that glazes can only be applied over a color that is completely dried, otherwise the two colors will blend and discolor.

6. After the red glaze is applied, both the red and green colors change in value, just as they would if viewed through red glass. Note the difference in consistency between the opaque colors and the area painted with a transparent glaze; the latter is much more suggestive and delicate.

SMOOTHING WITH PAPER

In this simple technique a page of newsprint or other type of absorbent paper is placed over the wet surface of the paint. The paper flattens the marks left by the brushstrokes and absorbs any excess paint, which is useful if you wish to continue painting on the wet surface without having to use impasto or worrying about muddying the subsequent colors. Furthermore, this technique can be used to make monoprints or to create softly diffused or distorted forms.

1. The picture contains the usual small raised marks left by brushstrokes wherever excess paint has been applied.

2. The paper is placed flat over the picture and is pressed down lightly with the hands.

3. The paper is then removed. Note how it has absorbed the excess paint and flattened the raised areas.

4. The technique allows an artist to create different effects. If the paper is moved slightly while on the surface of the painting it will produce an indistinct, blurred image, different than that created initially.

5. Note the perfect image left on the newspaper. Used with more suitable paper, this system is ideal for making monoprints; it is important to bear in mind, however, that oil paint gradually destroys the vegetable fibers of paper, so it is advisable to do prints on paper primed with oil.

PAINTING WITH

THE CAP OF A TUBE OF PAINT

Because artistic creativity knows no boundaries, a painter can make use of virtually any object at hand for achieving special effects or creating intriguing textures.

In addition to many household items, you can use the cap of a paint tube, which leaves an interesting mark that can suggest anything from the wheels of a tractor, to the complex pattern of a honeycomb, to a abstract design on a piece of fabric.

By pressing the cap into a layer of wet paint we can create this honeycomb effect.

PAINTING WITH

A FORK

The kitchen is the place where an innovative artist can find utensils with which to experiment and to create effects in an oil painting.

Some of these implements can be used to apply or lay paint directly on the canvas, while others, such as a fork, can be used to scratch lines in previously applied paint and as an aid in adding texture to the background color.

The mark of a fork's prongs can be used to create interesting designs and textures by dragging them across the surface of recently applied paint.

PAINTING WITH

A SPOON

A spoon leaves an entirely different, though no less interesting, mark from that of a fork. Pressed on the wet surface, it can be used to suggest, among many other things, a cobblestone path, ripples on water, or the texture of wickerwork.

In addition to countless other possibilities, a spoon can be used to lay down paint on the canvas or to create a texture over paint recently applied with a brush.

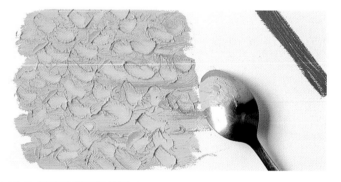

This texture was obtained by lightly pressing the spoon into recently applied paint.

PAINTING WITH

WAXED PAPER

Owing to its lack of absorbency, waxed paper is ideal for creating textures. After placing the sheet gently over a layer of wet paint and then lifting it, an uneven texture appears that is suggestive of, for instance, cement walls and tree trunks.

This procedure can be used over the entire painting or limited to smaller areas. To add small areas of texture the waxed paper should be cut to the size and shape of the section to be worked on.

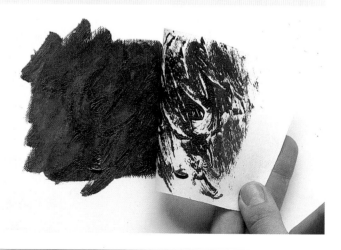

By gently laying a sheet of waxed paper over the paint and then removing it, you can produce an interesting textured surface.

PAINTING WITH

OIL STICKS AND TUBES

Oil sticks are suitable for drawing freehand and for complementing a picture painted with a brush. A tube of oil paint can be used for creating effects since its mouth leaves a spherical mark and the amount of paint applied can be controlled by varying the pressure you use to squeeze it. Furthermore, it can be used to paint in much the same way as an oil stick.

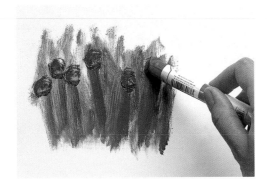

Oil sticks are suitable for use on a picture painted with a brush. They are generally used for painting details, lines, and touches of color.

The mouth of the tube leaves small round points of paint, ideal for suggesting flowers in grass.

PAINTING WITH

A SPONGE

The texture of a sponge is uneven and useful for painting soft, diffused forms like the foam of a wave's crest or the foliage of a bush.

1. Paint is loaded on the sponge from the palette.

2. It is then applied to the support, altering the surface's texture.

PAINTING WITH

A RUBBER-TIPPED BRUSH

This is one of the newest implements to come on the market. This type of "brush" has a piece of rubber in place of the usual bristles, a fact that makes it extremely easy to clean, and allows the artist to paint while applying pressure on the support. The rubber tip comes in several shapes, some of which are ideal for drawing lines.

1. Some paint is loaded on the "brush."

2. The paint is then applied to the canvas.

3. The rubber tip allows the artist to paint thick and thin lines and turn the picture into a drawing. (See Brushes, pages 16–21.)

PAINTING WITH

A PENCIL

An ordinary pencil can also be used as an implement in oil painting since it is excellent for *sgraffito* work. Always keep in mind the fact that the lead tip will leave a trace of color.

Colored pencils and charcoal can be used for painting and scratching, too. In such cases it is important to remember that since they add color, the background color will not show through.

A lead pencil, which removes paint and leaves the gray color of the lead can be used to suggest rain over a cabin.

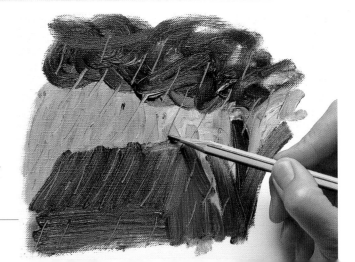

PAINTING WITH YOUR FINGERS

An artist's fingers can be used to apply thin layers of paint and fingerprints to build forms. You can paint an entire picture with your fingers or use them only for details. Whatever the case, fingers come in very handy in painting, but it is important to remember that oil paint stains and is generally toxic, so you should wash your hands carefully at the end of each session.

Fingerprints can be used to create images or fingers can apply paint in thin layers. In this example the background has also been painted with the fingers. You can appreciate the different textures developed on the colored background and the subsequent applications of paint: the first, applied by flattening the paint over the support, creates a smooth texture while retaining the lines produced by the direction of the finger; the second layer, obtained by jabbing the fingertip into recently applied paint, produces raised areas.

PAINTING WITH A SYRINGE

A plastic syringe can be used to apply the paint in thin, long streams that create relief. The syringe is also useful for drawing. This can be done by simply filling it with color straight from the tube and then pressing down on the plunger.

NOTE

Don't apply impasto with the syringe since the paint will take a long time to dry.

A syringe filled with paint can be used to apply color in the same way you would decorate a cake with icing.

PAINTING WITH THE HANDLE OF A BRUSH

One way to create new textures is to paint with the tip of the handle to obtain fragmented color and relief. Simply load some color on the handle and apply it on the canvas in order to create uneven track marks. Alternatively, a cotton swab, an old pencil, the handle of a knife, or any other implement can be used to leave similar marks and tracks.

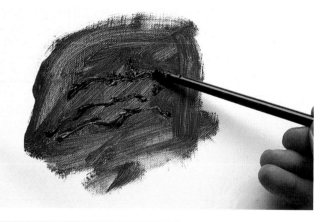

By painting with the handle of a brush, we can obtain a fragmented and uneven track, ideal for painting the branches of a tree or the foam on a wave.

PAINTING WITH A SLIDE FRAME

Another way of obtaining a kind of *sgraffito* effect is to use a piece of plastic or hard cardboard to lift out the paint. In this case we are using an empty slide frame to scrape out thick strokes and scratch out fine lines.

We lift out a layer of paint, in which there is an interplay of colors, creating thick strokes in some places and finer ones in others.

ADDING TEXTURE — WITH GROUND MARBLE

Interesting textures can be produced by adding particles of foreign matter to oil paint. Only non-organic materials can be added to paint in order to obtain these effects, since any other type will eventually rot the canvas and give off an unpleasant smell.

Ground marble is one of the most commonly used materials to mix into paint because, in addition to being light in weight, it is effective for creating texture and volume.

1. Some color is taken from the palette.

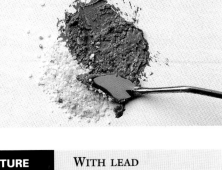

2. The ground marble is then mixed in.

3. Note how the volume and texture of the paint increase. We can use this method to paint a beach or a forest trail.

ADDING TEXTURE — WITH METAL FRAGMENTS

Because they do not deteriorate, bits of metal are a suitable material to be used in an oil painting.

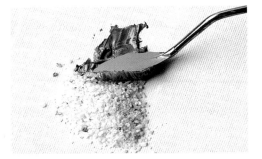

Metal fragments produce a less noticeable texture than that produced by ground marble, but it is equally interesting.

NOTE

Textural materials made of metal weigh a lot, therefore they should not be added in large quantities.

ADDING TEXTURE — WITH LEAD

Little lead balls weigh a lot, so it is advisable not to add too many to the paint, otherwise they may eventually fall off the canvas. Applied in small amounts, they produce a uniform texture.

Lead balls can be used to suggest, for instance, the pattern of a tablecloth or a string of pearls.

ADDING TEXTURE — WITH WASHED SAND

Washed sand can be used to create a texture similar to that produced by ground marble.

The sand can be fine or as coarse as the type shown in this example.

Washed sand mixed in oil paint produces a rugged texture that can be used to suggest anything from earth to the bark of a tree.

ADDING TEXTURE — WITH MOLDING PASTE

This is a type of paste that gives the paint more body and increases its volume without altering the color. It allows an artist to apply thick layers of paint and to add volume and mass to the surface of the support.

Molding paste for oil adds body to the paint and increases its volume without changing the color, thus reducing the cost of the painting. This paste is suitable for painting with impasto.

Skies

Skies have been an important feature throughout most of the history of oil painting, since they create the atmosphere of the picture and determine the lighting. The versatility of oil paints enables the artist to suggest with great expressive force anything from a soft mist in which the objects have blurred outlines to cumulus clouds with clearly defined volume, from a clear midday sky to one at dusk bathed in warm tones.

THE COLOR OF THE SKY

When speaking of the color of the sky, one usually thinks of blue, but in fact it is often very different, since the color of the sky depends on the color of the light. Atmospheric phenomena and the movement of the sun cause natural light to change continually, transforming the heavens into a giant display of ephemeral forms and colors.

At the beginning and end of the day, the sky is generally bathed in warm tones by the sun—pinks, oranges, yellows, and reds. During the day, a clear sky shows a gradation of blues that turn to grays as they approach the horizon; and at night the sky appears as a dark space with blues and blacks when there is no influence from electric lighting. If there is artificial light, and the sky is overcast, the mass of clouds takes on warm tones from the artificial light.

When speaking of the color of the sky, we must also take into account the color of the clouds. These may be pure white, tinged with rosy tones, or a dark mass of grays.

NOTE

It is important to take note of the light and the shape of the clouds when painting a sky from nature, since these may change considerably during the painting session.

THE SKY AND THE EARTH

Although in many landscapes and seascapes the sky is the protagonist, we must not forget its influence on the colors of the earth.

An oil painter must never forget that sky and earth are closely linked, and that in a painting the colors of the one affect the colors of the other, and vice versa. The sea, for instance, also has a changing color that is conditioned by the color of the sky. The clouds are bodies that continually cast a shadow on the earth and can change a landscape into an area scattered with patches of light and shade.

For this reason it is advisable to determine the tonal values of the earth before you begin painting the sky, since the color of the land or shining patches of water can produce a contrast that may be used to reinforce the expressive capacity of the sky.

TECHNIQUES

In oil painting we cannot speak of a single technique for every type of sky because its changing nature means that we must use different resources in each case; but it is true that any sky requires a preliminary study based on close observation and sketches, since when one is painting from nature, it is important to determine the light before it changes.

A clear sky can be rapidly resolved with a gradation of color, whereas cloudy skies must be treated with patches of color that convey the anatomy of the clouds. When painting clouds, it is advisable to make an initial assessment of their values in order to determine their shapes and the light and dark parts. As the painting progresses, continue working the intermediate values and leave the highlighted parts for the very last.

CLEAR SKIES

Clear skies are undoubtedly the simplest to resolve since the absence of clouds does away with the need for volumes, tones, and shadows. But, nonetheless, a clear sky requires a certain amount of work and a mastery of the techniques of oil painting for, as a general rule, they oblige the artist to gradate colors.

At dawn and dusk the blues are tinged with yellow, pink, and orange; whereas, at any other time of the day, the intense blue of the sky lessens as it nears the horizon. It is therefore unwise to paint a sky with a single uniform tone because the result would appear unreal and unnatural.

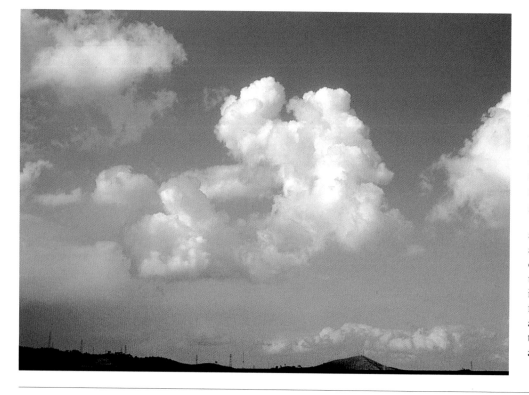

CLEAR SKIES DAWN

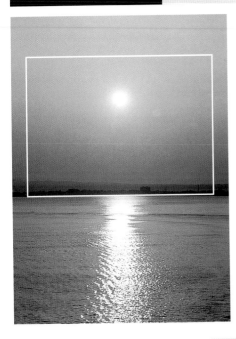

1. The upper part of the canvas has been painted with a mixture of chromium oxide green, white, and a touch of orange. For the lower part we use the same mixture in inverse proportions so that the orange dominates the green.

We are going to paint this sky at dawn. The early morning mist creates a special atmosphere by diffusing the sun's rays so that they are scarcely visible.

Clear skies are usually easy to paint, because the absence of clouds also means the absence of volumes and shadows in the sky. In order to paint the clear sky in this exercise, we have recycled an old canvas painted with an ochre very similar to the general tones of the sky, which will complement the gradations of the background color.

MORE INFORMATION . . .

For more information about the technique of gradation in oil painting see pages 50–55.

2. The area between the two colors has been painted with a mixture of both to achieve a gradation so that the three blend smoothly. In the gradation process, the brushstrokes have been applied smoothly, so that the texture of the brushstrokes do not detract from the visual sensation of the dawn sky.

4. To complete the exercise, all we need to do is touch up the area around the sun with a mixture of the two background colors in order to suggest the light radiating from it.

3. The sun is gently painted white with a fine, soft brush, and care is taken not to drag or pull up the underlying color.

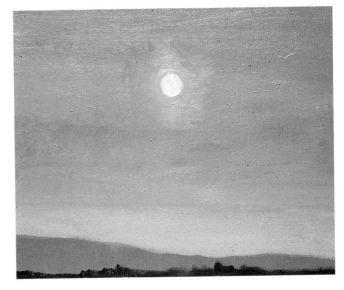

CLOUDY SKIES

Along with light, clouds help determine the atmosphere of a painting.

Clouds often produce changes of light, for as they pass in front of the sun, they generate shadows and alter the effect of the sun's rays.

A cloudy sky can be very lively if it is formed of small, white, fast-moving clouds, or it can be threatening, as when, on a stormy day, heavy, black clouds are charged with electricity.

The color of the clouds is as changing as that of the sky. In some cases they appear shining white with an almost blinding light, whereas at other times they are a dark mass with no contrasts; at dusk they are bathed in warm tones and at night they can become almost black or invisible in the dark.

When painting clouds, two important factors must not be forgotten: one is that their shape continually changes, and it is therefore advisable to take notes beforehand so as not to lose the original image; and the other is that, in addition to the shadows that some clouds project on to each other and that all project on to the earth, the shadows or shading of the clouds themselves should not be overlooked. It is this shading that enables their volumes to be distinguished and allows them to be presented as a three-dimensional, changing, gaseous mass rather than as a white or gray curtain covering the sky. The color of the shadow is not always the same, for it depends on the color of the light they reflect. On a sunny day, the shading of the clouds will have gray and blue hues; at dusk they will probably be orange and violet.

Oils are very appropriate for resolving cloudy skies as they enable us to suggest mistlike, shapeless clouds by means of rubbing or smudging, and to work their forms with patches of color or to accentuate volumes by using impasto in the brightest points.

CLOUDY SKIES　　**WHITE CLOUDS**

We are going to paint part of these white clouds that appear threateningly behind the mountain. From a tonal point of view, the image is interesting because of the contrasts and the play of whites between the snow and the clouds.

1. The complicated shapes of the clouds require a preliminary charcoal sketch on the neutral gray background to establish the light and shade and the outline of the mountain. Using white slightly tinted with ultramarine blue light, we indicate the highlights on the clouds.

2. The sky is painted with ultramarine blue light mixed with cerulean blue, in order to enhance the color and produce the contrast that will add luminosity to the lightest parts.

White clouds generally present considerable contrasts of value, since the areas where the sun strikes directly have points of maximum intensity and in their shadows there are some fairly dark tones.

NOTE

The exercises on these pages deal solely with the main subject of this chapter—skies. The rest of the picture has only been suggested in broad outline and should not be considered as finished.

4. Finally, additional touches of white have been added to reinforce the previous ones, as well as a touch of ochre to give a certain warmth to the clouds. Note that the white of the snow has not been painted since it is suggested perfectly by the background tone.

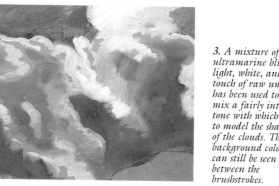

3. A mixture of ultramarine blue light, white, and a touch of raw umber has been used to mix a fairly intense tone with which to model the shape of the clouds. The background color can still be seen between the brushstrokes.

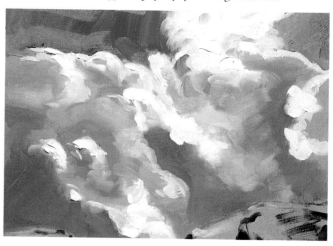

CLOUDY SKIES

CLOUDS AND MIST

A sky like the one in this exercise, with small wisps of cloud floating in the mist, needs to be treated with the technique known as *sfumato,* in which the edges of the forms are blended or smudged.

In the final result of this exercise we can see the influence of the sunlight on the water on the sky. For more information about this technique, see *Tricks of the Trade,* pages 82–101.

2. Using a violet made by mixing ultramarine light and alizarin crimson, the clouds are simply suggested, ensuring that they merge into the background.

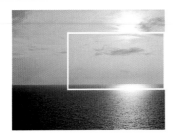

This sky, which has a few soft clouds and a hazy light due to the general mist, requires us to paint the clouds' volume over a background that suggests the mist.

3. A few touches of white have been added in certain areas and the colors are blended into each other with the fingers. This avoids dragging the brush, and the change from one color to the other is ethereal and undefined.

1. On a neutral green background color that has been left to dry, the upper and lower areas have been painted with a mixture of chromium oxide green, white, and a touch of orange. The rest of the area has been covered with the same color, but with more orange in the mixture, the brushstrokes dragged and deliberate so that the tones blend smoothly and give a feeling of atmosphere.

4. On completing the painting we can clearly see the results of the sfumato technique by which the colors were blended smoothly into each other, suggesting the lightness of the clouds and their undefined edges.

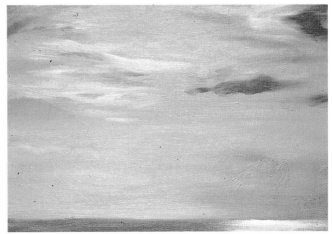

CLOUDY SKIES

CLOUDS IN A STORM

Storm clouds, with their complex forms, and the effect of rain seem a complicated subject since the usually dense, heavy, and gray bluish overtones often have a threatening appearance.

MORE INFORMATION . . .

For more information about the technique of *sgraffito* and the use of a fan brush, see *Tricks of the Trade,* pages 82–88.

3. After completing the background, we begin to suggest the rain by flattening the brush out like a fan and dragging it down the picture.

1. The background has been painted a bluish gray heavily diluted with turpentine; a bright white would not be suitable for this subject. The outline of the mountains has been suggested.

4. The effect of torrential rain is reinforced by sgraffito, using the point of the palette knife so that the color of the background—a transparent bluish gray that is appropriate for water—shows through.

2. After painting the darkest part of the cumulus cloud with a mixture of ultramarine and black, we suggest the lighter areas with a smoky gray, obtained by mixing raw umber with black and white.

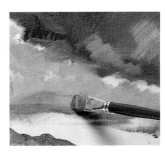

5. After finishing the exercise, we can clearly see the sgraffito lines made with a firm, steady hand; a hesitant gesture would have produced a different, probably unnatural effect.

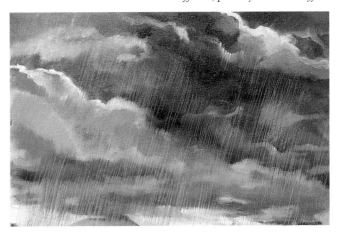

SUBJECTS FOR OILS

CLOUDY SKIES EVENING CLOUDS

We are going to paint this evening sky in which a few clouds are still white and others are impregnated with the glowing light of the setting sun.

1. We are using a recycled canvas with a neutral green background, the color of which contributes to the finished work. After blocking in the white clouds, the earth is painted in a dark color.

2. The sky blue used earlier has been mixed with ochre, white, and yellow; the tones blend together as we paint. Mauve has been used to paint the upper part of the canvas.

When the sun sets, the sky is filled with warm tones—reds, yellows, oranges—and the clouds are also affected by the presence of color reflected on their forms.

NOTE

For many painters it is important to cover the background rapidly or to use a colored background in order to prevent the white of the canvas from impairing the tonal values of the picture. At other times, the color of the background is used to complete the work. For more information on this subject, see *Background Color,* pages 64–65.

4. The finish consists of an application of impasto with a fine brush, which gives volume at the brightest points, using pure whites, oranges, and yellows in certain areas and blended with white in others. The upper part has been slightly darkened by adding a bit of black to the mauve. The color of the background shows through at certain points.

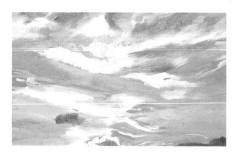

3. Once the patches of color have been blocked out, they are touched up with the tones used earlier, giving greater definition to the form of the clouds.

CLOUDY SKIES FIERY SKIES

We are going to copy a detail of a painting by J. M. Turner, The Fighting Temaraire *(1834), in which the sun, which is just about to disappear over the horizon, inflames the sky with intense fiery tones.*

1. On an ochre background we situate the first clouds with a mixture of ochre, yellow, and white. Orange is then added to the mixture and we continue painting the sky with deliberate brushstrokes.

2. We continue to work with the same tones, adding vermilion to the mixture and applying it alone in certain parts. Mauve, made by mixing ultramarine light, alizarin crimson, and white has been used on the horizon.

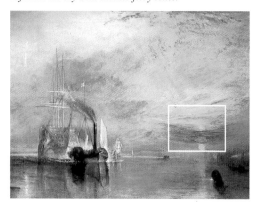

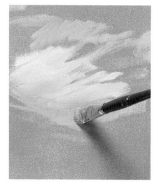

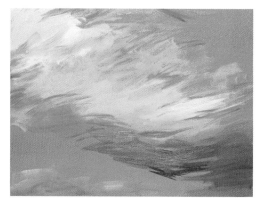

The appearance of evening skies can vary enormously; in some cases the light from the sun combined with light clouds produces the effect of a fire in the sky, resulting in a spectacle that is impressive but ephemeral.

3. For the ball of the sun we use a mixture of yellow and white, applied with a small, soft brush so as not to drag the background color. Juxtaposed with violet tones, this color will produce considerable brightness because of the contrast.

4. Looking at the completed copy, we see that a few touches of alizarin crimson have been added to the sun, as well as to a few areas throughout the clouds. This exercise shows how important brushwork is to the expressive quality of a painting.

CLOUDY SKIES

CLOUDS AT NIGHT

It is difficult to capture a cloudy sky during the night, because the clouds conceal the light of the moon and their shapes are hidden in the darkness. However, it is sometimes possible to capture the effects of moonlight between cumulus clouds, which add a dramatic touch to the image.

2. The above tones have been worked by dragging the paint across the canvas to affect a misty atmosphere. With the mixture of ultramarine light and alizarin crimson we can produce a violet that will serve to suggest the bluish light.

We will reproduce a section of the sky painted by J. M. Turner in The Fields of Waterloo *(1818), in which the white moonlight filters through the clouds to create a dramatic contrast with the darkness.*

1. Over a neutral background with reddish elements, we apply the first dark strokes of a mixture of alizarin crimson and burnt umber. For the patches of light, we alternate white mixed with ochre and yellow, orange and vermilion.

NOTE

The exercises based on details of works by known artists in no way aim to achieve the same result as the original; they only serve to show the method the artist used to produce the detail in question.

4. In the finished reproduction note how the details have been retouched with existing tones, without making any basic changes to the painting. Note also how in this sky the placement of patches of color at the outset has been fundamental to the final result.

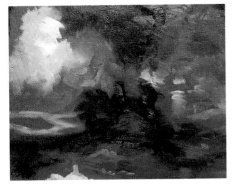

3. Using the dragging technique, white with a hint of the violet used above has been applied to suggest the presence of the source of light behind the clouds. The effect produced by the contrast of warm and cool tones can be appreciated.

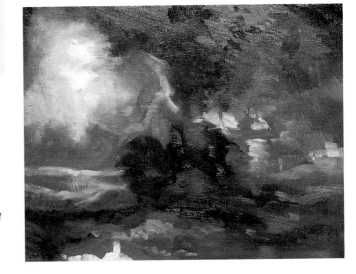

Water

Because water is a liquid and highly sensitive to changes of light and movement, it is an infinitely varied and extremely complex subject to paint. The same mass of water may range from an intense, transparent blue on a sunny morning to a heavy, dark, leaden mass on a rainy afternoon. In addition, water can produce foam, reflect objects like a mirror, distort shapes to the extent of turning them into moving patches, or reflect light in a range of shining surfaces and points of maximum intensity.

THE COLOR OF WATER

Although as a rule large areas of seawater are a deep blue, it is a fallacy to think that water is this color. The color of water depends entirely on the color of the sky, on pollutants and their density, on the accumulation of algae, and on the color of the seabed. All these factors cause considerable changes in color, and changes in the color of light can alter the appearance of a mass of water from one moment to the next. Furthermore, because of the influence of light and the color of the sky, a large body of water such as a lake can appear as a monochrome surface or as if it were composed of patches of different colors with an infinity of hues.

TECHNIQUE

Water is a transparent substance which, in its natural state, generally shows some kind of movement and therefore usually transmits a feeling of freshness and spontaneity that an artist must learn to capture. To do so, we should avoid overworking a painting and should try to produce a first attempt that transmits the spontaneity of movement with firm, definite brushstrokes. As with other subjects, it is advisable to leave the highlights until the end to avoid muddying the light colors. Do not forget that water has many shimmering surfaces and strong contrasts; therefore it should be painted by starting with large areas of color to establish mass and volume before progressing to the details.

STILL WATER

Still water can appear either to have a slightly irregular surface consisting of small, slow-moving waves that cause undefined, fragmented reflections, or the smooth, burnished appearance of a mirror reflecting the objects around it with extraordinary clarity. In either case, the surface of the water does not have a uniform color, but is altered by reflections and the light striking it. Generally speaking, painting still water also means painting reflections, and it is important to study these carefully before starting.

STILL WATER

When water is absolutely still it can reflect the color of the sky perfectly and the objects overlooking it with extreme clarity. Painting a reflection of this type can be complicated, since we must suggest the idea of a reflected image and avoid making it look like a double of the original. We must not forget, then, that however clear it may be, the image in the water is nothing more than a reflection and must be painted with less definition than the object that produced it.

WATER AS A MIRROR

We are going to paint a section of this scene, featuring a lake high up in the snow-capped mountains; the absolute stillness has turned the surface of the water into a giant mirror.

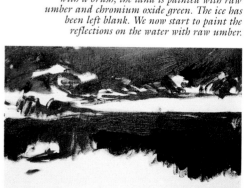

1. After sketching the composition on the canvas with a brush, the land is painted with raw umber and chromium oxide green. The ice has been left blank. We now start to paint the reflections on the water with raw umber.

2. Note the deliberate brushstrokes in the dark reflections, where forms near the water are suggested with horizontal strokes and more distant ones with vertical strokes. The sky is painted with burnt umber mixed with a little ultramarine blue light and white. More white is added to the mixture for the brightest areas.

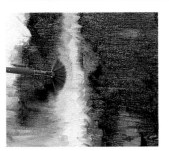

3. Once the various patches of color have been painted, all that remains are the details. To suggest the texture of the vegetation on the mountain, we have used a clean bristle brush to extend some of the color toward the sky.

4. Looking at the completed exercise, you can see how we have continued working on the reflection of the mountain with a dry brush and have given a few additional touches to the sky using white mixed with a little yellow. The ice on the water has been painted with pure white in order to enhance the contrast.

STILL WATER

BLURRED REFLECTIONS

Although the surface of the water appears smooth and flat, very often the reflections of the objects around it are not sharply defined but appear as patches of color similar to the reflected objects.

We will copy a section of Turner's Peace: Burial at Sea *(1842), in which the reflections on the water are soft and indistinct.*

1. We have used a background painted with a neutral green which we will allow to show through between the brushstrokes. The first strokes of color—burnt umber—suggest the reflection of the ship. Semi-diluted white and ochre are used to paint the reflection of the light.

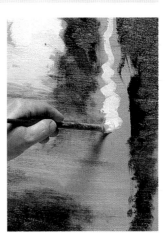

2. The forms are defined and the lighter values are corrected. In the bright center of the reflection we have used white mixed with yellow.

3. Using a dry fan brush, the paint is combed in order to blend the colors smoothly.

4. The finished painting shows how the toned background functions as a compositional element. From the start, the paint has been carried downward in horizontal strokes to suggest the irregular surface of the water and the blurred effect of the reflections.

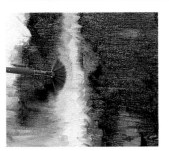

MOVING WATER A BREAKING WAVE

The movement of the sea can produce considerable contrasts of light and spectacular images as waves break against rocks and burst into spray. The magic of this type of image is fleeting, since waves swell and break very quickly. It is therefore important to paint quick sketches of the form of the waves breaking and memorize the first visual impressions, since it is practically impossible for two waves to break in the same way.

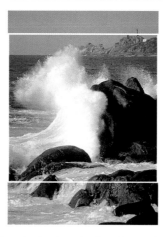

A wave breaking against the rocks is a highly attractive subject for a seascape. Nonetheless, capturing its ephemeral beauty and the spontaneity of the moment pose two challenges for the artist.

1. On a white canvas we have sketched in forms with a brush using semi-diluted ultramarine blue light. With very diluted cerulean blue, we then paint the areas corresponding to the water with deliberate strokes to suggest the rising direction of the wave.

3. The shaded areas have been developed to give them form and volume. The direction of the brushstrokes suggests the impact of the water on the rocks; ultramarine blue light with a touch of chromium oxide green is applied to the surface of the water to make it denser.

2. After painting the land, rocks, and sky in order to assess the intensity of the tones, the volume of the rocks is suggested by painting with a purplish gray made from burnt umber, cerulean blue, and alizarin crimson mixed with white.

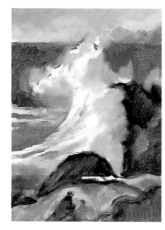

4. Examining the completed painting, we see that the changes since the previous step have consisted in defining the areas of lightest value by applying pure white impasto. This white impasto has also been used to suggest the spray.

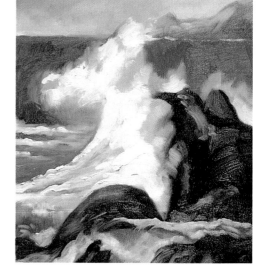

MOVING WATER OCEAN WAVES

The motion of waves on the sea produces large masses of water, which have the appearance of small moving hills that rise and fall constantly, and which are covered with foam in some parts and darkened in other parts.

1. A sketch has been painted with very diluted burnt umber to indicate the forms in space and the direction of the water.

Here we will copy a section of Turner's Dutch Boats in the Gale *(1801).*

2. Using the same color we block in the shape of the waves, diluting the burnt umber—more for light values, but less for dark values. The areas of foam are left unpainted for the moment. At this stage the picture is still composed of patches of color.

3. By adding white to the raw umber we can produce a gray with which to paint the light areas, taking care not to let the brush run over the crests of the waves where the highlights are. In order to create subtle variations of tone we have applied orange over the burnt umber in certain areas.

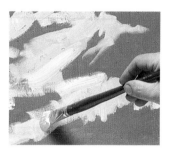

4. Looking at the finished painting, we can see that the highlights corresponding to the foam have been painted with pure white, mixed in certain places with a touch of orange.

NOTE

This exercise has been executed almost as a monochrome, using only burnt umber, white, and a little orange. Even so, the surface of the water reveals surprising tones and the monochrome coloring expresses as much as contrasting colors.

MOVING WATER

SMALL WAVES

The surface of the sea can seem to be covered with small restless waves in continuous movement, which are tipped with foam as they near the shore. In such a scene, the water resembles a swarm of bees, each little wave appearing and disappearing in a frenzy of activity, breaking against each other and moving in all directions.

In View of the Sea at Saintes-Maries, *Vincent van Gogh used impasto to capture the frenetic surface of the waves that are dragged toward the shore by the underwater current.*

1. A recycled canvas has been toned with a greenish gray background, on which yellow mixed with white is applied in individual strokes to create an optical effect.

NOTE

Vincent van Gogh used to paint on a toned background. Although this is often recommended for achieving the desired result without using too much impasto, here we have used a neutral green background in order to demonstrate the artist's technique.

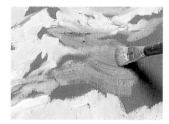

2. We continue working in warm tones, adding ochre and orange during the first stage, then adding cool tones in varying proportions to a mixture of ultramarine blue light and alizarin crimson.

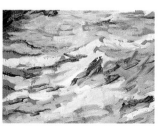

3. We have finished constructing the form with small strokes of raw umber for the dark areas, leaving the thick impasto and the highlights for last.

4. Examining the completed painting, we can see that the highlights have been painted on the previously painted background in an impasto mixture of yellow, white, pure ochre, and a little orange. With impasto, the paint must be applied gently in order to avoid lifting the background color and spoiling the overall effect.

MOVING WATER

GENTLE WAVES ON THE SHORE

Small waves on the beach always produce foam, which contrasts with the color of the water. It also contrasts with the color of the sand on the shore and the sand visible beneath the shallow water.

MORE INFORMATION . . .

Further information on the effects of toned or white backgrounds and the recycling of canvases can be found on pages 64, 65.

We are going to paint the water's edge, where the shallow water produces both large and small foamy waves and the color of the water changes from blue to the brown of the sand.

1. A recycled canvas has been covered with a dark ochre tone, ideal for an underpainting showing through the paint to suggest the various shades of the sand. For the initial strokes of color we use cobalt blue, chromium oxide green, and white in varying proportions.

2. Using the same tones, we continue refining the strokes of color that suggest the surface of the water, blending the colors at the edges and adding ochre to the mixture for the area nearest the foreground, where the water takes on the color of the sand. Note that here the brushstrokes are applied horizontally in order to suggest the water withdrawing from the shore.

4. After completing the exercise, we can see how the foam was suggested and how the wet sand and traces of foam on it have been touched up by applying mauve and light violet to portray the reflection of the sunlight.

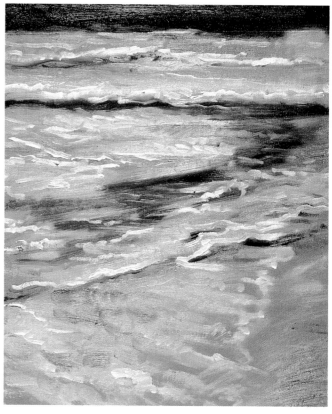

3. All that remains is to paint the highlights in white, applying the paint with light strokes to avoid muddying the colors beneath.

MOVING WATER A SMALL WATERFALL

Water falling in a torrent or cascade appears white because of the foam produced by so much movement. This often contrasts with the placid surface of the lake or pool into which it falls.

We are going to paint this small waterfall in a mountain stream above a rock pool where the violent movement of the falling water is absorbed by the mass of water in the pool.

2. In the rocky area we use diluted paint to block in the correct value of the water. Then we paint the foam on the waterfall with pure white, applying the paint somewhat thickly to suggest the volume of water.

1. We have blocked in the masses on the canvas with a brush and thinned paint. The blue water has been painted with chromium oxide green and white, with the addition of ultramarine blue light in some areas. The brushstrokes are applied in such a way that they suggest the whorls produced by the movement of the water.

4. We can see from the finished exercise that the highlights on the water were achieved by small strokes of ultramarine blue light mixed with a little white, quickly and lightly applied in order to capture the freshness and spontaneity of the subject matter.

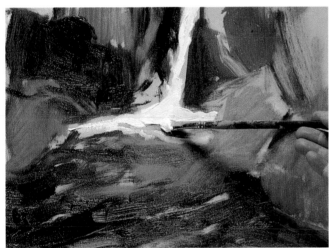

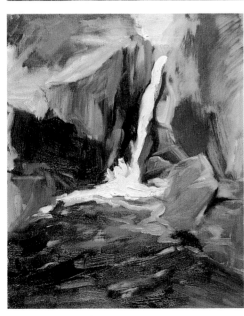

3. Note that where the waterfall reaches the pool, the white foam has been extended to blend with the greenish blue.

Vegetation

Vegetation as subject matter presents a vast range of possibilities for oil painting. Aside from landscapes and seascapes in which vegetation features prominently, plants can serve as important elements even if they are not the focus of a painting. Because it grows all around us, in rich color and diversity, an oil painter will sooner or later find it necessary to paint vegetation, whether in its natural habitat or as it appears in a domestic interior.

VARIETY

The representation of vegetation in art is so complex that no matter how often it is painted, there is always something more to learn.

When the time comes to paint in oil, the artist must bear in mind that, aside from the infinity of forms, sizes, textures, and colors that vegetation presents, an individual plant, sensitive to the climatic changes, undergoes surprising seasonal changes. Depending on the time of year, the foliage of any one species of tree can appear dappled with flowers, flowerless, filled with the ochre and yellow tones of fall, or even be completely bare, stripped by the cold winds of winter.

An artist will find that even if he or she has mastered painting the classic structure of a plant or shrub type, no two are identical. A single species may appear singly in a flowerpot, grouped together in a landscape, or mixed together with other species, adding complexity to their form and color.

And so, as we have seen with other subjects, in order to paint vegetation in oils, it is essential to observe and study, drawing and sketching forms, colors, and values.

TECHNIQUE

Oil painting is so versatile a medium that it can be difficult to decide on the best approach to painting vegetation.

Because oil paint can be applied either as an opaque or transparent layer, depending on the use of thick impastos or fine films of color, every artist develops his or her own style.

In spite of this, there are certain standard techniques to master when the time comes to paint vegetation.

Keep in mind that leaves and petals are supported by a well-defined structure; otherwise the painting will not be accurate or believable. Thus, a study of the harmony between a tree trunk and the branches of a leafless tree can be of great help when painting the same tree with its foliage intact.

To transmit the freshness and naturalness of vegetation, it is important to simplify forms and shapes and avoid details. A detailed work that lacks a consideration of the overall harmony of vegetation will make a painting seem unreal, wooden, and disjointed. It is also important to remember that, even though a meadow may appear completely green at first glance, a detailed study of it will reveal a surprising range of shades and hues, which cannot be represented by color applied directly from the tube but which must be mixed, combining a variety of colors and values. If not, the result is likely to be a monotonous, poorly painted work. A good method for avoiding this is to paint over background colors.

The treatment of light and shadow can also be quite com-

THE COLOR OF VEGETATION

When we speak of the color of vegetation, it is inevitable to think, first and foremost, of the entire range of greens. And yet, although green is indisputably the main player in any plant scheme, don't make the mistake of thinking that it is the only one.

Leaving flowers aside for the moment, with their endless combinations of colors, many other colors are found in vegetation than is at first recognized with a quick glance. Foliage presents so many contrasts and half-tones that the same green can be shaded into warm or cool tones. In this way, some parts of the foliage can be tinted toward violet and others toward a bright yellow.

Additionally, the influence of the summer and fall seasons on the plant cycles produces an infinite range of ochres, reds, earth tones, and yellows. During the spring, greens are brighter and filled with reds, whites, yellows, blues, and the whole color spectrum that flowers present. In winter, a snow-filled landscape is mainly white.

plicated, since in any bunch of leaves there are areas of luminous light as well as deep shadows, which create dramatic contrasts of value. It is these contrasts that a painter normally uses as a means of developing his work, beginning with the dark values and generally leaving the highlights for the end.

One of the properties of oil paint is that it can be molded and sculpted by a brush. This characteristic is yet another technique that can be used to suggest the texture of a tree trunk, the direction of branches, or the shape of leaves. An artist can play with different thicknesses of oil paint, buiding up layers of impasto in the foreground to create a sensation of volume.

TREES

Trees are composed of a trunk and branches, along with the foliage that adorns them. The apparently simple supporting structure of a tree can be complicated to paint when the subject is an oak or fig tree in winter, or when this structure practically disappears under the foliage, as in the case of a cypress or thuja tree.

Although trees all belong to one definite group in the plant world, a painter will find that their forms vary so widely that it is necessary to observe and study each one in order to paint a representation in oil that appears realistic.

In addition to the structural differences of tree trunks and branches, the diversity in the tree foliage is also surprising. From a palm tree, with leaves formed by a group of fronds that shoot out in all directions, to a spruce with foliage growing from the base of the trunk to the top, tree forms are infinitely variable. Foliage also presents important contrasts, caused by the interplay of light and shadow that leaves produce. Often times, the artist must paint what is behind a tree, to imply vacant spaces in the foliage.

TREES

FIR TREE

Even though firs are associated with mountainous regions, they are also found in almost any city park and in many private gardens. Their long branches extend out parallel to the ground, and the overall shape of the tree forms a rough cone.

This long-branched fir presents an interesting contrast between the areas of light and shadow.

1. The fir tree's form has been sketched with a brush, establishing the dark and light areas with diluted raw umber. Over the sketch, we have started to paint the lighter areas with a medium green tinted with a touch of ochre, using the brushstrokes to suggest the direction and the foliage of the branches.

2. The dark areas are covered with burnt umber, continuing the technique of merely suggesting forms with brushstrokes.

3. Once the proportions of the tree have been determined, all that remains is to work on the trunk, using ochre lightened with white, and on the shadows of the ground, using a semi-diluted mixture of raw umber and emerald green. With this same mixture, only thicker, the small parts of the branches are darkened, using a fine brush. The driest areas are suggested with a touch of orange.

4. Once the exercise is completed, you can appreciate how we continued working on the needles, giving the last touches of light with a mix of yellow, white, and ochre. The brushstrokes are soft, ensuring that the colors beneath are not lifted.

TREES

OAK TREE

A leafless oak tree presents a complicated framework of bare branches. In this case, the exercise is performed by painting in stages.

This oak is interesting due to the absence of foliage. It allows us to see the direction, structure, and complicated network of the branches.

1. This exercise will be painted in successive layers, beginning with the basic structure of the tree: the trunk and the main branches. On a semi-dry background, we have applied ochre; in certain areas, some of the color of the background is dragged into play to produce those dark lines that delineate the branches.

4. Looking at the completed tree, you can see that areas of light were suggested by using a mix of ochre, yellow, and white. The paint was applied lightly but decisively with a fine, ox-hair brush. Note also the touches of orange.

2. We finish the construction of the tree's form by applying a touch of alizarin crimson in some areas.

3. We have already applied the colors that will help us define the form of the tree. With alizarin crimson mixed with ochre and raw umber we fill in the dark areas of the branches.

NOTE

To paint this picture, we used a drying agent to accelerate the drying time of the background. If you are not in a rush, it is recommended that you avoid using drying agents, which can cause the paint to crack. Let the background dry for a day. (See *Painting over Dry Paint: Painting in Stages,* pages 70, 71.)

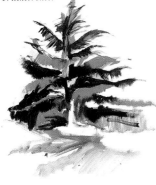

TREES — PALM TREE

We are going to paint this date palm, the erect trunk of which appears as a vertical line, crowned at the top by its foliage.

A palm tree is a tree without branches and with a slender trunk. Its foliage doesn't grow in a compact mass of leaves. Rather, its fronds open up in all directions. Although its form and structure are unique, the fundamental method for painting a palm tree does not differ much from that of other trees.

1. The background is a mixture of alizarin crimson and well-diluted ultramarine blue. It has been painted to cover the whiteness of the canvas, which would be troublesome and likely to throw us off the color scheme when the time came to judge the tones for the palm itself.

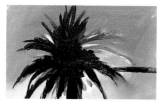

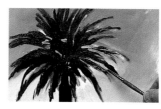

2. With a mixture of emerald green and burnt umber, the form of the palm is created.

3. After applying a dark green, the violet lines of the background sketch remain visible. The chromatic scheme of the foliage is enriched by including these distinct shades. Light values are added with a small, synthetic-fiber brush, which is softer than a hog bristle brush. A mixture of ochre and white is used.

4. You can see from the completed work that the foliage was retouched and that the trunk was finished with the addition of a light colored mixture of ochre and white that, by dragging part of the dark color from the trunk, turned into brown. To suggest the surface roughness, the trunk is intentionally painted with an unsteady hand, using burnt umber mixed with a hint of black.

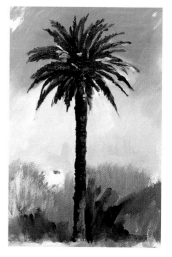

TREES — PINE TREE

We have taken as a model this Mediterranean pine. Because it is not part of a pine forest, it is outlined against the sky and allows us to see its structure quite clearly.

The trunk of a pine tree separates into several branches that support the green foliage. The needles are not perceived individually, but are seen as a mass of color.

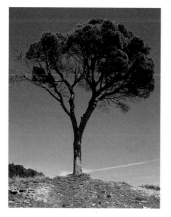

1. The sketch of the pine has been painted with a mixture of alizarin crimson and emerald green. Around it, the sky and ground have been blocked in to avoid the difficulty of establishing accurate values against the white canvas.

2. The entire tree, the foliage and the dark part of the trunk, have been worked over with a dark green, the result of mixing alizarin crimson and emerald green, with a predominance of the latter. Note how the brushstrokes suggest the mass of foliage. Afterwards, a fine brush is used to paint the lines of the thin branches.

3. For the touches of highlighted foliage, a mixture of medium green, ochre, and white is used, depositing the paint softly so as not to lift the background color and thereby spoil the freshness of the light green.

4. In the finished exercise you can observe the last touches of light we placed on both the trunk and the foliage using a mixture of ochre and white.

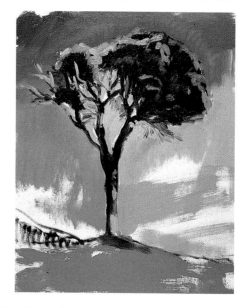

TREES — HOLM OAK TREE

This holm oak has three trunks that seem to emerge from the ground, giving the appearance of a group of trees.

This holm oak has an interesting structure; its foliage is supported not by one trunk, but by three. Even so, they lend the whole a sense of unity.

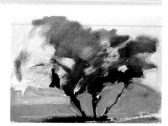

1. The holm oak is painted by using a frottage technique. This procedure consists of scrubbing the canvas to create a vaporous, undefined effect at the edges of the brushstrokes. We have used a mixture composed primarily of emerald green with alizarin crimson. The background is filled in last.

NOTE

In this exercise the background has been painted with the intention of allowing the mix of cerulean blue and white sky to contribute to the scrubbed green of the foliage. (See *Tricks of the Trade,* pages 82–101.)

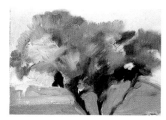

2. Olive green is made from a mixture of vermilion, cerulean blue, and ochre, and used to paint the foliage, again using the frottage method.

3. Ultramarine blue is added to the residue of emerald green and alizarin that is still on the palette, and the areas of shadow are painted with the mixture. To it we add vermilion, and, with the side of an almond-shaped brush, we traced the lines to suggest branches.

4. To finish this exercise, go over the darker areas with black; other areas will benefit from the addition of a little vermilion to the mixture.

TREES — THUJA TREE

The dense mass of its foliage conceals the trunk and branches of the thuja tree.

Painting a thuja tree in oil basically means working primarily on the foliage, since the thuja is a tree whose trunk and supporting branches are virtually invisible. These branches jut out in all directions.

1. We begin by blocking in the tree's form and establishing the darkest values with a mixture of emerald green and alizarin crimson. For the thick foliage, sap green is used, adding ochre to the previous mixture. With the brushstrokes we indicate the direction of the branches.

2. We finish constructing the form of the thuja tree, and paint the background. If we don't paint the background, the white canvas will make it difficult to assess the color intensity.

3. When the paint is semi-dry, alizarin crimson is applied at the base of the tree, allowing it to mix with the darker underlying layers. For the upper part of the tree, we have added emerald green to alizarin crimson, and, using brushstrokes that follow the direction of the branches, we have highlighted the dark areas.

4. In the finished exercise, note how the lightest areas have been touched up with a mixture of medium green, ochre, white, and yellow.

TREES

A TREE IN BLOSSOM

In the spring, a mimosa appears completely yellow from all the flowers produced by the tree. In cases such as this, the use of green is exchanged for the brighter predominant color of the flowers.

We are going to paint this flowering mimosa, which is covered by brilliant yellow flowers.

1. The initial sketch is made with a neutral green, the result of mixing emerald green with burnt umber. The form of the tree is placed on the canvas and areas of light and shadow are established. The sky is then painted, followed by filling in the flowered area of the mimosa with medium yellow.

NOTE

For the highlighted areas, a yellow mixed with white is applied. This last layer is more opaque and proportionately thicker.

4. To create volume, a thick impasto is called for. We have applied the touches of color using a synthetic brush and a mixture of ochre and yellow in the areas of half-light, and yellow and white to the highlighted areas.

3. Because the white areas in the background diminished the intensity of the brilliant flowers, they were covered with a brown made from a mixture of cobalt blue and alizarin crimson. The same brown is used to add some touches of shadow between the flowers. The intensity of the flowers is now greater than in the previous stage.

2. The suggestion of flowers is finished by allowing the medium yellow to blend at its edges with the previously applied colors, producing medium greens.

MEADOWS AND FIELDS

Meadows and fields are important, and appear in many landscapes. Although the initial idea that one may have of them is that of a flat, green plane, the truth is otherwise. Cultivated fields present an ordered geometric pattern, the ground divided into spaces of color. Wild meadows and prairies, on the other hand, are usually irregular and often include rocks with grass and weeds, as well as shrubs and trees. Even though meadows often appear as an expanse of color, it is important to suggest in them a sense of the different types of grass to confer realism.

MEADOWS AND FIELDS

A MEADOW IN SPRING

We are going to reproduce a fragment of a meadow that Claude Monet painted in 1873 in his impressionist work, The Poppy Field at Argenteuil.

Meadows in the spring are covered with a bright green that contrasts with the touches of color provided by the new flowers.

1. The background is very important in this composition, since the final painting depends on this initial underpainting. We work on a dry background of neutral green, applying the main shades: emerald green toned with white, a mauve made with a mixture of ultramarine blue and alizarin crimson and toned down with white, and a celestial blue, which is a blend of ultramarine blue and white.

2. We continue covering the canvas with the colors that make up the background, all of them neutral tones. Alternating warm and cool hues defines the areas of color, adding additional contrast.

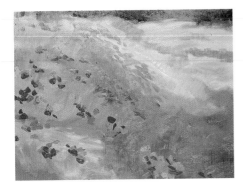

3. The poppies are painted on the finished background with small touches of color, produced by a mixture in varying proportions of orange, vermilion, and white.

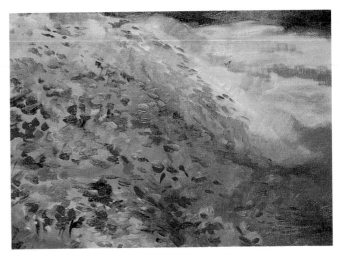

NOTE

When applying the colors that make up the base on which the poppies will be painted, a frottage technique was used. This results in areas of transparent color that allow the neutral green underpainting to remain visible. If a white canvas had been used, the artist would have been obliged to apply much more paint, and the result would be quite different.

4. In the finished exercise, you can see that we continued working on the poppies, and added some grass with light brushstrokes of differing shades of pure emerald green, mixed with ochre and medium green.

MEADOWS AND FIELDS | **A MOUNTAIN MEADOW**

This attractive meadow at the summit of a mountain range presents an interesting exercise, since it provides a combination of rocks and short grass.

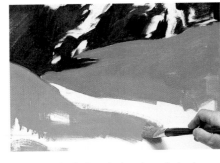

1. We begin by painting the rocks in the background, blocking in the dark areas with cobalt blue shaded with a touch of raw umber. The area of the meadow is treated with a medium green mixed with ochre, and the area of the foreground with pure ochre.

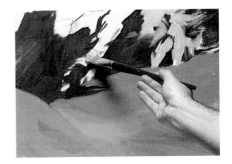

2. We apply some touches of medium green to the meadow to suggest the contours of the ground. The light areas of the rocks are covered with a neutral white mixed with ochre and a touch of raw umber.

Meadows in the high altitudes of a mountain are usually composed of short grass that spreads out over the ground like a green blanket sprinkled with rocks.

NOTE

In this exercise, the base color of the meadow has been painted with paint diluted in turpentine, covering the white canvas rapidly so as not to allow the white to distract us.

4. We complete this exercise by highlighting the small areas of light and shadow that are found on the meadow as well as on the rocks. This is accomplished by applying the same dark colors that were used to highlight the mountain summit. Notice that the brush strokes used to create the short grass are the same as those used to indicate the uphill slope of the mountain.

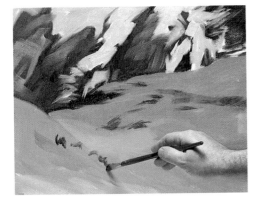

3. We paint half-tones on the rocks with some touches of mauve, and suggest the small stones of the meadow and their shadows with raw umber.

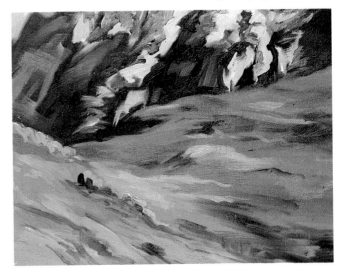

MEADOWS AND FIELDS CULTIVATED FIELDS

Land worked by farmers forms beautiful geometric shapes that often present distinct contrasts and value differences within the color groupings of earth tones and greens.

1. A perspective has been chosen in which the furrow lines form a Z. We have drawn the lines on the canvas with a fine brush, and have filled in the principal areas with a medium green mixed with a hint of burnt umber and white.

2. We continue to cover the canvas, suggesting the earth with a brown produced from a mixture of red, ochre, and a touch of medium green, creating medium values by blending colors on the canvas where they overlap.

3. We add the yellows, always toning with medium green and white, covering the canvas completely. We begin to work on the areas in relief and the shadows with a mixture, in varying proportions, of emerald green and raw umber.

4. From the previous stages we continue to work on details by adding new shades to the canvas through mixtures: cerulean blue to accentuate cool tones and vermilion to emphasize warm tones. You can see that we have lightly shaded the colors of the most distant areas with a bluish tinge to create a sense of perspective.

GRASS

Grass is an integral part of many landscapes painted out of doors with oils. For this reason, a painter should avoid merely suggesting grass by painting a flat green expanse. Grass must be given close attention, since its texture and treatment in oil painting can add to a sensation of three-dimensionality and to the realism to the work.

GRASS LAWNS

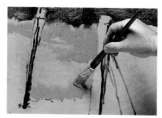

2. The grass is blocked in by painting from the bottom up, with brushstrokes suggesting its form, creating in this way a sense of texture. Later, with a small, soft-hair brush, we blur the colors together slightly, always following in the direction of the grass.

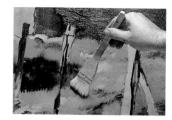

We are going to paint this part of a lawn next to a fence, paying special attention to texture.

1. A recycled canvas serves as an excellent background for this exercise. Over it, we have painted the darkest areas of the lawn, the house, and the fence, with raw umber.

4. To complete the exercise, we paint the fence in a color that will enhance the contrast between the light and dark values and sharpen the illusion of depth.

3. To further convey the texture of the lawn, we scratch some lines with the handle of a brush, creating small clusters of lines, and allowing the background color to show through.

Lawns, as well as short weeds, may be represented with an expanse of color, but if the grass is in the foreground, the varied texture of individual blades should be suggested in some detail, in order to enrich the work and create a sense of depth.

GRASS | CULTIVATED FIELDS

An unharvested wheat field is covered with stalks of grain, giving it a well-defined texture.

NOTE

More information about the technique that we use in this exercise can be found in *Painting Over Wet Paint: Painting* alla Prima, pages 68, 69.

2. We use a mixture of vermilion, yellow, and white for the oranges, and another mixture of cerulean blue, white, and ochre for the blues. Note that you should always apply your brushstrokes so that they suggest the form and direction of the wheat.

Wheat fields appear covered with stalks of yellowish and reddish tones. We are going to copy a fragment of A Wheatfield *by Vincent van Gogh, in which the wheat field is painted impressionistically.*

3. We continue covering the canvas with small, impressionistic brushstrokes, always playing with the contrast of cool and warm colors.

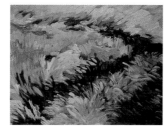

1. For this exercise, we are going to use the impressionist alla prima technique. Van Gogh painted over background colors, and so we will apply a background colored with the paint residue from the palette and then allow it to dry. The areas of dark value are blocked in, using burnt umber and a touch of vermilion. We have also begun to paint in the highlights.

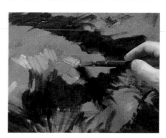

4. The lightest values of the ripe wheat, which appear in the finished exercise, were added last. The wheat stalks were painted with yellow in some parts with touches of a lighter value of yellow and white for highlighted areas.

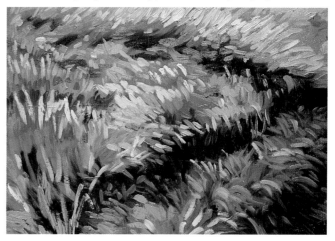

GRASS | TALL GRASS

Meadows appear uniform and unvaried when seen from a distance. However, a close look at these tall meadow grasses shows great variety of shapes, colors, and shadows. This network of lines might at first seem difficult to render, but when painting in oil it is not as complicated as it seems.

We are going to paint the tall prairie grass in the foreground, where the shapes of the leaves are clearly defined.

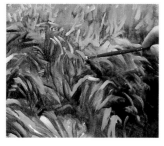

2. Over the dry background, which is painted with alizarin crimson and emerald green in varying proportions, we begin to paint the linear grasses with medium green, toned with ochre and some white.

3. This is the time to accentuate the areas of maximum intensity with ochre and yellow, using light brushstrokes to avoid lifting the background color.

1. We have sketched the image on the white canvas using diluted paint to cover the entire area. At this stage we delineate the shapes, the direction of the grass, and the areas of light and shadow. Keep in mind that the colors used later will allow this underlying layer to remain visible in certain areas, so it is important to be precise in choosing the proper colors from the outset.

4. In the final result you can see the importance of the initial sketch, without which the result would have been a disorganized, meaningless painting.

FLOWERS

The purity and infinite variety of colors that flowers display make this subject matter extremely attractive to paint in oils. Flowers may exhibit an extraordinary complexity of form in their petals, or a surprising simplicity, as in the case with daisies.

Unlike most other plants, flowers can be painted outdoors from nature or inside a studio, where an artist can arrange them in a still life. In the studio, you may find it difficult to arrange a bouquet of flowers to your liking, or even to place one flower in a way that is interesting. You will have the same problem if you are going to paint any still life in oil, for you have to organize the components first, looking for an arrangement of objects that will result in an interesting composition with the greatest artistic potential.

FLOWERS	DAISIES

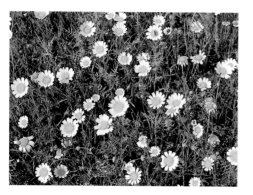

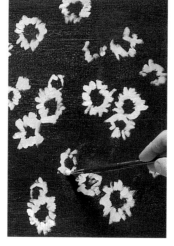

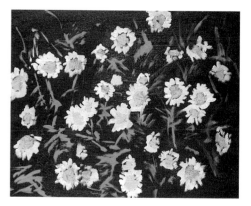

These small daisies are growing among grass and weeds, in their natural environment, so there is no possibility of arranging them to the artist's personal taste. They must be depicted as they are found.

An artist painting flowers found among the weeds and grass in a natural setting does not have the option of arranging them to his or her liking. The composition must be adapted to the setting that is presented. These flowers are usually accents of color interspersed with the green expanse of a field, but if the flowers are in the foreground, they must be painted with thoroughness and care, with more attention to the details.

1. Since the daisies appear as highlights against a dark background, we will use a recycled canvas, covering the old painting with what remains on our palette. On this dry background color we begin painting the flowers in the space with white toned with ochre and a touch of emerald green. For this task we have used a small filbert brush appropriate for painting the contours and outlines of the small petals.

2. The buttons of the daisies have been painted with a mixture of orange toned with medium yellow, and for the framework of stems we have added a hint of ochre to medium green.

NOTE

It is far more convenient to use a color background for a subject such as flowers since, on a white background, an artist would be obliged to continually paint over the unpainted patches of white, and use much more paint, thereby running the risk of muddying the colors.

3. The background is resolved by painting the darkest areas with a mixture of emerald green and alizarin crimson. For the splashes of light we have used orange, light green, and white, applying all of these colors with a small, fine brush.

4. The finished exercise shows how the work has gained considerable depth. This is due to the use of impasto, which gives a sense of form and volume to the flowers. The background has hardly been touched. Pure white has been applied to the daisy petals. Some of the buttons have been given light touches of orange, and others of medium yellow.

FLOWERS

AN IRIS

Complex flowers like the iris can be very attractive when painted in oil, although this requires a preliminary sketch on the canvas to define its complicated form.

The petals of an iris take unusual shapes that require an initial sketch before beginning to paint. The yellow center contrasts sharply and beautifully with the purple.

1. The initial sketch is made with a pencil, since the shape of the iris is complicated and it is essential to define it properly before starting to paint.

2. The dark values of the petals have been painted with a mixture containing less white than that used in the lighter areas. The iris centers have been painted with a medium yellow.

3. Once the flowers are completed, the stalks are painted using a medium green mixed with ochre for the lighter parts, and an emerald green mixed with raw umber for the darker parts.

4. The finished exercise demonstrates that, although the previous stage of the work was quite advanced, we still needed to work on details and adjust the values, to give the work more realism. Nonetheless, it is essential to know when to stop.

NOTE

The mauve used in this exercise is a color produced from a difficult mixture of cobalt blue, alizarin crimson, and white. The mixture should be made on a clean palette, with a clean brush, and diluted with clean thinner. Otherwise, you may mix a mauve that lacks intensity or becomes muddy.

FLOWERS

A BOUQUET OF FLOWERS

We are going to paint this arrangement, which presents considerable diversity of color and shapes due to its composition of six different types of flowers.

1. The complexity of the overall arrangement, as well as that of individual flowers, requires an initial sketch. The dark areas and the stems are painted with emerald green, which has medium green and ochre added for the lighter parts. The background has been painted a neutral gray.

2. The shapes of the flowers are blocked in with strokes of color: vermilion for the rose, vermilion and white for the daisies, and varying hues and values of yellow for the rest of the flowers.

3. With the range of colors used before, we continue painting the flowers working on one color group at a time, adding details with lighter or darker values as needed.

An oil painting of a bouquet of flowers can be complicated, especially if it is made up of various types of flowers that present complicated forms and a difficult interplay of colors.

4. In the finished product we see that the lighter and darker areas of the stems have been defined in more detail. In the darker areas we used emerald green mixed with raw umber. As a final touch the color of the background was reinforced, creating a predominantly violet to red atmosphere that increases the effect of its contrast with the yellows.

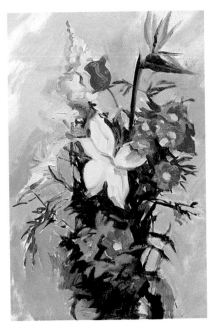

Flesh Tones

One of the most popular subjects for oil painters throughout history has been the human body, with its individual characteristics and flesh tones. With this challenging subject, an artist is faced with the task of transmitting those fundamental visual sensations that describe a person. The versatility of oil paint makes it the preferred medium for many artists when painting the body. Its permanence of color, its malleability, the option of painting in thin layers or with thick impasto, and the ability to make corrections during and after painting, make an otherwise difficult theme a suitable subject for painting.

THE CHARACTER OF SKIN

Color, texture, delicacy, and other characteristics of skin contribute to the visual elements that distinguish one person from another and that confer personality to the figure.

Because of this, it is essential to consider each type of skin as unique, and when painting, to portray accurately what the eye perceives. If the rough face of a day laborer is painted like the skin of a baby, the work will lose validity, changing the model into someone else.

THE QUALITY OF SKIN

Among humans the variations in skin quality and its shadings are virtually endless. Though there are obvious differences in skin color between the races, there also exist among individuals of the same race important differences of color and texture. Even the skin of one person may differ radically, depending on whether it is the skin of the hands or face tanned by the sun, or the sensitive skin found on parts of the torso.

Aside from complexion, the same body presents a limitless range of tones and shadings. One must be aware of the way the skin stretches and moves, and study the gestures of the model, which can produce wrinkles and unexpected folds that confer new qualities to skin.

THE IMPORTANCE OF THE FIGURE

In this chapter we will basically concern ourselves with skin, but it is important not to forget the significance of the model's bone structure and musculature,

MORE INFORMATION . . .

If you study the exercises in this chapter carefully, you will observe how, when painting skin, background color is extremely important. The background is often used as a medium value to construct shapes. For more information, see *Background Color*, pages 64, 65.

NOTE

Painting flesh tones is one of the most difficult challenges to master. Even if only a portrait is attempted, treating the texture of the skin and its shadings requires the artist to consider all the elements that differentiate one individual from another. Because of this, we suggest that you be patient while you familiarize yourself with this subject matter and not despair. Only practice will allow you to master the technique.

since this is what determines the size and shape of an individual figure. Therefore, it is important to study the figure before putting brush to canvas, taking note of the posture, and attempting to understand the function behind it. Even if you manage to accurately and skillfully depict the texture of skin, if it covers an anatomically incorrect human frame, the final result will be unrealistic.

FLESH TONES

DELICATE SKIN

Delicate skin has certain nuances of softness and smoothness that the artist must transfer to the canvas. Delicate skin, like that of babies, or of those parts of the body that are normally protected from the sun and the elements, offers contrasts with other areas of the body, such as knees and elbows, where the skin is rougher.

We are going to reproduce a detail from The Venus In the Mirror *(1650), painted by Velázquez, which depicts delicate skin of the model. During the seventeenth century, upper-class women protected their skin from the sun and dedicated themselves to continuous skin care.*

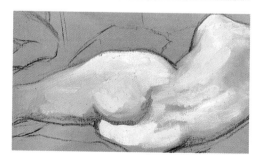

1. On a neutral brown background suitable for intermediate values, we have drawn a pencil sketch and have begun to paint the flesh with mixtures of white, ochre, vermilion, and raw umber in varying proportions to obtain light and dark shadings.

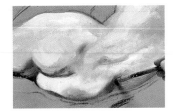

2. We have applied the paint in thin layers, using a brush to scrub the canvas in order to effect intermediate values with the background color.

NOTE

The interplay of light and shadow is a technique artists use to suggest the rounded form of a figure. One mustn't forget the importance of the direction and quality of the brushstroke when molding and shaping the texture of the skin.

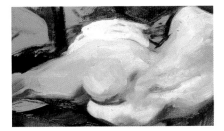

3. The background has been shaded in to offer the proper contrast and give a sense of value to what has already been painted. Note the tonal changes of the skin. The body has taken on strength and feeling from the colors around it.

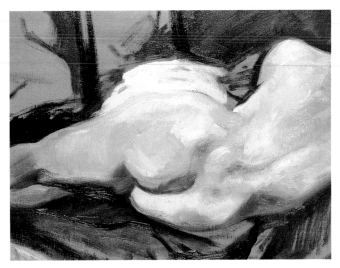

4. We finished by adding touches of light to produce the soft reflections of light on the skin with a mixture of white toned with ochre; we brushed on the color smoothly, fusing the tones together to create subtle color transitions.

FLESH TONES SKIN WITH BODY HAIR

Not all skin is soft and smooth. Some skin has defects such as moles and scars, and some parts of the skin are abundantly covered with body hair. The latter is particularly true of male bodies and, although it may be suggested by lightly darkening the skin tone, if the body is in the foreground the hair must be painted with more definition.

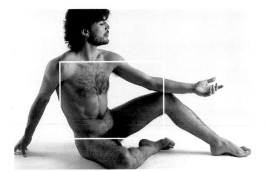

We are going to paint the torso of this model whose abundant hair is clearly evident.

1. On a background color related to the subject's skin tones, we have made a pencil sketch and subsequently painted over it, establishing the dark values and beginning to suggest the texture of the skin and hair. We used a mixture of burnt umber and orange, diluted liberally with turpentine.

4. The finished exercise demonstrates, in addition to the chest hair, the added details of the stomach, the navel, and the armpit. To assure that the work doesn't appear flat and more like an illustration than an oil painting, we have painted the details without applying too much pressure on the brush, thus maintaining the freshness of the brushstrokes.

2. After coloring in the background with medium values, we have worked on the figure with ochre mixed with white for the lighter areas, adding a dash of alizarin crimson to paint the abdomen.

3. Using the same mixtures, we continued working and detailing the torso, applying the paint in thin layers and allowing the underlying colors to show through. With a small brush of synthetic hair we painted the chest hair with fine lines of burnt umber.

FLESH TONES　WET SKIN

Skin, when wet, changes from a soft and velvety appearance to a smooth and shiny. The change is even more dramatic when wet skin is seen under a bright light like the sun.

When painting wet skin, keep in mind that moisture intensifies the skin color, producing significant contrasts of light from reflections, and that water confers a special luminosity that must be conveyed.

We are going to reproduce a detail from Joaquin Sorolla's, The Horse Bath *(1909), in which a boy is portrayed under the midday sun with strong reflections of light on his wet skin. Due to the importance of the Mediterranean light in Sorolla's work, the background is reproduced to complement the treatment of the skin with its brilliant reflections and the influence of the surrounding colors.*

1. The figures are situated in the space with a brush sketch using a thinned mixture of ultramarine blue and burnt umber, establishing at the outset the shadows and their intensity.

NOTE

The background color plays an essential part at the moment of constructing a picture, since it is fundamental for integrating the figure into the area of light where it is situated.

2. We worked on the colors and the light of the background that directly affect the figure of the boy, and then we painted the skin in the shaded areas with a mixture of orange, a hint of alizarin crimson, and some touches of burnt umber.

4. To finish the work, we retouched the shapes and tones over the previous underpainting, and, as a final touch, added some touches of white to indicate the reflections of water on the skin.

3. We painted the bright areas of reflected light on the boy's skin with orange in some parts, later on adding white to the other, brighter points.

FLESH TONES **DARK SKIN**

Black and brown skin have the same textures and qualities as white skin. The only differences are the intensity of tone and the contrasts that are generated.

As is the case with white skin, black and brown skin tones are derived from color mixtures and are affected by the contrast generated by the surrounding colors and by the intensity and quality of light.

We are going to paint the arm of this woman. Her skin is soft, and her skin color intense.

1. We begin by applying the darkest values with a mixture of burnt umber, alizarin crimson, and white. For the light values we added orange and more white to the previous mixture and applied the color with careful brushstrokes calculated to suggest the direction of the muscles.

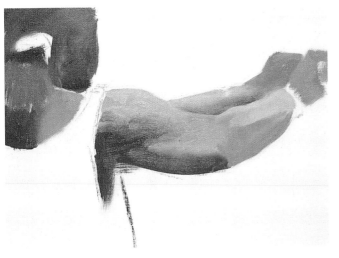

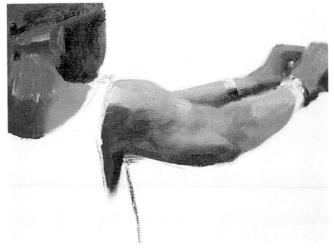

2. We blurred the tones softly with a brush, adding orange to some areas and alizarin crimson to other parts, such as the hands.

3. We continue molding shape with value changes, adding a hint of ultramarine blue light on the elbow, and constructing the hands by means of shadows.

4. You can see in detail how we blended the dark values with the light values, as a way of developing the rounded forms and soft curves that represent the musculature.

5. We finished by painting the background and the t-shirt, which gives the skin the necessary contrast and tonal balance and lends unity to the whole composition.

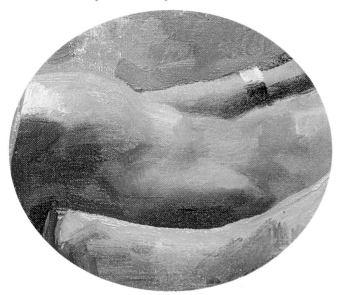

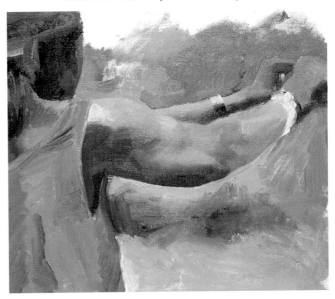

FLESH TONES **WEATHER-BEATEN SKIN**

With age and the effects of weather, human skin becomes rough, wrinkled, and weather-beaten. This type of skin must be depicted as it is, since it is an important element in defining a person. The skin contributes to our perception of an individual's personality. When painting weathered skin, be careful to avoid exaggerating the wrinkles, since the result could seem more like a mask than a real face reflecting life's experiences.

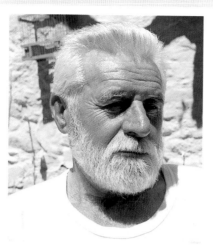

We are going to paint this man's face, which has been tanned by the sun. The subject's white beard adds an interesting element to the portrait.

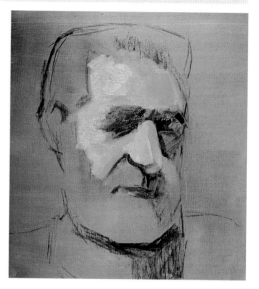

2. The beard and hair are painted with slightly neutralized white tones. Note how the colors of the first phases have undergone a complete transformation from the effect of the white hair and beard. Note the importance of the brushstrokes made in the first applications, which have already established the direction and placement of the wrinkles.

1. This will be a portrait since we are focusing on the face, so it is essential that we first draw a detailed sketch in charcoal. Then we apply the dark values with burnt umber, mixed with alizarin crimson. The light and medium values are obtained with mixtures in various proportions of orange, white, and alizarin crimson.

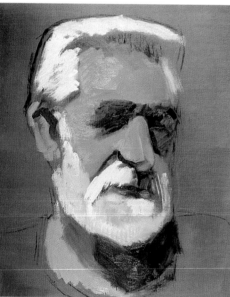

4. In the finished portrait, you can appreciate how the artist has molded the skin qualities of the model and all the detail work that this implies. It shouldn't be forgotten that a portrait is one of the most difficult subjects to master in painting, and it demands careful and concentrated observation before such a work can be undertaken.

3. To create the reflections on the skin, we have used white, allowing it to blend softly with the background colors. The details of the small shadows and wrinkles are brought out with a fine brush, using alizarin crimson and burnt umber.

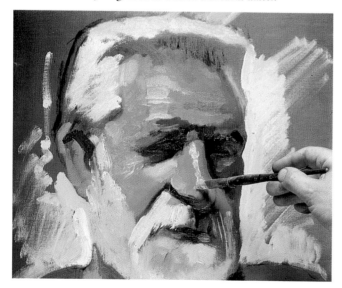

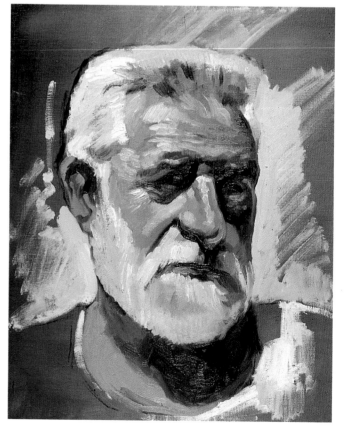

FLESH TONES SUGGESTED SKIN WITH SPECIAL COLORS

The quality and characteristics of human skin can be painted with colors other than those of the model's skin. Indeed, we can go so far as to use green instead of a flesh tone.

Human flesh can be suggested by the interplay of contrasted tones of varying intensities. In this case we are going to paint a nude using colors completely unrelated to the model. The colors chosen act almost like complementary colors, creating form and volume through contrast.

We are going to paint this model with contrasting colors using a technique similar to that used by the Fauves, a group of early twentieth century artists who created controversial paintings filled with strident colors.

1. A violet tone is obtained with a mixture of alizarin crimson, cerulean blue, and white, which we use to paint the darkest areas.

2. The background has been filled in with slightly thinned down ultramarine blue light. The most luminous parts are painted with medium green. The soft shadows that give the body volume are painted with the same green mixed with some ochre and white.

4. Now that the exercise is over, note the vibrant nature of the painting and see how the forms have been constructed by means of color contrasts.

3. Once the shirt has been painted in contrasting blue and yellow, we search for the maximum vibration of the color by outlining the model's form in red.

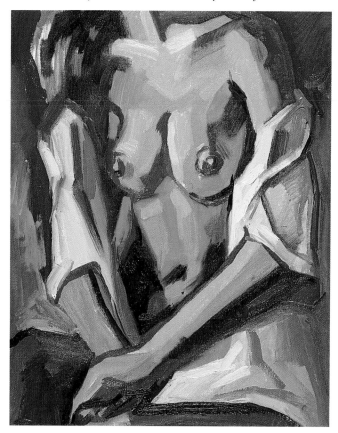

Animal Textures

As painting subjects, animals offer a considerable range of textures that can be quite daunting to the artist who attempts to capture them in oils. Aside from the spectacular textural differences of animals, be they furred or feathered, the same type of coat or plumage encompasses all manner of tones, sizes, and colors. For instance, the sleek fur of a wet seal bears little resemblance to the fur of a shaggy-haired dog. Thus, although we will always follow the classical procedures for oil painting, which consist of first blocking in the basic shapes with large areas of paint, and later painting the details with precise brushstrokes, the development and results of one animal painting will be totally different from another one. One should never forget that an animal is a living creature, and the sensation of warmth and movement that each animal possesses must be transmitted. Because of this, it is advisable to eliminate excess details. Otherwise, the painting will lose its freshness and credibility.

FUR

When it comes to painting an animal, the artist must bear in mind that fur differs widely among species and even on the same animal. A horse's mane, where tufts or even individual hairs are visible and well defined, cannot be dealt with in the same manner as the hair on a horse's flank, which often appears as a soft surface that can produce reflections of light and important contrasts.

FUR

A COLLIE

The collie is a dog with long hair that waves slightly on some parts of its body. This makes it a nice subject to paint in oil. The length of the hair and its flowing form requires that the brush is well-handled, the key to a proper rendition. This exercise will demonstrate how the brushstrokes will indicate the direction of the fur and support its soft, flowing texture.

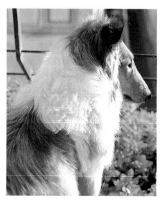

We are going to paint this collie, whose wide collar of white, brightly shining fur contrasts with the light brown of other areas of its coat.

1. A brush-sketch of the shape is painted, establishing the darker areas, with a mixture of ochre and burnt umber. The background is used in order to set up the correct contrasts and values of the colors to be used.

2. The brown fur is painted, using the brushstrokes to indicate the direction of the hair. For this part we have used a mixture of burnt umber, ochre, and a hint of white, in varying proportions, lightening or darkening the value as the model dictates. For the neck area we have used white mixed with a touch of burnt umber and ultramarine blue light, which lends a cool sensation to the shadows.

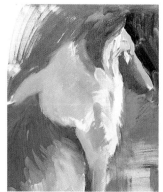

3. Once the general forms have been determined, we begin to work on the details, suggesting the texture of the dog hair with thicker impastos.

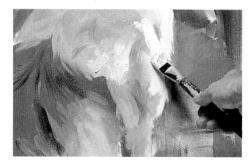

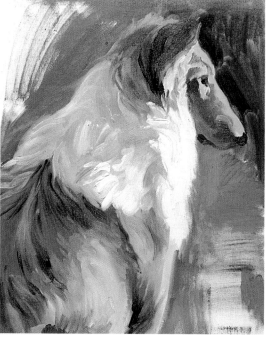

4. Now that the painting is finished, note the important role played by the brushstrokes in capturing the texture and direction of the hair. Furthermore, observe the interplay of the light and dark areas that the artist has created.

FUR

A SURICATE

The suricate, a small South African carnivore, has short fur of gray and earth tones that, depending on the position of the animal and its movement, can look like a smooth surface or a striped mass of light and dark shades. The main challenge in painting this unusual pelt lies in capturing the light and dark lines that characterize the fur, and avoiding a result that looks more like wrinkled skin.

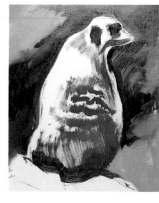

We are going to paint this motionless suricate with its characteristic flat, polished pelt on the upper part of its body and the lightly striped pattern on its flank.

1. We have made the initial drawing with a mix of burnt umber and ochre, fixing the areas of light and shade. The background has been painted with an interplay of dark greens.

4. The last step entails rendering the direction and texture of the fur with small brushstrokes, so that we can contrast its light and dark values.

2. We have made a mixture of orange, white, and burnt umber and have used it to work on the reflected light of the fur with brushstrokes that follow the direction of the hairs.

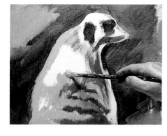

3. We have added a touch of alizarin crimson to the previous mixture in order to paint the intermediate vlaues. We have also begun to suggest the rock on which the suricate is sitting, since the contrast between the two is fundamental for determining the dark values of the lower body.

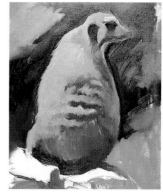

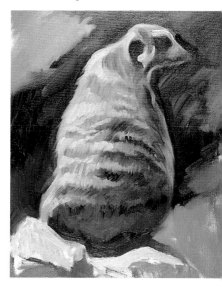

FUR

A FAWN

This young red deer has a short soft coat without any significant color contrasts. The size and shape of the form can be constructed by playing with value.

We are going to paint the head of this fawn with short hair, which is uniform in color and length.

1. The background is painted a light value of cool gray, which will emphasize the animal's warm tones. We have drawn the shape in charcoal, since it is somewhat complicated, and then over this sketch, we have blocked in the dark areas with a very diluted mixture of burnt umber and alizarin crimson.

NOTE

When executing a work in oil, it is advisable to paint the sketch and the initial large strokes with paint thinned with turpentine, so that it dries quickly and is less likely to muddy the colors that are superimposed afterwards.

2. With a mixture of ochre and white, we have painted the light areas. We then added yellow to this color to paint the light background, a fundamental step in bringing the dark parts of the painting to life. Note that, although at this stage of the painting we are still using a wide brush, the brushstrokes suggest the direction of the hairs.

3. With a mixture of orange and ochre we have worked on the intermediate values on the cheek and nape of the neck.

4. To finish the work, we have retouched the details with a hint of impasto on the highlighted areas, and have painted the eye, a detail that gives character to the expression of the animal. You can see how the background shows through some of the brushstrokes, thus complementing the construction of the work.

SCALES

Skin covered with scales is another type of skin in the animal world. This is visually attractive, but may be difficult to paint in oils. Any attempt at painting scales with geometric detail will result in a flat and lifeless picture. On the other hand, scales create a texture that begs for some form of explicit depiction, and the artist must find the right approach, so that he neither gets lost in the details nor fails to depict the scales for what they are.

SCALES

FRESH SEA BASS

A trip to the fish market is a good opportunity to study the scales of fish. The structure of the scales is interesting, as are their transparency and apparent fragility. The transparent nature of fish scales is precisely what makes them difficult to represent with oil paint; since they are colorless, they must be painted the color of the underlying fish skin.

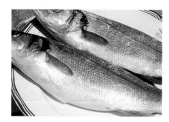

We are going to paint these fresh sea bass. Their scaly texture can be seen at a glance.

1. We have made a pencil sketch on white canvas, focusing our attention on their texture. With a very diluted mixture of ultramarine blue light and alizarin crimson, we paint their sides, suggesting the texture of the scales from the outset. We have added white and a touch of vermilion to the previous color to paint the abdomen.

4. To complete the exercise, we added some final highlights on the stomach and head, allowing the white to lightly blend into the surrounding colors.

3. We have painted the fish with light streaks of yellow, orange, and neutral cool tones. A strong effect of light reflected by the scales is created with white. The gridwork that suggests the structure of the scales is formed by cross-hatching brushwork.

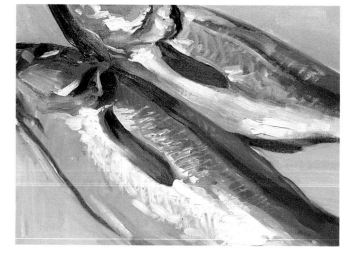

2. We continue configuring shapes with the previous mixtures, creating some contrasts with vermilion and raw umber.

SCALES

AN IGUANA

An iguana is a lizard that has scaly skin in attractive colors. It is of special interest to the painter because the shape, size, and structure of its scales differ from one part of its body to another.

NOTE

In this exercise, the artist has preferred to avoid too much detail of the scales so that the work doesn't acquire the quality of illustration, but maintains the character and freshness of an oil painting.

1. We have merely suggested the background with a dark blue to heighten the luminosity of the iguana's coloring. We begin by painting the body with brushstrokes of ochre.

We are going to paint the head of this iguana, whose scales are colorful and offer a great diversity of shapes.

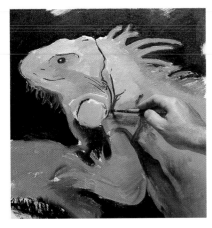

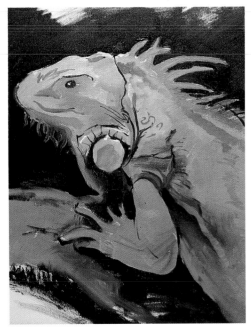

2. For the area of the head we have used cerulean blue mixed with white. In some parts we have shaded this tone by mixing it with ochre that was already on the canvas. The belly is painted with a medium green, applied with long, smooth brushstrokes.

3. Once the large areas that make up the basic form have been completed, the texture of the scales is suggested with raw umber, applied semi-diluted with a fine brush.

4. To finish, we have lightly indicated the larger scales, and have painted the shadows that establish the depths of the folds in the skin.

SCALES	A SNAKE

Snakes, in addition to being completely covered by bright and shiny scales, have long bodies that bend, twist, and coil in varying rings. This sinuousness makes drawing snakes even more complicated.

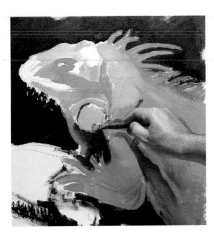

We are going to paint this snake, which, aside from having typically scaly skin is marked by a beautiful pattern, distinctive to this species.

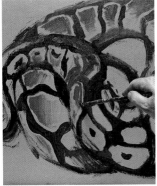

2. Some orange is added to the violet in order to enclose the lines of the drawing. The rough texture of the snake's skin has already been suggested with the first layers of paint.

1. We begin by drawing the complicated form in charcoal, then going over the sketch with a brush and a mixture of ultramarine blue and alizarin crimson, making it more violet or blue as desired. Note that we have used a neutral green background that adds to the color scheme of the work.

4. The work is finished by blending certain tones, and suggesting the scales in the areas of medium light by lightening the background color with white. In the dark areas, we have added some touches of cerulean blue, allowing them to blend into the background color.

MORE INFORMATION . . .

In this exercise, you can see how the background has functioned as one more color by appearing between the gaps of the snake rings. You will find more information on this in *Background Color*, pages 64, 65.

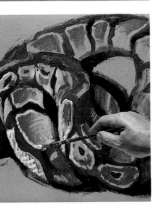

3. We have used black to reinforce the lines, to give body to the dark areas and, through contrast, to emphasize the lighter areas. For the highlights we have used a mixture of white and yellow which is applied with cross-hatched brushwork to suggest the array of scales.

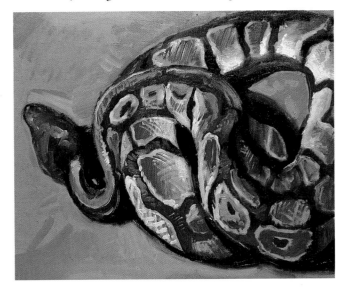

SKIN

Animal skins vary widely and evoke very different responses. The skin of a frog, for instance, is fine, moist, and delicate, and conveys to the observer a sensation of freshness and moistness. The skin of a rhinoceros, on the other hand, is hard, thick, and dry, conveying a sensation of impenetrability. In each case, the oil painter is faced with the problem that, in addition to presenting the proper texture, he will also have to provoke the same feelings in the viewer that the real animal does.

SKIN — A WET SEAL

A seal is an aquatic mammal covered with a thick pelt, its fur saturated with a greasy oil that makes it waterproof. When sealskin is wet, it takes on the aspect of a smooth and uniform skin, and so must be painted in this way.

The sleek condition of this seal's fur is due to the natural oil that covers and permeates it, making it appear more like smooth skin than fur.

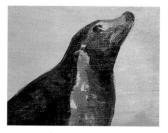

1. Over a cerulean blue background that suggests water, we have painted the shape of the seal with a mixture of burnt umber and alizarin crimson to represent the overall body. For the lighter areas we have added white to the previous mixture. The paint is applied by lightly rubbing or scrubbing with the brush rather than using normal brushstrokes. This avoids leaving any brushmarks on the smooth form.

NOTE

If you study the exercise carefully, you will be able to appreciate that the lower part of the seal's body has been painted utilizing the frottage technique, with the brush loaded with paint to ensure that the coat does not appear transparent; the background colors then are prevented from showing through. This technique has been used to eliminate obvious brushstrokes that would imply direction, something inappropriate for this texture, since the skin of the animal is completely smooth.

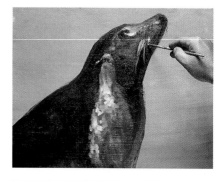

2. In order to suggest reflections on the skin's wet surface, we have used white toned with alizarin crimson and some ultramarine blue light, allowing the brushstrokes to blur softly at the edges.

4. No major changes have been made since the last stage illustrated. By following the exercise from the beginning, you can see that the seal has been painted without using many retouchings. Rather, we have attempted to preserve the first impression in order to convey the freshness of the image in the photograph.

3. After working on the reflections and accentuating the highlights with pure white, we have painted in the whiskers with a fine brush, using a mixture of ochre and white, ensuring that none of the underlying color is lifted by accident.

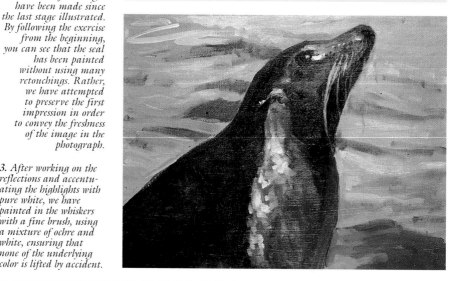

SKIN — A RHINOCEROS

Large land mammals like the rhinoceros are usually protected from the elements by a thick skin that is generally gray or earth-toned. Its texture is rough and produces deeply accentuated folds and wrinkles, transmitting a sensation of durability, dryness, and resistance.

A rhinoceros is a curious animal whose thick skin forms exaggerated folds that divide its body into various well-defined parts, thereby creating a sense that it is covered in a protective armor.

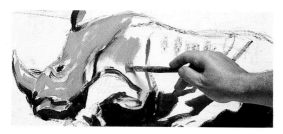

1. Over a pencil sketch, we have painted the animal's form with a brush, blocking in the part in shadow with a very diluted burnt umber. We have then added white to this mixture, and with thick paint have begun to fill in the body of the animal, suggesting the folds and protuberances of the skin with brushstrokes.

2. You can see that we have covered the entire body of the rhinoceros with paint, altering the proportions of the mixture to play with the light and dark values that help to develop the mass of the animal.

3. After filling in the background with colors that are warmer than those of the animal, we have added highlights that will emphasize the massive form, with a mixture of burnt umber, white, and ochre.

4. In the finished exercise, you can see that we have worked on the skin's folds and wrinkles with burnt umber and a fine brush, developing the details with lines and small touches of color.

| **SKIN** | A FROG |

A red-eyed frog has a thin, delicate skin that appears fresh and moist; its coloring offers extraordinary contrasts. In spite of its delicacy, the skin of the red-eyed frog is slightly rough, which makes it somewhat challenging to paint in oil.

1. We have used a background of neutral green very much in keeping with the subject matter. Over this we have drawn the form, using a brush and medium green, diluted in some parts to obtain a lighter value, while adding emerald green for the darker areas. The background is painted black, and the lighter parts of the frog with a mixture of cerulean blue and white.

4. From the finished painting, you can see that we continued to work on the lightest areas of the flanks with a mixture of yellow and green, and that we added details to the leaves on which the frog is squatting, darkening the value in order to heighten the contrast with the highlights.

2. The legs are painted with orange and the eyes with vermilion. We proceed to work on the texture of the skin with white paint shaded with ochre, and apply dark greens with a semi-dry brush to allow the colors of the background to show through.

We are going to paint this red-eyed frog; its skin is delicate and moist, and slightly rough.

3. The last touches of color are added for the highlights, using pale values of yellow and orange mixed with white.

PLUMAGE

The plumage of birds is as varied as that of other types of animal coats. That is to say, it is virtually limitless in form, size, and color. Feathers, like fur, offer a soft and fluffy covering that to a large degree hides the structure of a bird's body. This is one of the reasons why it is so important to take some time and carefully study a model of a bird before beginning to paint. Otherwise, an artist may commit the common error of focusing on details such as the direction and coloring of the feathers, without understanding the bird's underlying shape. This results in a painting that is neither accurate nor believable.

PLUMAGE **A PARAKEET**

The feathers of a parakeet vary. Virtually the entire body is covered with small oval-shaped feathers, while the wings possess long feathers the colors of which contrast with the fluffy body plumage.

We are going to paint this parakeet of bright coloring and simple plumage.

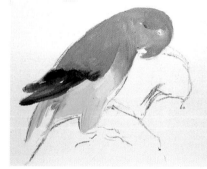

1. We first sketch the bird in charcoal, since it has a somewhat complex shape. With a mixture of medium green and yellow, we paint the belly, using brushstrokes to suggest feathers. The area of the beak and the head is suggested with a neutral gray, which is mixed by adding ultramarine blue light and a touch of alizarin crimson to the previous mixture.

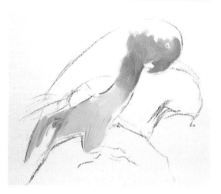

2. The area of the back is painted with a medium green subtly shaded with yellow and orange. For the wing feathers we have added ultramarine blue light and alizarin crimson, darkening the previous color and obtaining a dark value that creates shadings of ochres and greens. The paint is deliberately left only partially mixed in order to achieve this effect.

4. Note how details have been added to suggest the texture of the parakeet's plumage. During the first stages of the work, only the form was defined, with larger brushstrokes.

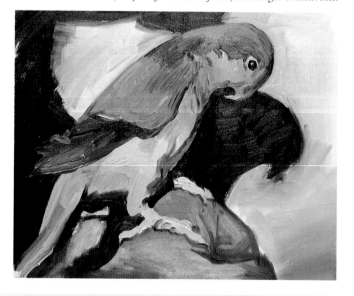

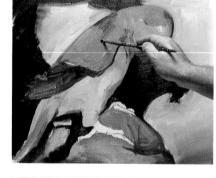

3. After painting the background, which will serve as a reference for establishing correct values, the texture of the feathers is developed with a fine brush, playing with the color contrasts.

PLUMAGE **A MOTTLED ROOSTER**

This mottled rooster is covered with soft and small oval feathers, which augment its truly large size. The execution of this type of plumage is quite simple. The secret is to know how to establish from the beginning the areas of light and shadow, taking advantage of the intermediate values of the background color.

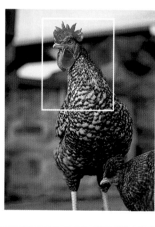

We are going to paint the plumage of the neck of this mottled rooster. The texture of the feathers will be suggested by painting with contrasting values.

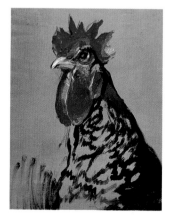

1. On a neutral gray background, a color quite appropriate for intermediate values, we have sketched in charcoal the form of the rooster. Then we painted this with a brush loaded with a mixture of black and ultramarine blue. The crest was painted with vermilion, orange, and white.

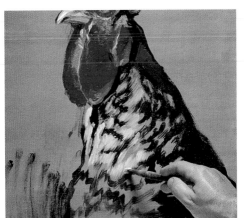

2. For the grays under the crop, we have applied white shaded with ochre, and have used small brushstrokes to suggest the size and direction of the feathers.

3. Note that we have created grays by applying a muddy white and allowing it to blend with the dark value at the edges. For the areas of reflected light we have applied pure white, making sure we haven't lifted any underlying color from the background.

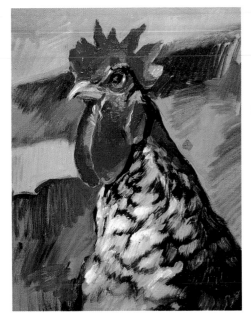

4. From the finished exercise, you can see how we have painted the background in a way that complements the color and value of the rooster, adding emphasis to its value contrasts. Further contrasts are created because the rooster is painted in cool tones, while the background is predominantly warm.

PLUMAGE

A FLAMINGO

The feathers of a flamingo are a striking, showy color, which suggest the form and mass of its body through the interplay of values. Its stylized body, the curve of its neck with its soft, short feathers, and the long, strong feathers displayed on the rest of its body make it a worthwhile subject for oils.

The flamingo, with its long legs and admirable plumage, is a good subject as much for its striking and intense color as for the characteristics of its feathers; short and soft ones on its neck, and long ones that closely follow the line of its body.

2. We have finished delineating the form and have begun to suggest the rounded mass of the bird with wide brushstrokes and contrasts of value, applying a mixture of alizarin crimson shaded with ultramarine blue light.

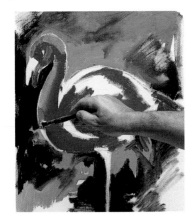

1. We have painted the background after sketching the bird's shape in charcoal. With a mixture of vermilion and orange, we begin to fill in the area of the body, varying the proportions of the paint to mix dark and light values.

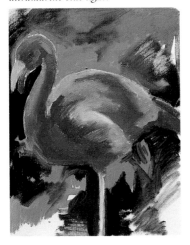

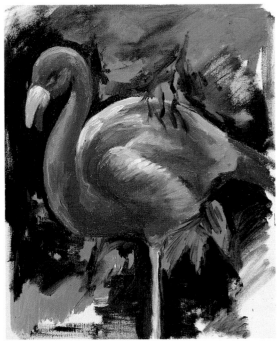

3. With a fine brush we proceed to suggest in more detail the texture of the plumage.

4. In the finished exercise, you can see the change that has been produced in the flamingo. The texture of the feathers is suggested by the brushwork and by the small contrasts of light and shadow.

Glass

Glass is a fragile material that is found wherever people live—in the windows of a house, in a bottle, or even in a pair of eye-glasses. It is the transparency of crystal and its quality as a cold material that makes it difficult to render by an inexperienced painter; a glass object allows you to see what is behind it, produces intense highlights, and can function like a mirror, reflecting nearby figures.

QUALITIES OF GLASS

Glass is a cold material, transparent and fragile, and can be found wherever people live. It is hardly surprising for the oil painter to discover that, within any chosen subject, there is something made of glass that must be depicted.

When glass is totally transparent and lacks color, it must be represented by what it contains, by the objects that can be seen through it, and by the highlights and reflections that it produces. For these reasons painting glass in oil can be difficult. One must observe a glass object closely, breaking down the image into colors, shapes, shine, and reflections in order to later reconstruct them on canvas.

To further complicate matters, we should bear in mind that if the glass, however transparent, is colored in some way, this color will affect those of any object visible behind the glass.

GLASS

Colored glass has the same transparent quality as clear glass, producing the same kind of highlights and reflections, but the colors of the objects that can be seen behind it are altered. Additionally, colored glass casts soft shadows of its own color.

2. The unobstructed part of the jacket has been painted with alizarin crimson and vermilion. The part seen through the glass jug is painted by adding some green to this mixture, thereby changing its color in the painting in the same way its color changes in real life.

A GREEN JUG

We are going to paint this green glass jug, which lets us see the objects behind it perfectly, but which varies their color shadings somewhat.

1. Having drawn the subject in charcoal, we paint the first areas with emerald green and white, intensifying and lightening the value as necessary. The jacket behind the jug is suggested with vermilion lightly tinted with the previous mixture.

3. The background has been painted, and we have worked on certain details to suggest textures and reflections. The highlight is painted with a brushstroke of white, deposited carefully to avoid lifting the color from the underlying background.

4. In the completed exercise, you can see that we have finished filling in the background, and that we have retouched some parts of the bottle to emphasize its transparency. The bottle is composed of three parts: the glass, the jacket behind it, and the reflected light.

GLASS

Transparent glass and colored glass act the same way in many respects, even though the latter usually alters the color tones of the objects seen through it. Transparent glass always has a touch of color, which in one place or another is more evident and which will have to be depicted as seen at the time of reproducing it in oils.

SEVERAL BOTTLES

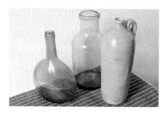

We are going to paint these three bottles, a combination of colored, lightly tinted, and completely transparent glass.

1. We have used a semi-diluted mixture of emerald green, medium green, and white to paint the upper part of the first bottle. Then we added ochre to the mixture for the lower section. With white, ultramarine blue light, and just a touch of burnt umber, we mixed the gray used to suggest the other bottle.

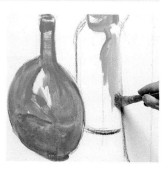

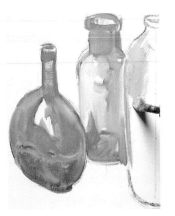

2. We have finished painting the shapes of both glass bottles. It is possible to see how, at this stage, the values of the colors are already determined, as are the areas of reflected light.

3. The background has been painted to accentuate the highlights and lighter colored areas of both bottles. We have added some detail to the glass, working on the bases of the bottles to suggest the color of the tablecloth, which can be seen through the glass, detailing its form.

4. We have continued working on details with a fine brush, shading the tones and blending colors. Note the influence of one bottle's colors on those of the other, and the small, green reflection that can be seen on the center bottle.

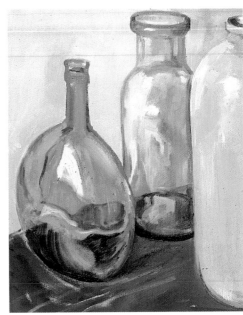

GLASS

A WINDOW AS A MIRROR

The smooth plane of a window, depending on the incidence of light, can act as a mirror, reflecting on its surface the shapes and colors of objects around it. In many cases, windows are not totally flat, but softly curved, which distorts the images and alters their forms.

We are going to paint this car window, which, because it is slightly curved, distorts the shapes and creates an image that is almost abstract and surreal.

NOTE

Because glass is transparent, you cannot paint it as a single solid form. You have to break down the image and paint the colors of the objects behind the glass, the reflections, and highlights, in addition to the form of the glass itself.

4. We finished by developing more of the details, and adjusting some values. Finally, the car's bodywork has been painted to heighten the impact of the highlights and reflections in the glass. Note the implied reflections of light suggested by the fine, sinuous lines on both parts of the car.

1. Since this is a complicated subject, we need a careful charcoal drawing before starting to paint. We are going to use an appropriately neutral colored background in order to begin working on the light areas; we want the background to show through the brushwork.

2. We painted the lighter values with a combination of white and ochre. Afterward, in order to delineate the shapes, we painted the dark areas with burnt umber and ultramarine blue light. The areas of color on the car itself have been painted, as has the roof of the house in the reflection.

3. We have painted the sky with cerulean blue toned down with white, and then worked on the details of the painting with a fine brush.

Metal

Metal is another product that is found wherever people live. Even though it may not be the principal focus of a work, an artist should know how to paint this type of material. It can appear polished and bright, or old and rusty. In any event, its color—which, to those who don't know the technique of painting, can seem a mystery—is simple to suggest with mixtures of color.

POLISHED METAL

Polished metal reflects nearby objects, usually distorting them if the surface of the metal is curved.

As a result, when the time comes to paint a brightly polished metal object, an oil painter is faced with several problems. The first is the choice of colors needed to suggest metal, since the color of metal is not normally available commercially. The second problem is learning how to mold and shape the forms distorted by the reflection. The third is learning how to achieve the proper colors of the figures reflected in the metal object, since those colors can be altered by the reflection. Polished metal produces reflections and highlights that at times are soft and shaded, and at other times are intense and blindingly white.

POLISHED METAL AN ANTIQUE MOTORCYCLE

Polished or well-painted metal produces similar types of reflected light. The latter, however, does not have the same capacity to reflect nearby objects. Generally speaking, polished metal objects are not flat planes. Rather they have molded and curved surfaces, which distort the images they reflect.

We are going to paint the headlight of an antique motorcycle, which has both highlights and reflections of objects. We will also include the black mudguard, which is so clean that it sparkles.

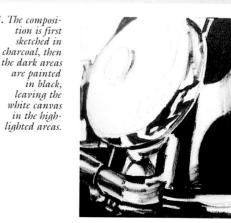

1. The composition is first sketched in charcoal, then the dark areas are painted in black, leaving the white canvas in the highlighted areas.

2. For the bright areas of the vehicle we have used a mixture of ultramarine blue light, black, and white, which is ideal for these intermediate values. The headlight is also worked with ultramarine blue and white, but here we have included some ochre in place of black, to suggest the reflections of the ground.

3. We have added the last touches of light to the headlight with ochre, and then worked on the body with some highlights of pure white.

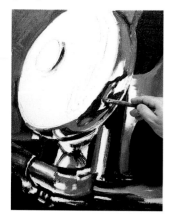

4. The finished painting shows how the white highlight is blended into the surrounding colors, resulting in a soft graded color without abrupt changes.

OLD RUSTED METAL

Rusted metal has lost its original brilliance, presenting a surface that is dull and often rough.

Old metal can also resemble polished metal, but its reflections of light are darker and not as sharp.

The characteristic coloring of rusty metal can only be produced by mixing colors, since it is difficult to find such a color in an art supply store. Finally, rusted metal has an irregular, rough surface. Therefore, an artist must know how to use the right brushstrokes to paint the irregularities or to blend light and dark values.

OLD METAL

Copper is a metal that must be cleaned to maintain its shine. Otherwise, it becomes covered with a natural, oxidized, dull coating, although it always reflects some light and has soft, glowing highlights. Polished copper, like any other metal that has been polished and cleaned, produces intense highlights.

COPPER POTS

Hammer marks are typically seen on copper pots made by artisans. The result is an irregular and highly distinctive surface.

1. After sketching the subject with a brush and raw umber, we fill in the areas of shadow, painting the old pot by mixing raw umber with white for the upper area, and vermilion with alizarin crimson for the base and the softer reflections.

2. We have begun to paint the polished pot with pure ochre on the intermediate areas of light, reserving the white of the canvas for the reflected light.

3. We finish painting the older pot by applying the same colors used for the other one, plus some black. Note the effect of the brushstrokes, a series of short strokes that suggest the irregular texture of hammered metal. The background is painted to emphasize the metal's shine.

4. Once the background is painted, we have lightly blended the colors of the pots and have used white to add the small glints of light on their edges.

RUSTED METAL

Iron is a metal that rusts easily. Even if painted, the corrosion produced by time's passage deteriorates the paint and the iron's direct contact with the air initiates the oxidization process. The rust is usually a reddish color, and the texture of the surface becomes rough and pitted.

IRON OBJECTS

1. After painting the background, giving it texture by using thick impasto, we begin to paint the metal, applying raw umber on the dark areas.

We are going to paint these rustic, iron household objects that, with the passage of years, have been lightly covered with a coat of rust.

2. The natural shadow has been blended with a mixture of ochre, vermilion, and white to suggest the intermediate values. Additional white is added to the mixture to paint the lightest areas.

NOTE

The color of metal can be captured by mixing paints. It is important to keep the proper value, and to reproduce the reflections that convey the coldness of this material.

3. Taking advantage of the previous mixtures, we work on the rest of the details, gently depositing the paint to avoid mixing it with the background color, which is still wet.

4. Finally, we have painted the chains. You can see how the pot and the oil lamp have not undergone any substantial alterations since the last stage illustrated. They were already well defined by the first strokes of paint.

Topic Finder

MATERIALS AND TOOLS

Paint . 6–9
Components 6
Pigments 6
 Characteristics 6
Toxicity of Oil Paint 7
Binders . 7
Problems of Oil Paint 7
• Cracks . 7
• Dry Spots 7
• Swelling 7
Presentation in the Stores 7
• Tubes . 7
• Jars . 8
Quick Drying Paint 8
Oilbars . 8
Quality . 8
Advantages and Disadvantages 8
Color Chart 9

Supports10–15

Canvas 10
Unprimed Canvas 11
Canvas . 11
Linen, Cotton, Sackcloth, and
 Synthetic Fibers 11
Primed Canvas 11
Coarse, Medium, and Fine Weaves 11
Types of Primed Canvas 12
Thicknesses of Cotton 12
Thickness of Linen 13
Grades of Canvas 13
Formats: Rolls or Prestretched 13
Advantages and Disadvantages
 of Different Types of Canvas 14

Stretchers 14
Joining . 14
Inexpensive Stretchers 15
Spanish, French, and Levantine
 Stretchers 15
European Stretchers 15
Standard Sizes of Stretchers 15

Wood, Cardboard, and Paper15

Brushes 16–21
Design of a Brush
• Handles 16
• Ferrules 17
• Fibers . 17
Types of Fiber 18
• Hog Bristle 18
• Mongoose 18
• Sable . 18
• Ox Hair 18
• Synthetic Hair 19
Types of Brushes 19
• Round Brushes 19
• Rubber-tipped Brushes 19
• Flat Brushes 19
• Flat-tipped Brushes 19
• Bell-shaped Brushes 20
• Filbert . 20

• Fan-shaped Brushes 21
• Large Flat Brushes 21
Numbering System of Brushes 21

**Additives for
Oil Paint** 22–27
Oils . 23
Linseed Oil 23
• Refined Linseed Oil 23
• Bleached Linseed Oil 23
• Boiled Linseed Oil 23
• Purified Linseed Oil 23
Other Oils 23
• Safflower Oil 23
• Poppy-seed Oil 23
• Walnut Oil 23
• Stand Oil 23
Volatile Oils 23
• Rectified Turpentine 23
• Lavender Oil 24
• Odorless Mineral Spirits 24
• Mineral Spirits 24
Advantages and Disadvantages 24
 Oil Solvents and Thinners 24
Drying Agents 24
• Courtrai Dark Siccative 24
• Courtrai Pale Siccative 24
• Cobalt Drier 24
Advantages and Disadvantages 25
Mediums 25
• Flemish Medium 25
• Egg Medium or Tempera 25
• Venetian Medium 25
• Painting Medium 25
• Oleopasto 25
Textural Additives 26
• Ground Marble and Alabaster 26
• Abrasives 26
• Priming the Support 26
• Varnishes and Finishes 26
• Asphalt 27

Paintboxes and Cases . . 28–29
Economical Cases 28
Empty Paintboxes 28
Complete Paintboxes 29
Outdoor Easel-Boxes 29

**Palettes, Palette
Knives, and Cups** 30–31
Palettes . 30
• Square Palettes 30
• Oval Palettes 30
• Paper Palettes 31
• Improvised Palettes 31
Palette Knives 31
Palette Cups 31

Easels and Seats 32–33
Studio Easels 32
Lightweight Folding Easels 32
Tabletop Easels 32
Metal Outdoor Easels 32
Stools . 33

Folding Seat 33
Canvas Holders and Separators 33

**Other Materials
and Accessories** 34–35
Cleaning Utensils 34
• Rags and Papers 34
• Sponges 34
• Newspaper 34
• Solvents 34
• Hand Cream 34
Other Painting Accessories 34
• Dusting Brush 34
• Erasers 35
• Jar for Brushes 35
• Pencils and Charcoal 35
• Stapler, Pliers, Knife and Scissors 35

OIL TECHNIQUES

**Stretching Canvas on
Stretcher Bars** 36–37
Stretchers: Stretching Canvas with
 Staples 36
Stretchers: Stretching Canvas with
 Tacks . 37
Stretchers: Stretching Paper 37
Stretchers: Plywood 37
Stretchers: Cardboard 37
 A Solution for Slackening 37

Priming 38–41
What Is Priming? 38

Making Your Own Primer 38
Making Your Own Primer:
 Preparing Rabbitskin Glue 38
Making Your Own Primer: Making
 Rabbitskin Glue for Canvas 39

Priming Canvas 39
Priming Canvas: Applying Rabbitskin
 Glue to a Canvas 39
Priming Canvas: Acrylic Priming 39
Priming Canvas: Latex 40
Priming Canvas: Priming
 with Turpentine 40
Priming Canvas: Leftover Paint 40
Priming Canvas: Priming with Color . . 40

Priming Rigid Supports 41
Priming Rigid Supports: Gesso 41
Priming Rigid Supports:
 Acrylic and Latex Priming 41
Priming Rigid Supports:
 White Underpaint 41
Priming Rigid Supports:
 Rigid Support with Muslin 41

Using a Brush 42–45
Using a Brush: How to Hold It 42
Using a Brush: Precision 42
Hints: How Many Brushes
 Should You Use? 43
Taking Care of Brushes: How to
 Clean Them 44
Maintenance: How to Store Brushes . . . 45
Bad Habits: Mistakes to Avoid45
Versatility: Different Kinds of
 Brushstrokes 45

Using a Palette Knife . 46–47
Using a Palette Knife: Ways of
Holding a Palette Knife 46
Using a Palette Knife: Mixing
Colors . 46
Using a Palette Knife: Applying
Paint . 46

Taking Care of Palette Knives . . . 47
Taking Care of Palette Knives:
Cleaning a Palette Knife 47
Taking Care of Palette Knives:
Storing a Palette Knife:
Bad Habits 47

How to Make Oil Paints
and Use the Palette 48–49
Making Oil Paint: How to
Make Oil Paint 48
Using a Palette: Making a
Palette Out of Plywood 48
Using a Palette: Arranging the
Colors on a Palette 49
Using the Palette: Cleaning a
Palette 49

One Color 50–53
How to Paint a Graded Color 50
Gradations: Grading with
Turpentine 50
Gradations: Grading with
White Paint 50
Gradations: Grading over
an Oily Surface with White 51

Value 52
Value and Hue 52
Value: Changing Values by
Diluting the Paint 52
Value: Changing Values
by Adding Black and White 52

Monochrome Painting 53
One Color: Raw Umber and White . . . 53

Two Colors 54–55
Grading Two Colors 54
Grading Two Colors: Yellow,
Blue, and Green 54
Exercise in Two Colors: Emerald
Green and Vermilion, plus White . . . 55

Three Colors 56–58
Color Characteristics of Light 56
Color Characteristics of Pigment 56
Primary Colors: Oil Colors 56
Secondary Colors: A Mixture
of Primary Colors 57
Tertiary Colors: A Mixture of
Primary and Secondary Colors 57
Contrast: Complementary Colors. 58

Mixtures 59–60
Mixtures: Methods for Mixing
Oil Paints 59
• On the Palette 59
• Glazes 59
• Color Frottage 59
• Mottled, *alla prima* 59
• Broken Colors and Pointillism 59
Three Colors and White: A Still
Life with Vegetables60

Several Colors 61
A Suggested Palette 61

Ranges 62–63
Ranges: Warm Colors 62
Ranges: Cool Colors 62
Ranges: Neutral Colors 63

Background Color 64–65
Background Color: White
Backgrounds 64
Background Color: Colored
Backgrounds 64
Background Color: Coloring a
Background 65
Background Color: Using
Leftover Paint 65
Background Color: Re-Using
a Canvas 65

Oil Painting Procedures:
"Fat over Lean" 66–67
"Fat over Lean" 66
The Proportion of Oil 66

Procedure 66
Procedure: A Pair of Boots 66

Painting over Wet Paint:
Painting *alla Prima* . . . 68–69
Painting over Wet Paint68
Painting *alla Prima*68
Painting over Wet Paint: A Still
Life of Little Cakes 68
Painting over Wet Paint: Details
of the Procedure 69

Painting over Dry Paint:
Painting in Stages 70–71
Painting over Dry Paint 70
Painting in Stages: A Table
with a Bottle 70

Painting with Diluted
Oil Paint: Painting
with Glazes 72–73
Painting with Diluted Oil Paint 72
Glazes . 72
Painting with Diluted Oil Paint:
Painting a Basket of Potatoes 72

Painting with a
Palette Knife 74–75
Characteristics of Painting
with a Palette Knife 74
Hints for Painting with a
Palette Knife 74
Painting with a Palette Knife:
The Smoker's Table 74
Painting with a Palette Knife:
Details of the Result. 75

Painting with Impasto . . 76–77
Characteristics of Impasto 76
Hints for Painting with Impasto 76
Painting with Impasto: A Sewing
Basket 76
Painting with Impasto: Correcting
Errors .77

Painting with Small
Strokes of Color 78–79
Optical Effects of Color 78
Painting with Small Strokes
of Color 78
Painting with Small Strokes
of Color: The Laundry Room 78
Painting with Small Strokes of
Color: Details of the Painting 79

Painting over a Base of Oil:
Creating Atmosphere . . 80–81
Oil as a Base 80
Atmosphere 80
Painting over an Oil Base: The
Atmosphere of a Landscape 80

Tricks of the Trade . . . 82–101
Corrections 82
Corrections on Wet Paint:
Reducing the Paint's Density 82
Corrections on Wet Paint:
Darkening a Color 83
Corrections on Wet Paint:
Lightening a Color 83
Corrections on Wet Paint:
Correcting with a Clean Brush 84
Corrections on Wet Paint:
Correcting with a Finger 84
Corrections on Wet Paint:
Correcting with a Rag 85
Corrections on Wet Paint:
Correcting with a Palette Knife 86
Corrections on Dry Paint 87
Corrections on Dry Paint: Changing
the Ambience, Creating Effects 87
Corrections on Dry Paint:
Painting over Dry Paint 88
Contours 89
Difficult Contours: On a Background
Color . 89
Sharply Defined Contour: Juxtaposing
Two Colors 90
Painting Contours in Stages: Juxtaposing
Two Colors 90
Sharply Defined Contours: Masking
with Latex and an Oil Base 91
Sharply Defined Contours: Masking
with Adhesive Tape 92
Sharply Defined Contours: Masking
with Glue over Oil Paint 92
Indistinct Contours 92
Indistinct Contours: *Sfumato* with
a Brush 93
Indistinct Contours: *Sfumato* with
a Rag . 94
Indistinct Contours: *Sfumato* with
a Finger 94
Scrubbing. 95
• with a Brush 95
• with a Rag 95
Dry Brush: Fan Brush95
Sgraffito: Scratching the Paint 96
Glazes: Diluting Paint 96
Smoothing: With Paper 97
Painting with:
• the Cap of a Tube of Paint 98
• a Fork98
• a Spoon 98
• Waxed Paper 98

ALL ABOUT TECHNIQUES IN OIL

- Oil Sticks and Tubes 99
- a Sponge 99
- a Rubber-tipped Brush 99
- a Pencil . 99
- Your Fingers 100
- a Syringe 100
- the Handle of a Brush 100
- a Slide Frame 100

Adding Texture:
- with Ground Marble 101
- with Metal Fragments 101
- with Lead 101
- with Washed Sand 101
- with Molding Paste 101

SUBJECTS FOR OILS

Skies 102
The Color of the Sky 102
The Sky and the Earth 102
Techniques 102

Clear Skies 102
Clear Skies: Dawn 103

Cloudy Skies 104
Cloudy Skies: White Clouds 104
Cloudy Skies: Clouds and Mist 105
Cloudy Skies: Clouds in a Storm . . . 105
Cloudy Skies: Evening Clouds 106
Cloudy Skies: Fiery Skies 106
Cloudy Skies: Clouds at Night 107

Water 108–113
The Color of Water 108
Technique 108
Still Water 108
Still Water: Water as a Mirror 108
Still Water: Blurred Reflections 109
Moving Water: A Breaking Wave . . . 110

Moving Water: Ocean Waves 110
Moving Water: Small Waves 111
Moving Water: Gentle Waves
 on the Shore 112
Moving Water: A Small Waterfall . . . 113

Vegetation 114–123
Variety . 114
Technique 114
 The Color of Vegetation 114
Trees .114
Trees: Fir Tree 115
Trees: Oak Tree 115
Trees: Palm Tree 116
Trees: Pine Tree 116
Trees: Holm Oak Tree 117
Trees: Thuja Tree 117
Trees: A Tree in Blossom 118

Meadows and Fields 118
Meadows and Fields: A Meadow
 in Spring 118
Meadows and Fields: A Mountain
 Meadow 119
Meadows and Fields: Cultivated
 Fields . 120

Grass 120
Grass: Lawns 121
Grass: Cultivated Fields 121
Grass: Tall Grass 121

Flowers 122
Flowers: Daisies 122
Flowers. An Iris 123
Flowers: A Bouquet of Flowers 123

Flesh Tones 124–129
The Character of Skin 124
The Quality of Skin 124
The Importance of the Figure 124
Flesh Tones: Delicate Skin 124

Flesh Tones: Skin with Body Hair . . . 125
Flesh Tones: Wet Skin 126
Flesh Tones: Dark Skin 127
Flesh Tones: Weather-beaten Skin . . . 128
Flesh Tones: Suggesting Skin with
 Special Colors 129

Animal Textures 130–137
Fur . 130
Fur: A Collie 130
Fur: A Suricate 131
Fur: A Fawn 131

Scales 132
Scales: Fresh Sea Bass 132
Scales: An Iguana 132
Scales: A Snake 133

Skin 134
Skin: A Wet Seal 134
Skin: A Rhinoceros 134
Skin: A Frog 135

Plumage 136
Plumage: A Parakeet 136
Plumage: A Mottled Rooster 136
Plumage: A Flamingo 137

Glass 138–139
Qualities of Glass 138
Glass: A Green Jug 138
Glass: Several Bottles 138
Glass: A Window as a Mirror 139

Metal 140–141
Polished Metal 140
Polished Metal: An Antique
 Motorcycle 140

Old Rusted Metal 140
Old Metal: Copper Pots 141
Rusted Metal: Iron Objects 141

Original title of the book in Spanish: *Todo sobre la técnica del Oleo.*

© Copyright Parramón Ediciones, S.A. 1997—World Rights
Published by Parramón Ediciones, S.A., Barcelona, Spain.
Author: Parramón's Editorial Team
Illustrators: Parramón's Editorial Team

© Copyright of the English edition 1997 by
Barron's Educational Series, Inc.

All inquiries should be addressed to:
Barron's Educational Series, Inc.
250 Wireless Boulevard
Hauppauge, New York 11788

International Standard Book No. 0-7641-5045-6

Printed in Spain
9 8 7 6 5 4 3 2 1

Library of Congress Catalog Card No. 97-23436

Library of Congress Cataloging-in-Publication Data

Todo sobre la técnica del oleo. English.
 All about techniques in oil / [author, Parramón's Editorial
Team ; illustrators, Parramón's Editorial Team].
 p. cm.
 ISBN 0-7641-5045-6
 1. Painting—Technique. I. Parramón Ediciones. Editorial Team.
II. Title.
ND1500.T6313 1997
751.4—dc21 97-23436
 CIP